Front Line Artists

Peter Johnson

Front Line Artists

Cassell

London

to Christopher and Matthew

CASSELL LTD.
35 Red Lion Square, London WC1R 4SG
and at Sydney, Auckland, Toronto, Johannesburg,
an affiliate of
Macmillan Publishing Co., Inc.,
New York.

First published 1978

Designed by Simon Bell

ISBN 0 304 30011 X

Printed in Great Britain by
Fletcher & Son Ltd, Norwich

Contents

Acknowledgements

No newspaper has played a greater part in the story of the special war artists than the *Illustrated London News* which today continues the fine traditions of illustrated journalism founded by Herbert Ingram in 1842. It is fitting therefore that this publication should have been the largest single source of pictures used in this book, from Chapter 1 right through to the Boer War. I am indebted to the *Illustrated London News* for assistance and for permission to reproduce material, and particularly I acknowledge the invaluable help I have received from H. E. (Bill) Bray, the picture library manager; I would also like to thank Ursula Robertshaw of the *Illustrated London News*.

Here, I would devote a special note of thanks for the kind and enthusiastic assistance afforded me by Mr and Mrs H. H. Ingram, both of whom are members of the distinguished family which founded the *Illustrated London News*; to Mrs Ingram I am grateful for her encouragement in the writing of this book and permission to reproduce the original drawing by William Simpson of a rocket detachment in Abyssinia.

The second largest source of illustration has been the National Army Museum in London, which made available much research material as well as original pictures by Melton Prior, and was invaluable in illustrating the work of artists in the British army's campaigns in Zululand, on the Nile, in South Africa and elsewhere. The Library of Congress, Washington, provided a considerable number of illustrations, including all those concerning the Civil War and several in the chapter 'Covering the West'; I am grateful for the help provided by Jerry L. Kearns and his staff.

My thanks go to Phillips, the London fine art auctioneers, for permission to reproduce several illustrations including examples of William Simpson's work in the Crimea and India. Joe D. Thomas and his staff at the National Archives in Washington generously gave their assistance and, as a result, the chapter on the West and Chapter 13 contain several illustrations reproduced from the files of the U.S. War and Navy departments, the Signal Corps, and the Bureau of Public Roads.

I would also like to acknowledge the help of the following: Edith Schmidt of the Museum of Fine Arts, Boston, Massachusetts; Norman Potter of London for photographic assistance; the Westminster public libraries, London; Sotheby Parke Bernet of London. And to my wife, Anne, go my thanks for help in research and revision.

1 Infernal Fools

... the bullets are flying from all directions, and camels, mules and men keep dropping down; we are all cramped up together, so the bullets cannot fail to strike

Diary of an officer in Hicks Pasha's army

As the vultures screamed and fought over the entrails of an army and the chain-mailed, mud-plastered, ragged-bannered host of Dervishes closed in, dancing, for the final kill, it must have seemed to Frank Vizetelly that the wastes of Kordofan were an awful place in which to end a career that had taken him, as a civilian, into more risks to life than the average soldier experiences in all his years of campaigning.

He had ridden with Lee and Garibaldi, courted execution as a spy on the Potomac, come unscathed through Sadowa and Solferino, dodged bullets in Sicily and lynch-mobs in Spain, suffered thirst, starvation, heatstroke and exposure, risked cholera and typhus. But it was now the morning of Monday 5 November 1883, Vizetelly was fifty-three, and he waited behind a hastily erected fence of thorn bushes with the remnants of what Churchill has called the worst army that ever marched to war.

It did not need a historian to tell Vizetelly that. As a special artist for the *Illustrated London News* and other newspapers, he had travelled with many armies in Europe, America and Africa, and his experienced eye told him that the rag-bag expedition which moved out of Khartoum on 9 September with bands playing was woefully ill equipped for the task ahead in the Sudan: the subjection of a revolt raised by the Mahdi, a religious fanatic who had declared a holy war on the corrupt, tottering Egyptian regime.

Vizetelly's job was to draw pictures of wars wherever they took place. In the Sudan he was working for the *Graphic* of London. The role of his colleague, Edmond O'Donovan of the *London Daily News*, was to report the wars. If they had doubts about their chance of survival as they embarked on the desert with the polyglot army, they thrust them aside in professional eagerness to be first on the scene in the fighting that lay ahead.

Tacitly supported by Britain, the Khedive of Egypt had cobbled together a motley field force of 10,000 made up of Egyptians, Sudanese, Circassians and Bashi Bazouks from the Turkish empire. Many were unwilling, pressed men who had been drafted from the ranks of a rebel army defeated by the Khedive's nursemaid, the British, in the Nile delta only the year before. In joint command with an Egyptian was a retired member of the Indian Staff Corps, Colonel William Hicks, Hicks Pasha, supported by a handful of British and other European officers and 'soldiers of fortune'. Even before the expedition left Khartoum an ominous warning about the calibre of his troops was given in a letter from Hicks. 'Fifty-one men of the Krupp battery deserted on the way here, although in chains,' he wrote.

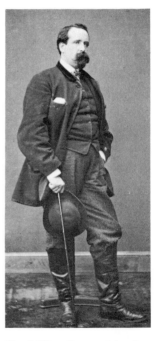

Frank Vizetelly, special artist, was born in Fleet Street and came from a family of newspapermen. He was described as 'a hale, bluff, tall and burly-looking man, with short dark hair, blue eyes and a big ruddy moustache'. Toughness and resource carried him unscathed through a dozen wars, but his luck ran out in the sands of the Sudan. The mystery remains: did he die with Hicks Pasha, or end his days caged in the Mahdi's camp? (*Reproduced from the collection of the Library of Congress*)

From the start, disagreements racked the command shared by Hicks and the governor of the Sudan, a man steeped in the ways of the old Turkish system. The army chose a route that was conspicuously short of water. Guides deserted. Allies who were expected failed to turn up: they had been suborned by the cunning Mahdi who lured the miserable column on and on into the desert and sent his emirs with bands of hard-riding horsemen to cut communications and pick off stragglers. The camels were badly cared for: the saddles were for the most part without straw, so that the bare wood rubbing on their backs made terrible wounds; many died every day and their loads were piled on the camels that survived so that they, in turn, collapsed. Six weeks out and almost within sight of the place that was to be the last battle-ground in Kordofan province, nearly every horse was dead. The one-thousand-strong cavalry contingent stumbled on foot, grumbling and near to mutiny when the men had to drag heavy Krupp cannon and Nordenfeldt machine-guns through drifting sand and over flinty rock.

At Rahad, little more than a series of wooded knolls in the wasteland, Hicks pitched camp, foolishly within range of Dervish riflemen hidden in bush on a nearby rise. Several Egyptians were picked off and a bullet entered Hicks's tent and hit his camp stool. Forty miles away at El Obeid, 'the Prophet sent by God to defeat the Turks' gathered a legion of 400,000 tribesmen, whom he rehearsed daily in warfare. Between the two armies a huge flock of vultures turned the bleached rocks black.

Much of what happened on the march and during Hicks Pasha's week-long pause at Rahad comes from a diary kept by an Austrian-born officer, Major Herlth. It told of the deep forebodings voiced by the officers and the two newspapermen as they discussed the prospects of battle with an enemy who, it now appeared, was in much greater strength than had been anticipated. The only hope seemed to lie in the Mahdi's ignorance of the true state of affairs in the Egyptian army, a hope that was soon to become groundless.

A German adventurer named Gustav Klootz, servant to the correspondent O'Donovan, decided that Hicks Pasha's army was no place for a sane and realistic Berliner to be found in the imminent battle. Doubtless he was influenced by the pessimistic opinions of the veteran reporter and his artist colleague, Vizetelly, whose tent he shared. He simply crept out one night and walked into a Dervish outpost, despite the knowledge that deserters were usually treated by the enemy as infidel spies and impaled on spears.

The Dervishes were amazed by the apparition of this *Ingleesy* with blond hair and blue eyes. They stripped and chained him. Then horsemen dragged him barefoot and with a rope around his neck for a day and a half in the burning sun until he was at last flung in front of the Mahdi. The Mahdi immediately recognised the propaganda value of the situation and decided to fête the deserter around camp as a British officer. But first he listened to Klootz through an interpreter, a European captive. What Klootz had to say at first astonished, then delighted, the Mahdi. The deserter babbled out the whole truth about Hicks Pasha's column, and, although the interpreter concealed some of the information, it became very apparent that in front of the Dervish host lay a disorganised, demoralised rabble and not a well drilled, powerful modern army as had been thought.

Within a few days the Mahdi ordered the raising of the huge multi-coloured battle flags and the army of Allah moved out to meet the unbelievers.

The clash came on Saturday 3 November. To add to the column's misfortune, it had now run out of water, and the Egyptian troops struggled forward in agonies of

thirst, losing heavily to the marksmanship of the Mahdi's black Sudanese riflemen. These were a remarkable corps which terrorised the Sudan with its courage, cruelty and weapons: Remington rifles which their owners brought over with them to the Mahdi as the *Jehad*, or holy war, swept up one Egyptian garrison after another. The blacks were organised into a tight-knit force by Abu Anga, a former slave. Their rifles gradually broke what was left of the fighting core of Hicks's army, so that the Mahdi merely had to bide his time before unleashing his horsemen with their vicious two-edged swords, and the hordes of Dervish spearmen.

A typical example of the work of the home-based artist Richard Caton Woodville, who produced superb death-or-glory illustrations from material supplied by specials in the field and his own research. This two-page wood engraving in the *Illustrated London News* of 25 October 1884 spelled out a fact that was as true then as it was a year earlier when Hicks marched to disaster: as the Mahdi's Dervish empire spread across the Sudan, the Egyptian flag held sway only along the tenuous lifeline of the Nile.

On the Sunday, Hicks was fighting back desperately from behind a *zeriba* (thorn barricade) in a grove of stunted trees. Guns were abandoned. Those that remained could not be laid properly because discipline had broken among the thirst-crazed Egyptians. Major Herlth wrote his final diary entry:

> These are bad times; we are in a forest, and everyone very depressed. The General orders the band to play, hoping the music will enliven us a little; but the bands soon stop, for the bullets are flying from all directions, and camels, mules and men keep dropping down; we are all cramped up together, so the bullets cannot fail to strike. We are faint and weary, and have no idea what to do. The General gives an order to halt and make a zeriba. It is Sunday, and my dear brother's birthday. Would to God that I could sit down and talk to him for an hour! The bullets are falling thicker——

Here the diary ended abruptly. Herlth was never heard of again.

The final episode, on Monday 5 November, was witnessed by the deserter Klootz who had been brought to the battle by one of the Mahdi's war chiefs. The day ended with the complete annihilation of the Egyptian force, the bodies being scattered in three large groups extending over two miles. The largest heap was in the grove of Shekan where the Europeans and a handful of remaining soldiers were overwhelmed by an avalanche of Dervish spearmen. Their long-handled Baggara spears, with blades the size of a palm leaf and capable of taking off a man's head at one sweep, exacted terrible havoc on the living, wounded and dead.

Even Klootz admitted he was near to breaking down when he saw the mutilated bodies of Colonel Hicks and his former colleagues. About one hundred survivors took refuge under waggons and in thorn bushes. These were prodded out and later dragged naked with ropes around their necks into El Obeid as part of a triumphal procession led by the Mahdi on a magnificent white camel.

O'Donovan died in the fighting or immediately afterwards. That much could be gained from the grisly evidence left, even after the mutilations, the vultures, time and the Sudanese heat. Klootz is said to have recognised O'Donovan's English mackintosh and other items of clothing in the Dervish camp after the battle.

What happened to the artist Vizetelly is a mystery. Almost a year to the day of the massacre a report filtered through Khartoum and was published briefly and without corroboration in the *Illustrated London News* of 29 November 1884: 'It is stated that Mr Frank Vizetelly, the artist, who was with Hicks Pasha's army last year when it was destroyed in Kordofan, is still living in the Mahdi's camp.' If the report was true, the fact was not noted by survivors of Dervish captivity. Certainly death in battle would have been preferable to the treatment experienced by some of the Mahdi's prisoners. There were accounts of ears being cut off, of brutal guards with whips, of captives being forced to live in cramped cages. One 'traveller's tale' linked Vizetelly's name with rumours of a European existing in a barred box no bigger than a small commode.

Frank Vizetelly's epitaph was recorded by Archibald Forbes, the renowned war correspondent of the London *Daily News,* when he came to set down his *Memories and Studies of War and Peace* in 1895. He wrote: 'The last hope has faded that Vizetelly, endowed though he was with more lives than the proverbial cat, has still a life in hand.'

Vizetelly and O'Donovan were members of a long roll of special artists and reporters who met death in the pursuit of news during nineteenth-century wars—

men whom a hysterical commander once described to Forbes as 'drones who eat the rations of fighting men and do no work at all'.

Forbes, a highly realistic professional, took a more pragmatic view of these men, and especially the artists. 'However interesting a battle may be,' he once told the young special artist Frederic Villiers, 'you must always get away before your communications are cut, for your material will be held up or never arrive. You must not be taken prisoner, for then you will be out of business completely. You must not get wounded, for then you will become a useless expense to your paper. And if you get killed you will be an infernal fool.'

Frank Vizetelly certainly transgressed the first and last of these commandments (and possibly the other two). Equally certain is that he and most others in his unusual profession would agree that only infernal fools, anyway, would seek out faraway wars just to draw pictures, such were the hardships, even if the ultimate risk was avoided. It is to such infernal fools that this story is devoted.

2 War Makes News

Never shoot over the heads of the people

Frank Leslie, founder of Frank Leslie's Illustrated Newspaper

Nothing sold a picture newspaper like a good war. Editors, rightly convinced of the truth of this maxim, exploited it enthusiastically through nearly sixty years of the last century and kept their popular illustrated journals rolling to ever greater circulation and their proprietors to ever-expanding fortunes on the strength of it.

Wars could be illustrated reasonably inexpensively, of course, by an artist working safely in a studio at home, and often they were. But as the pennies poured in from a public increasingly eager to read of glories and carnage at its breakfast table, as more money was consequently made available for editorial expenses, as rivalry sharpened between competing newspapers, it became almost as important to announce that 'our representative is at the seat of war' as it was to have his pictures back in the office for publication. Thus the special artist was born.

During a span of time that coincided almost exactly with the effective emergence and rapid technical developments of the camera, he reigned supreme over the photographer in pictorial reportage. The camera's limitations and the fact that no newspaper installed the necessary equipment to reproduce photographs speedily until near the end of the century fended off the competition of the photographer. Even then, the special artist's was no rearguard action. He complemented the work of the cameraman at war until well into the present century.

Until the rise of the illustrated newspaper in the 1840s, artists in the field were usually serving soldiers and almost invariably officers. Sketching of topographical subjects formed part of an officer's training in map-making. There was, however, a small tradition of 'amateurs' who went to war specifically make illustrations of the scenes they found. Thomas Heaphy, a watercolourist, travelled with the British armies in the Peninsular war at the end of the eighteenth century, but his role was mostly confined to making portraits of officers. Throughout the Napoleonic wars it was not unusual for artists to follow the soldiers to make military designs; one such was John Clark, a landscape painter known as 'Waterloo Clark' from the scene of the battle he drew immediately after it ended.

In coy deference to its antecedence, the *Illustrated London News*, pioneer of popular picture journalism, informed its readers in 1884:

> Just as of the two Royal Services the Navy is acknowledged to be by a long way the senior; so is the illustrated newspaper, practically considered, very much older than the oldest of merely type-printed gazettes. The Bayeux Tapestry was a history in illustration; but when Hernan Cortes landed in Mexico, he found there, regularly established, an 'Aztec Illustrated News', the 'special artists' of which daily transmitted (by deer-footed Indian runners) from Vera Cruz to the capital of Montezuma faithful pictorial records of the proceedings of the hated Spaniards.

The pictures of the 'Aztec Illustrated News' were traced with the spikes of a cactus leaf dipped in variously coloured dyes on large strips of linen or cotton cloth.

If this was true, the Aztec artists were professionals whose job was to report the news to Montezuma. Whatever soldiers in the field drew—and their efforts continued to complement the work of the staff artists in the picture papers throughout the nineteenth century—their main role was to fight; for them art could only be a hobby or a means of modestly augmenting their salaries and allowances.

The professional—the special artist, or special as he became known—was not easy to recruit in the early years of pictorial journalism. Few artists of the right skills and temperament could be persuaded to change their existence for arduous assignments in the field. Few wanted to risk their careers, their health and possibly their lives in what they considered to be ill-founded and short-lived experiments in mass communication. None relished the prospect of seeing his work tampered with and often altered beyond recognition, finally to be published bearing the signature of an artist or engraver who worked at home while he, the originator, shared the soldier's hazards. And very few indeed had news sense, a quality that was needed as much even as skill in drawing.

The special had to be a journalist. He had to know *what* to draw, and how to get it back to his newspaper. As the system of pictorial war coverage developed, he was increasingly called upon to write about the events he illustrated. Editors demanded detailed descriptive pieces which were printed alongside or close to the pictures in the paper. Sometimes these ran to several columns in length and provided the main eye-witness accounts in any particular edition. An illustrated newspaper frequently relied on its artists to provide the principal written coverage of a war and spent large sums of money advertising 'I was there' series by the specials when wars were temporarily difficult to find and circulation flagged.

They came, the specials, in many varieties. William Simpson was a hefty sen-

7

'How we have to work'—
Melton Prior's caption of his
self-portrait, sketching in the
Sudan in 1884. Prior invar-
iably drew himself in the field
wearing a hat as he was
almost completely bald, a
feature which, coupled with
his high-pitched voice, earned
him the nickname among
colleagues of 'the screeching
billiard ball'. Once, in South
Africa, he was angrily ordered
to cover his bald head
which was drawing the
enemy's fire. ('*Illustrated
London News*')

timental Scot with a meticulous eye for detail and accuracy; he roamed the world
with a flask of rum in his pocket and a picture of his daughter by his heart; he hated
killing so much that he deliberately aimed short when a soldier asked him to try a
pot shot at the Russians before Sebastopol. The Frenchman Constantin Guys loved
absinthe, horses and women; he was hypermodest, shunned publicity, left the
engravers to do what they wished with his work, and died in poverty. Melton Prior
never missed an opportunity to draw himself in his pictures; his career as a special
was the ruin of his marriage; after scrambling on foot through swamps and forest in
Ashanti with only a knapsack, he vowed never again would he be unprepared, and
covered the Zulu war with a waggon, five horses, bed, tent and cases of whisky.
Alfred Waud sketched every major action of the Army of the Potomac for an
American newspaper, with his British passport in a side pocket in case of emer-
gency. His Civil War colleague Theodore Davis was twice wounded, pulled a gun to
prevent surgeons cutting off his leg, shot Indians and fought battles with his editors
over the way his work was treated. Frederic Remington rode the West on borrowed
horses and only gave up when his weight topped twenty-one stone. Frederic Villiers
took a bicycle to war in the deserts of the Sudan.

Different in character as they were, these men and others of their ilk shared a
common taste for adventure and action. They were able to indulge it through the
success of the illustrated newspaper, a phenomenon that owed its birth to Herbert
Ingram and a laxative pill.

Ingram was born in Boston, Lincolnshire, in 1811. After apprenticeship with a
local firm, he worked in London as a journeyman printer and later moved to the
Midlands. There he settled in Nottingham as printer, bookseller and newsagent in
partnership with his brother-in-law, Nathaniel Cooke. Their fortunes began to shine
when they bought from a Manchester druggist the recipe for a successful aperient
pill, whose secret, Ingram claimed in widespread advertising, had come from the
descendants of one Old Parr. Parr's longevity—he is reputed to have lived to be a
hundred and fifty-two—was attributed to the effects of taking the vegetable pill.
The science of herbal remedies was much in vogue, and the pill's proprietors moved
to London in 1842 to exploit its success where spending power was higher and
where there were more people to pay their money for patent medicines. Ingram,
however, had other designs on the popular market and he intended to use the profits
from Old Parr's pills to make his dreams come true. A stocky, well-built man who
looked remarkably like Napoleon, he believed he could start a successful national
newspaper.

Behind his newsagent's counter in Nottingham he had often noticed that the
demand for the *Weekly Chronicle* rose on the rare days when it carried woodcut
illustrations. He noticed, too, that people asked for 'London news', the news which
told them of events in the capital, and, through the capital, of the world outside.
These two observations led him to decide that his newspaper would be called the
Illustrated London News.

Until that time, journalism was rarely illustrated and there were few examples of
experiments with copperplate engravings and woodcuts to relieve the endless
columns of turgid prose in news-sheets and papers. In the early part of the nine-
teenth century the excursions into picture journalism were so few that most are on
record. *The Times* printed an engraving of Nelson's coffin and funeral car in 1806.
The *Observer* illustrated the siege in the Cato Street conspiracy in 1820 and used
pictures in 1827 to report the murder in the Red Barn, a popular sensation following

the killing of a girl by a farmer's son (there was in early attempts at popular journalism an obsession with murders). In 1842, when Ingram came to London, his preparations for a new type of newspaper were well under way. The timing was just right.

Only England enjoyed the circumstances to make such a venture prosper. German, French and American publishing aspirants were eager to strike out into illustrated journalism, but success demanded the combined ingredients of capital, large populations with money to spend and the necessary communications to bring the copies of the paper to the masses. England of the Industrial Revolution had the populations and the railways and there was a new lower middle class of shopkeepers, clerks and merchants with literacy, spending power and desire for knowledge. And Ingram had the capital, thanks to Old Parr's pill.

In the early part of 1842 Ingram was ready to embark on his venture. Despite the trade secrecy he tried to maintain, news of his plans leaked out. Charles Knight, proprietor of the *Penny Magazine*, one of the many rival journals that were to suffer critically from the runaway success of the new paper, one day found a strange artist sketching during an Old Bailey murder trial. It was whispered that the newcomer was drawing for the first issue of the *Illustrated London News*, due to come out the following week. Knight later observed:

> I know something about hurrying on wood engravers for the *Penny Magazine*, but a newspaper was an essentially different affair. How, I thought, could artists and journalists so work concurrently that the news and the appropriate illustrations should both be fresh? . . . I fancied that this rash experiment would be a failure. It proved to be such a success as could only be ensured by resolute and persevering struggle.

Ingram's new newspaper came out on Saturday 14 May 1842. It cost sixpence and contained sixteen pages and thirty-two woodcut illustrations, including portrait heads set in the columns. The front page had a 'View of the Conflagration of the City of Hamburgh'—a fire which destroyed a large part of the city—but its display was modest, occupying less than a quarter of the page. Inside were eight specially commissioned drawings of Queen Victoria's fancy-dress ball at Buckingham Palace. There were book reviews, fashions, and features on a French train crash and war in Afghanistan, with the pictorial emphasis on topography. It was a sell-out—26,000 copies which rose to 66,000 a week by the end of the year.

Ingram's early guide and mentor was Henry Vizetelly (1820–94), elder brother of Frank who died in the Sudan with Hicks Pasha (they were from a family of Italian extraction, and Frank, appropriately for a newspaperman, was actually born in Fleet Street). Henry Vizetelly later left Ingram to start his own newspaper, the *Pictorial Times*, in 1843, but it was he who persuaded Ingram that the role of an illustrated weekly meant much more than slavishly following the editorial techniques of the *Observer* and *Weekly Chronicle*, with their obsessive interest in sensational crime. There was a new middle-class market to be tapped. It was passionately interested in what was going on in Britain and in the affairs of the world. The crime sheets could be left to the poorer classes. It commissioned successful artists to portray events of state and industrial progress, and eventually paid men of the right calibre to become specials in the field.

The *Illustrated London News* had many imitators in Britain. Among short-lived competition were the *Illustrated Midland News* in Manchester, the *Illustrated London and Provincial News*, and the *Pictorial World*. The *Graphic*, its most serious

competitor, came on the scene in 1869 on the eve of the Franco-Prussian war. In 1842 when Ingram launched his enterprise there were eighty newspapers in London alone and over three hundred others in the provinces. The mortality rate was high. On 21 July 1855 the *Illustrated London News* printed a newspaper 'obituary': 'A few days ago we announced the demise of two penny daily newspapers in Manchester, which died in early infancy from want of adequate nourishment. Since that time two other penny journals have given up the ghost—namely, the *Leeds and Yorkshire Daily Express* and the *Newcastle Courier*. The former was the offspring of the *Leeds Times*, and it expired on Tuesday, aged fourteen days, of actual starvation.'

After the introduction of the electric telegraph in 1844, readers had news on their breakfast tables fresher than ever before. Artists, called in to illustrate this news, relied heavily on imagination and were capable of committing blunders. One such howler appeared in the *Pictorial Times* when an artist was asked to illustrate a news story about the Queen and Prince Albert's visit 'to see the shearing' in Scotland. He drew shepherds shearing sheep in a pastoral scene, unaware that 'shearing' in Scotland meant cutting the corn. To any Scot, the artist patently had not been 'on the spot'. Gradually the realisation was taking shape that honest, accurate reportage from men on the scene was needed of artists as much as it was required in the news columns of the paper from writers.

In 1848 for the first time the *Illustrated London News* put this policy into practice in war—civil war. Revolution had broken out in France and Ingram commissioned the talented French artist Constantin Guys to draw pictures of the fighting. He could thus claim to be the world's first special war artist in the true sense, Circulation doubled in three months. Here was proof indeed that war was beneficial to newspaper profits. The public clamoured for copies of the editions with Guy's pictures. Once, the publishing manager was pelted with flour and rotten eggs because the London 'trade' could not get supplies quickly enough to satisfy demand.

There seemed to be no limits to the rising sales curve of the *Illustrated London News*. The Great Exhibition of 1851 pushed it higher, and the Crimean War of 1853 higher still. When the penny newspaper stamp duty was lifted in 1855 the circulation was 200,000. In its Christmas issue of that year the paper published its first picture in colour. Ingram was now what he had set out to be, a powerful figure in publishing, the owner of the most successful newspaper in Britain and probably the world. In 1860 he was dead. On a journey to America to organise pictures for the Prince of Wales's transatlantic tour, he was drowned with his eldest son in a paddle-steamer disaster on Lake Michigan. His body was recovered and he was buried in Boston cemetery, Lincolnshire, almost within sight of his birthplace.

He left behind not only a thriving newspaper organisation; he had also set a pattern of illustrated journalism that was being copied with success in the capitals of Europe and elsewhere. In the United States its architects were Fletcher Harper and Frank Leslie, an Englishman whose guiding maxim in popular publishing was, 'Never shoot over the heads of the people.' Within the framework of this new industry, the special artist played a key role. Singularly, however, through half a century that saw some of the most momentous scientific and technical advances the world had ever known, the techniques employed to bring pictures of war to the newspaper public hardly changed.

In the field, the special could choose to work in several ways. Much depended on his personal preferences, the amount of sketching material and time available, the method by which he was going to send his work back to the office and the conditions

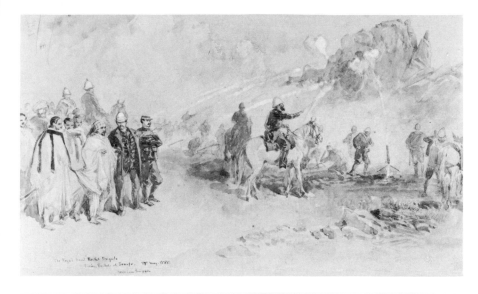

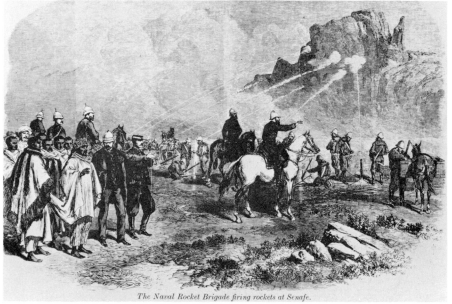

The Naval Rocket Brigade firing rockets at Senafe.

William Simpson, trained as a lithographer before he took to the field, had an unerring instinct for producing pictures whose quality and style would survive the processes leading to publication. In indian ink, blue wash and chinese white, he drew the naval rocket brigade in Abyssinia in 1868 on the back of an old proof (*above*). When it appeared a few weeks later as an engraving in the *Illustrated London News*, a figure had been changed here and there, but basically the drawing was Simpson's. Undoubtedly because of his reputation the engravers treated his work with deference. (*Original sketch: Mrs H. H. C. Ingram; engraving: 'Illustrated London News'*)

under which he was operating.

For speed he could make a rough sketch, which was no more than a shorthand note, but encompassing enough in pencil line and caption detail to give the office artist the necessary information to work up the illustration for publication. Many of these original sketches have an immediacy and zest that was often lost in the published picture. What other branch of fine art contains such laconic detail as Civil War artist's Henri Lovie's instructions to the engraver in a drawing done at the battle of Stone's River? An arrow points to the hastily sketched figure of a falling Union officer, with the caption, 'Head shot off'. Similarly, some of Melton Prior's work during the siege of Ladysmith in the Boer War is a valuable military record thanks to his finely annotated detail on his outline sketches; a wide view of the battlefield of Lombard's Kop in October 1899 is documented with neatly pencilled

captions such as 'Shells from enemy Hotchkiss bursting among our infantry', 'Imperial Light Horse on kopje' (a small hill), and '40 pounder shell bursting and upsetting ambulance cart'. Once a photo-mechanical process had been introduced during the early eighties the *Illustrated London News* and other picture papers had the good sense frequently to reproduce these facsimiles, even if an elaborated version appeared in a subsequent edition. Thus, from about 1882 the caption increasingly appeared: 'Facsimile of a sketch by our Special Artist.'

Given the time, some artists preferred to produce a studied drawing in indian ink, coloured with wash and highlighted with chinese white. This was William Simpson's favourite medium of expression. Some of his efforts, even if they were 'translated' by the engravers, remain as valuable works of watercolour art. An illustration he made of a rocket battery being demonstrated for the benefit of native potentates in the Abyssinian campaign of 1867–8 is delicately outlined, tinted and heightened; it is worked on the back of a sheet of woodcut proofs of portraits, obviously the best material he had available at the time.

In the Franco-Prussian war of 1870 Simpson found himself a vantage-point in the room of a château from which he could see and draw the battlefield of the Sedan. 'I had only a sketchbook with me, and seeing in the room some rolls of wallpaper, I cut off a piece, and sketched on the back of it,' he said. He worked in colour. The drawing was folded and sent back to his newspaper 'through the post'—a remarkably efficient service for war artists thanks to Prussian military helpfulness. It was published in a double-page spread and the sketch eventually became the property of the Earl of Rosebery; it exists to this day with the pattern of the wallpaper showing through from the back. Simpson's regard for strict accuracy was such that when his drawing was later seen by the German military attaché in London, who had been at the battle, he remarked that it was true in every detail.

Before examining other sketching methods of the specials, some idea of the technical processes of engraving must be grasped. Once the special's sketch had reached his newspaper, the main outlines were redrawn, or traced, *in reverse* onto wood that was divided into separate blocks, each measuring about $3\frac{1}{2}$ inches by 2 inches; these were of boxwood, the best of which came from the Caucasus, chosen for its close grain and hardness. The small size was preferred for convenience and speed. A double-page spread might need as many as forty of these blocks, and several artists worked simultaneously, one specialising in architectural detail, another in topographical, another in figures and so on.*

Some of the wood artists never saw the complete drawing until the work was completed. Team work was of the utmost importance, especially at the edges where the blocks were joined. When the drawing on wood was finished, the blocks were bolted together with much care taken to ensure that there was the closest fit where the pieces of wood met; in some newspaper reproductions the line of the join can be clearly seen. Then the work was sent to the engravers who cut away all except the lines. A wax impression of the wood engraving was made. Finally, from the wax mould a metal printing block carrying the reversed image of the original was electrotyped ready for the printing press.

* Kate Greenaway, the illustrator of Victorian children's books, has recalled that her father, an engraver for the *Illustrated London News*, worked long night hours to catch the edition when pictures of the Indian Mutiny poured into the office in 1857–8. Proof copies he brought home deeply moved her: 'I would sit and think of the sepoys until I would be wild with terror, and I used to dream of them. But I was always drawing the ladies, nurses and children escaping. Mine always escaped and were never taken.'

With this process in mind, some artists preferred to work on flimsy paper which could be reversed and from which the home-based artists traced the salient lines directly onto the wood. This could account for the relatively few original sketches still in existence today compared with the huge volume of material despatched from the field by the specials.

Yet another method was used by only a few specials, but it was the most effective of all in ensuring fidelity to the original artist's line and style. This was the technique of drawing directly onto wood, one that demanded the highest of skills. The drawing would have to be done in reverse, the simplest method being for the artist to trace it from a master copy on flimsy paper. Arthur Boyd Houghton, book illustrator and special artist, chose this method wherever possible during a tour of America for the *Graphic* of London and later in his coverage of the Paris Commune disorders of 1871.

Owing to the problem of transporting a supply of boxwood blocks in war conditions—and the even more acute problem of getting them home again—it was not always possible for him to work directly onto wood, but when it was, his characteristic, vivid style shines through the published work. He would first make a rough sketch, develop it with finer detail, then transfer it in reverse onto the wood which had been coated with white to provide a more suitable drawing surface. The advantage of this method was that it cut out completely the intermediate artist. The block could go straight to the engraver.

For there was no doubt at all that the work of the intermediate artist all too often obliterated the individual style imparted to the drawing by the man in the field. Uniformity reigned. Before the custom of identifying the special artist by name became universally established, it was almost impossible to tell one special's work from another, apart from the fact that one might be known for choosing large, panoramic subjects and another for close-up scenes or human studies. In the *Illustrated London News* of 28 July 1855 there was a double-page spread containing two large engraved drawings of Lord Raglan's funeral procession in the Crimea, one by Constantin Guys and one by Edward Alfred Goodall, artists of widely different style. So ruthless has been the process artist's work that one sketch is indistinguishable in style from the other as published. It needed skills of a high order and the willing participation of the intermediate artists to reproduce faithfully a particular special's style. William Simpson, of the *Illustrated London News*, was one of those fortunates whose drawing techniques lent themselves to faithful reproduction.

In a review of an exhibition of original sketches and engravings of the Franco-Prussian war in 1870, *The Times* made some interesting comments on the relationship of the special artist and engraver. The writer conceded that of all artists 'the palm belongs to Mr Simpson', and went on:

He is, as they say, good all round. . . . Mr Simpson's outlines are distinct and firm in his roughest drawings; his hand is always sure . . . he gives the engravers what they want. His method is to sketch the outlines with a common pen and to wash the rest in with Indian ink . . . none are nearly so skilled as he. The 'Charge of the Prussian Cavalry' is an excellent specimen of what may be done with inks; the high lights are touched in with body-colours, which wonderfully sets off a drawing and turns rough work into fine.

Sydney Hall, of the *Graphic*, gave a great deal of work to the engraver in the view of the critic, who continued on the theme of artist–engraver partnership:

FUNERAL OF THE LATE LORD RAGLAN—THE PROCESSION LEAVING THE TRAKTIR INN, BEFORE SEBASTOPOL—FROM A SKETCH BY C. GUYS.

FUNERAL OF THE LATE LORD RAGLAN—ARRIVAL OF THE REMAINS AT KAZATCH BAY—FROM A SKETCH BY E. A. GOODALL—(SEE NEXT PAGE)

When Lord Raglan, British commander in the Crimea, died of cholera in 1855, the world's first illustrated newspaper had two special artists on the spot to record the funeral procession. Edward Goodall, British, was a landscape artist who saw war in terms of sweeping terrain, entrenchments and fortifications. Constantin Guys, French, was a globe-trotting dandy, lover of women and horses, an artist who found his images of war in people. Their styles were totally different. Yet when the engravers had finished their work—Goodall's is the lower sketch—the illustrations had a uniformity of style that could have come from one original pen. ('*Illustrated London News*')

The visitor who has seen the engravings of which these sketches are the originals will be impressed quite as much with the skill of the engraver as with that of the artist. He will notice several instances in which the latter has made alterations in the pictures. But in all cases . . . the engraver does more than second the efforts of the artist; and a survey of these sketches convinces us that a newspaper with good engravers and inferior artists will turn out better and more faithful pictures than one whose artists are excellent, but whose engravers can only copy what is before them. The engraver who works from the field drawings must complete them as he goes; it must be his constant endeavour to repair the haste of the artist. Mr Simpson's method unquestionably leaves the engraver least to do; for with his pen he gives firmness of outline, and with his Indian ink light and shade.

(The writer was obviously one of the school which believed in 'worked up' illustrations of *Boys' Own Paper* style.)

In a system that placed the special at the mercy of those at home, it was inevitable that disagreements would arise, that resentment and dissatisfaction would sometimes be bred. Some of the campaigners were able to adopt a philosophical approach to the difficulties; others waged running feuds with those at headquarters who they believed rightly or wrongly were not treating their work with the respect it deserved.

Two celebrated Civil War specials of *Harper's Weekly* who suffered spasmodically from editorial interference and frequently from poor engraving were the Briton

Alfred Waud and his American colleague Theodore Davis. During a particularly unpleasant bout of campaigning with McLellan's army in 1862, Waud wrote to a friend: 'I heard Nast was with you. Between you and I, I detest him. Give my remembrance to all friends. I have been told Sol is down up on me. I never meant to give him offence and do not understand how I have—however, can't stop for that as we say in the army.'

Sol Eyetinge was an artist–engraver with whom Waud had obviously crossed swords. Thomas Nast was an artist, subsequently famous for his political cartoons, employed in an executive capacity by the magazine's founder, Fletcher Harper. He prepared other people's field sketches for the paper. He joined *Harper's Weekly* in 1862 shortly after Waud, whose dislike for him stemmed from Nast's insistence on altering the war special's sketches and constantly signing his own name on the published engravings.

Waud's detestation of Nast was fully shared by Davis, a veteran of countless battles on Harper's behalf and with wounds to show for it. In 1868 Davis wrote:

It was Thomas Nast's province during the late war to make for himself the reputation of a war artist, without the unpleasant necessity of exposing himself either to the hardships of campaign life or the dangers of the battle-field. Some of his illustrations, published in *Harper's Weekly*, were good and to a certain extent truthful, for Mr Nast is a careful observer and noted closely the sketches and photographs of campaigns and battle incidents, to which he had access; but in some of his pictures, the oldest veteran would fail to discover anything the original of which he had ever seen except in one of Mr Nast's own pictures.

It was the sort of criticism that Nast became accustomed to receiving. A Kansas newspaper in 1872 alleged that a Nast cartoon in *Harper's* was pirated from one sent in by a Kansas artist, Henry Worrall, who occasionally contributed sketches of frontier life to both *Harper's* and *Leslie's*, both of which were based in New York.

It would be unfair to attribute all the *Harper's* irregularities to Nast (after all, its founder, Harper, 'really conducted it as long as he lived', in the words of one of his editors and on him ultimate responsibility rested) but it was in Nast's tenure of office that some doubtful practices were allowed to flourish. These included the representation of pictures as having been drawn 'on the spot' when in fact they had been produced inside the weekly's office in New York.

Undeniably, however, the home-based illustrator had a valid function in interpreting the special's 'shorthand' sketches for the public. He was usually a man of considerable talents of draughtsmanship. He often had more time, and certainly better facilities, in which to produce an illustration than the artist in the field. And, in turn, special artists—such as Sydney Hall—assumed the role themselves at some stage in their career: during spells at home or in years of semi-retirement.

Outstanding among these illustrators was Britain's Richard Caton Woodville (1856–1926) who depicted a score or more wars in 'death or glory' style for the *Illustrated London News* and other publications. In addition to his magazine illustrations, which were often based on the original sketch of a special, he is known for his action-filled watercolours and paintings of military achievements with titles such as 'All That was Left of Them' and 'Conquered but not Subdued'. It was said that his work represented 'an artist's victory over many a British defeat'. He complemented the function of the special and his newspaper did not pretend that his finished work came from the field.

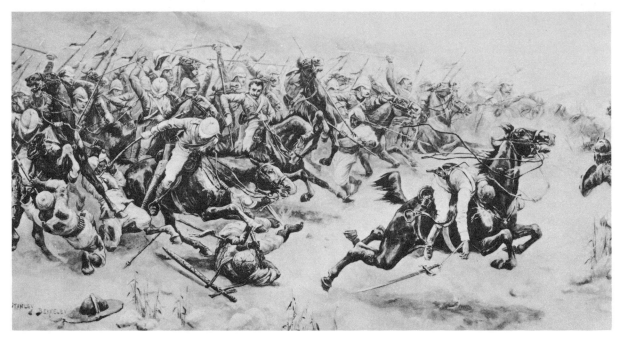

'An artist's victory over many a British defeat' was how a critic described the work of Richard Caton Woodville. An ex-officer with immense knowledge of military detail, he had a prodigious output of war illustrations, produced in his studio from imagination, background information and help from specials. Omdourman towards the end of the Sudan campaign was far from being a British defeat, however, and in the charge of the 21st Lancers—in which the young Winston Churchill took part—Woodville found a ready subject for his artistry. This photogravure of his illustration was published by Thomas McClean on 2 September 1899. (*National Army Museum*)

It is perhaps unfortunate that *Harper's* has been singled out for alleged lapses in journalistic integrity; certainly it had no monopoly in this direction. Nevertheless, it was again *Harper's* that was the subject of a damaging revelation by Howard Pyle, an illustrator who went to New York in 1885 to see Charles Parsons, art editor of Harper's publications. In a letter to an associate, Pyle told how he was shown engravings of a Broadway procession that had not yet taken place. 'It struck me that this was a trifle previous—I asked Mr Parsons what they would do if it rained,' wrote Pyle. Parsons blandly replied that the sky in the engraving was not dead white so that it could quickly be made to show either a clear sky or driving rain.

Speed was the essence of highly competitive pictorial journalism and those responsible for its shortcomings would cite this as one of the factors which caused them to err. Surely there was nothing reprehensible in preparing drawings of scheduled events in advance, leaving details to be filled in at the last minute? Specials in the Franco-Prussian war often used the technique before set piece battles, and it was common practice in America and Europe on ceremonial occasions.

In the early days of the *Illustrated London News* it was customary to 'lock up' the paper on the Thursday of the week before publication, leaving a 'dead' gap of eight full days before the Saturday publication date. Improvements in printing techniques and the spur of competition from the *Graphic*, which came on the scene in 1869, pushed the press time nearer and nearer to publication day. Thus on Saturday 8 March 1890, it was possible to publish in the *Illustrated London News* pictures of the opening of Scotland's splendid new Forth Bridge by the Prince of Wales, an event which had happened on the Tuesday only four days earlier. How it was achieved was explained by William Simpson in his memoirs.

He travelled to Edinburgh with an engraver, Forrestier, who carried a block. They reconnoitred the site, studied the details of the ceremony in advance and interviewed the officials responsible for the opening. Simpson then drew the basic

scene and the engraver completed the block as far as possible. On the opening day, Simpson went to the ceremony and returned in a cab to the hotel where he added and corrected a few details. The two then caught the night train to London—which took ten hours—arriving on Wednesday morning in time to put the block to press for its publication on the Saturday. Pictures of events such as this were frequently published as a special slip-in supplement which could be printed after the main section of the issue.

It is appropriate that this chapter on the rise of illustrated journalism ends with William Simpson, an artist who had few equals among the ranks of the early specials. Born in humble circumstances in Glasgow, he trained as a lithographer and went to London at the age of twenty-seven on 1 February 1851, the year of the Great Exhibition. Three days later he sat in the Cock Tavern in Fleet Street over a lamb chop and a glass of ale and wrote a letter to his mother telling her that he had got a job with a firm of lithographers at a wage of £2 a week, exactly what he had been earning in Glasgow. Within a few months his pay from Day and Sons in Gate Street, Lincoln's Inn Fields, was doubled and then raised to £8.

Lithography, printing from stone, had by this time ousted copperplate engraving, as it was soon to be superseded by wood engraving. As part of a publishing industry with its own market other than that served by the *Illustrated London News* and its fellows, the lithographers of London had bulging order books for plates to illustrate the whole gamut of Victorian achievement in the wake of the Industrial Revolution—great events, exhibitions, new buildings, railways, the launching of steamships. And now, in 1854, there was war.

The Crimean conflict, fought with French and Turkish allies against the Russians, came as food and drink to a war-starved British public, which had had to be content with a few minor colonial confrontations since Napoleon had been shipped away to St Helena.

The Victorians, served by the growing popular press, put the battle of Alma under their belts and looked forward greedily to the fall of Sebastopol. The artist Simpson was told to start preparing a picture of the city's fall from maps and whatever drawings of the town he could find. But there was precious little research material available, and Sebastopol did not fall, anyway, for another year.

He pressed his employer, William Day, to be allowed to go to the battle front. Flourishing a newspaper, he argued: 'Here they are, making "gabions", "fascines", "traverses", etc. What are they? No one knows. If I were there I could send sketches of them, so that everyone could understand.' It was the journalist speaking. And Day knew he was right. He decided to talk to the enterprising publishing firm of Colnaghi.

Some days later Simpson had a tooth out on the way to work—undoubtedly a painful ordeal in those days—and, feeling shattered by the experience, he spread out a newspaper on the floor of his office and lay down on it to recover. He was stretched out there when Andrew Mackay of Colnaghi's walked in. Mackay later confessed that his first impression was that it was all a ghastly mistake and here was the large Scot laid low by drink. But the deal was signed, with Colnaghi providing clothes, baggage, colours and paper and the artist paying his own travelling expenses. Simpson, the war artist, had arrived. He was in such a hurry to go to war that he left behind his shaving equipment and so emerged from the Crimea with a beard he could tuck in his waistcoat. He emerged, too, with a taste for action that never left him.

3 Crimean Simpson

It is all wrong

Lord Cardigan, Light Brigade commander at Balaclava

On a winter's evening in 1854 William Simpson, reared in a Glasgow tenement, the son of a marine engineer, faced James Thomas Brudenell, seventh Earl of Cardigan, across the carpeted saloon of the steam yacht *Dryad*. The setting was the sleet-whipped harbour of Balaclava, where in the lamp-lit opulence of the *Dryad*, a deeply depressed Lord Cardigan consoled himself on champagne and the offerings of his French chef while the savaged remnants of his Light Brigade huddled under canvas and fed off boiled salt pork at Kadikoi three miles away. The usually tight-corseted figure of Cardigan was swathed in a bath robe covering the dressing on his hip where he still smarted from the gash of a Russian lance. Much more painful, however, was the recent memory of the destruction of his command, the finest and fairest of Europe's light cavalry, the magnificently mounted lancers, hussars and light dragoons, hurled onto the muzzles of massed artillery in twenty minutes of the most glorious, foolhardy and pointless action in the story of British arms. Sick at heart and sick in body from dysentery and bladder trouble, his normally florid face pale under the bristling cavalry moustache and sideburns, Cardigan was in choleric mood as he motioned to Simpson to proceed with his business.

The artist spread before the Earl a drawing. Cardigan looked at it, in Simpson's words, 'with a vacant stare'. He stabbed a figure. 'What is that?' Deferentially Simpson started to explain. 'It is all wrong,' snapped Cardigan. The interview was obviously at an end. The next day Simpson was back aboard the *Dryad*, having made several alterations to the sketch. Again he was received haughtily, with a series of grunted criticisms and sent packing. He resolved to make one last attempt to complete, with the principal participant's approval, his impression of the Charge of the Light Brigade at Balaclava, undeniably the most famous action he was ever to put on paper in a lifetime of drawing battles. This time, approved or not, the finished work would be sent off from the Crimea to his publishers in London. Lord Cardigan's response took a moment to formulate. Simpson waited in silence. Slowly, Cardigan's face brightened, then he beamed with approval, showered the drawing with praise and informed the artist that he might despatch the sketch to London with his highest admiration. The truth was, as Simpson later remarked, 'that in the last sketch I had taken greater care than in the first two to make his lordship conspicuous in front of the brigade.'

Two months later Cardigan was back in Britain, his confidence restored by the national acclaim he was receiving as a hero for his part in the battle of Balaclava. Inevitably he was summoned to dine with Queen Victoria at Windsor Castle, where a major topic was the Charge of the Light Brigade. Arrogant, autocratic, impetuous,

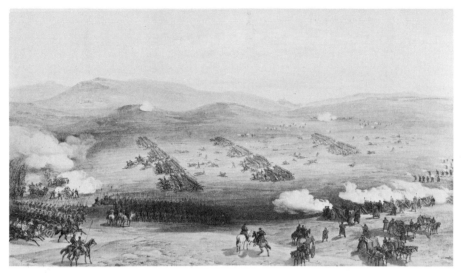

William Simpson's panoramic illustration of the Charge of the Light Brigade shows the leading rank about to reach the Russian guns. On Causeway Heights, the low range in the middle distance, are the captured redoubts which were meant to be its objective, obscured from the cavalry's view when Nolan delivered the controversial order. The illustration formed one of a set of eighty lithographs, *The Seat of the War in the East*, published by Colnaghi in 1855. (*Phillips Fine Art Auctioneers*)

nevertheless Cardigan could play his cards diplomatically when it suited him. On this occasion he played them superbly well. Victoria noted in her journal that Lord Cardigan spoke 'very modestly as to his own wonderful heroism', adding, however, that he did so 'with evident and very natural satisfaction'. Cardigan could afford to assume the role of modest hero. He had before him the evidence of Simpson's finished watercolour, which he had procured and brought along specially for the royal occasion and with which he made much play when describing the action. Queen Victoria was hardly likely to know the news-managed background of the drawing.

Simpson's concern with establishing authoritative approval of his Light Brigade sketch stemmed partly from the fact that he had arrived in the Crimea as a specially commissioned artist three weeks after the action had happened. In fact, the battle of Balaclava and the charge had taken place some thirty hours before Simpson caught the evening train to Paris at London Bridge station on 26 October 1854, on the first leg of his journey to the Crimea, a journey that was to lead to a long and eventful career as a war artist. Inkerman, another battle he had to draw, took place before he reached Constantinople. Both actions, then, had to be reconstructed after visiting the scenes and talking to those who fought there. An officer named Calthorpe, aide to the British commander Lord Raglan, took the artist over the Balaclava battlefield and explained the ground. Topographically the subject presented no problems to an artist of Simpson's skills. But the events of those mad, murderous twenty minutes of the charge were a different matter.

The reason why the Light Brigade was sent headlong into disaster against a solidly entrenched enemy supported by artillery and massed infantry has been the subject of recurring enquiry by military historians and writers for a hundred and twenty-odd years. It was a lethal compound of blunders, military mismanagement, poor communications and misunderstandings. Further, here was a cavalry arm, impatiently inactive in the major clashes of the Crimean autumn and fretting for the action it had not seen since Waterloo in 1815. As if all that were not enough, the relationship between two of the key commanders, Cardigan in charge of the Light Brigade, and his brother-in-law Lord Lucan with overall responsibility for the cavalry division, was soured by a bitter, longstanding and unrelenting quarrel which

Clearly seen in close-up is Lord Cardigan, drawn in the final version in a prominently leading position in front of the 17th Lancers and the 13th Light Dragoons. After two attempts by Simpson, Cardigan beamed with approval on this sketch: there was no doubt at all who was leading the Light Brigade. (*Phillips Fine Art Auctioneers*)

allowed for no cool or sane communication between the two on any matter, military or otherwise.

Against this background of confusion, the Light Brigade's disaster was foreshadowed in a pencilled message carried at full gallop by a Hussar officer, Captain Lewis Edward Nolan, just before eleven o'clock on the morning of 25 October. From a hilltop vantage-point, the British Commander-in-Chief, Lord Raglan, had perceived the Russians about to carry off captured British guns from four earth redoubts abandoned by Turkish allies of the British and French. To a soldier steeped in the old traditions, the loss of guns to the enemy was the ultimate disgrace. 'Lord Raglan,' said the message, written by a senior aide, 'wishes the cavalry to advance rapidly to the front and try to prevent the enemy carrying away the guns . . .'

The cavalry in question was the Light Brigade of 673 men, drawn up in ranks of scarlet, blue and gold on the brown floor of the valley below. It was a sight to inspire any artist, and yet a tragic anachronism: the British army, accoutred and mounted in the parade-ground splendours of another age, about to do battle under leaders who had not yet realised that now and henceforth warfare was to be decided by the technology of firepower. High above the front rank fluttered the red and white pennants atop the nine-foot bamboo lances of the 17th Lancers; razor-sharp and highly polished, the twelve-inch lance blades of diamond section reflected beams of morning sunlight across the valley which was uncannily silent except for the jingle of harness and the impatient stamp of horses.

Alongside, the 13th Light Dragoons were an unbroken line of blue, relieved by white cross belts and the glitter of heavy steel scabbards. Cardigan's own, the 11th Hussars, slim-waisted under gold and crimson sashes and wearing the skin-tight crimson overalls that gave them their nickname, The Cherrybums, formed the second rank. Behind came the black beaver shakos and blue coatees of the 4th Light Dragoons, and with them the 8th Hussars, the fronts of their blue cloth jackets ablaze with yellow cord and pelisses of scarlet-lined lamb's-wool thrown back over their shoulders.

Captain Nolan delivered the message to Lord Lucan, whose view of the redoubts on higher ground was obscured by undulating terrain. In fact, the only guns he and the Light Brigade could see were the massed artillery pieces of the main Russian army of 25,000 men blocking the way to Sebastopol at the end of the valley.

Lucan was dumbfounded at the apparent import of the order. For cavalry to attack an army in position with artillery was madness. He protested. 'Lord Raglan's orders are that the cavalry should attack immediately,' snapped Nolan, who held both Lucan and his brother-in-law, Cardigan, in deep contempt. 'Attack, sir! Attack what? What guns, sir?' asked Lucan. Nolan's next words, accompanied by a somewhat vague wave in the general direction of the Russians, sealed the fate of the Light Brigade, 'There, my lord, is your enemy! There are your guns!' After that, events moved swiftly to the moment when the bugle sounded the call to advance. Lord Cardigan, mounted at the front of the leading rank, bellowed at his brother-in-law: 'I shall never be able to bring a single man back.' His protests were to no avail and survivors who rode with him heard him say, 'Well, here goes the last of the Brudenells,' just before he gave the order to advance, first at walk, then at trot.

In twenty minutes it was all over. The valley floor was strewn with dead and wounded. The finest of the Light Brigade lay mangled and shattered in the smouldering earth which had been ploughed up by a hail of shellfire directed by the first

disbelieving, then terrified Russian gunners. In the first moments of the charge, Captain Nolan's head was shot off and his horse bolted back through the ranks of the lancers and dragoons still carrying his headless corpse, upright in the saddle; he had appeared to ride obliquely across the path of the charge, shouting incoherently, as though, too late, he had realised the brigade was heading the wrong way and into disaster. Of the leading rank, only thirty reached the Russian guns, among them Lord Cardigan, who took a lance thrust as his horse cleared a parapet before returning back down the corpse-strewn battlefield. His second in command, Lord George Paget, a keen foxhunter, led the supporting 4th and 8th into the guns with a shout of 'View halloo!' Afterwards he said, 'As far as it engendered excitement, the finest run in Leicestershire could hardly bear comparison.' The first roll-call mustered only 193 mounted men, but more straggled in later, wounded, tattered and horseless. Incredibly, the charge down the valley of death had reached the guns and scattered the gunners and their supporting infantry; further, it instilled in the Russians terrors of a cavalry that would stop at nothing, fears that demoralised the enemy army for the rest of the Crimean campaign. But the Light Brigade was finished by folly, and not even the most stirring pictures by the war artists, nor the sonorous words of the Poet Laureate, Tennyson, could palliate that fact.

From a hill above the battlefield, the correspondent of *The Times*, reporting on the 'melancholy catastrophe', saw the glittering squadrons prepare to charge the Russian army in position and noted, 'We could scarcely believe the evidence of our senses.' That conflicting evidence should be given by actual survivors comes as no surprise. Two officers who rode apparently side by side and lived to tell the artist Simpson about it gave wildly differing accounts; one argued that he had ridden further than the other; the other rejected this and claimed that he was in a better position to describe the final moments. It was inevitable that on such spikily disputed ground and in the charged atmosphere of allegation and counter-allegation after the battle, Simpson felt obliged to submit his drawing to the man who led the six hundred, Lord Cardigan (who, let it be said, had not flinched in his duty and to his credit had actually questioned the wisdom of the controversial order to ride against the guns).

Accuracy was pursued by William Simpson with almost religious zeal. This reason alone was sufficient for him to submit sketches, many of them containing intricate technical detail, to the appropriate military authority before despatching them to London. In later wars he did not show the same readiness voluntarily to submit to censorship—notably in the Franco-Prussian war of 1870 when open dealing with the authorities could mean instant confiscation of material. The Crimea, however, was his first assignment and previous military experience had not gone much further than watching the militia parade through the streets of Glasgow.

There was more to Simpson's caution, however. The independent war artist, as distinct from the soldier artist, was a new animal. His existence at the front, his facility to visit key positions, to watch battles or to tour battlefields after the action, even his shelter, food and drink depended on military patronage. This was no less true for the half-dozen special artists of the *Illustrated London News*, the only picture newspaper which made a comprehensive and successful attempt to cover the Crimean war, than it was for Simpson who was there on assignment from Colnaghi's, the London print publishers. (His own full-time association with the *Illustrated London News* did not begin until 1866.)

Contacts and patronage were important if the artists were to do their job

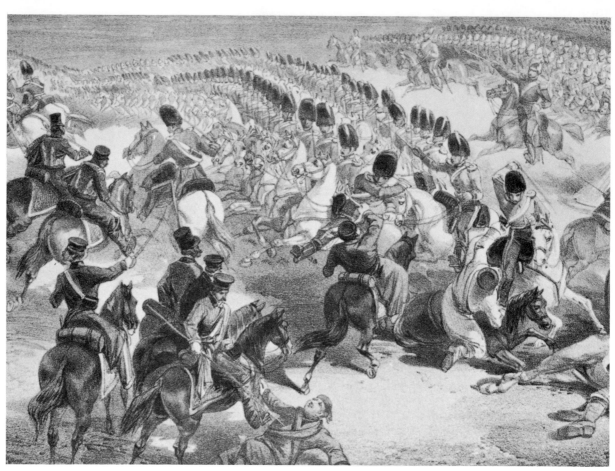

William Simpson's superb draughtsmanship is seen in detail from the Charge of the Heavy Cavalry, an action which involved the Scots Greys and other regiments in a head-on collision with the Russian cavalry while the Light Brigade chafed impatiently, waiting for its moment of immortality. Simpson drew this after the event from painstaking questioning of those who had taken part. (*Phillips Fine Art Auctioneers*)

adequately, and it is interesting to see how Simpson, the newcomer who emerged from the Crimea head and shoulders above all other artists, set about the task. His initial laissez-passer was a sheaf of introductions to the men who mattered in the Crimea, the Duke of Cambridge (Guards and Highland brigades), Sir Edmund Lyons (a naval commander) and, most important, Lord Raglan, the British Commander-in-Chief, who died of cholera the following summer. Contacts made from those first introductions in the Crimea served Simpson well for many years to come and, from Afghanistan to Abyssinia, opened doors which were closed to lesser artists and correspondents. If, therefore, Simpson's submission of his work to the Commander-in-Chief meant a form of censorship, there were advantages: for example, the sketches travelled home in Lord Raglan's personal post bag, which meant sure and speedy delivery to his publishers in London. Constantin Guys, a French artist working for the *Illustrated London News*, did not enjoy such privileges and had to catch the evening mail to London, sometimes sending off a dozen sketches on thin paper, hoping they would arrive safely. Other artists hitched lifts on supply ships to Constantinople where they could put their packets of pictures aboard a homebound vessel. From the start Simpson learned the essential lesson for a correspondent: organise your lines of communication. Once in London, his sketches went even further up the Establishment line, being shown to the Duke of Newcastle, the Minister for War, and finally to Queen Victoria herself, shrewd,

tactical moves which underwrote the artist's fame and future income as they led to several royal and noble commissions.

It would, however, be unfair to give the impression that Simpson's pen recorded only what the generals wanted to see. Although he saw no reason to refuse the proffered claret, sherry and Fortnum and Mason delicacies in the officers' messes of the Guards once a Crimean spring and reorganised supply lines had brought some degree of ease into campaign life, he was deeply moved by the plight of the badly fed and equipped troops in that first Russian winter. The experience left him with a compassion for the common soldier and a hatred of war which endured throughout his career. On the day of his arrival at Balaclava harbour he found a scene of destruction and death wreaked by a storm the previous night: one of the ships damaged was Lord Cardigan's luxurious *Dryad*, described as a 'fairy ship' amid the horrors of war by the redoubtable Fanny Duberly who followed her hussar husband to battle and kept a pungent diary of her adventures. Of the ordinary soldiers, cold, hungry and without tents, Simpson wrote home that first day: '. . . what miserable looking beings they are, covered with mud, dirt and rags . . . a scene which I cannot describe.' Where words could not succeed for Simpson, however, his pen and brush could. Important examples from his portfolio of Crimean watercolours dealt with the suffering of the sick and wounded. His sketch of the embarkation of haggard, fever-racked victims at Balaclava was an indictment of a system which had reduced a large proportion of the British army to such a plight only a few months after it had been despatched from the shores of England on a wave of popular pride and jingoistic fervour.

The horror of war deeply moved Simpson. He drew the glorious actions, but he also drew war for what it was. His lithographed watercolour, 'Embarkation of the Sick at Balaclava', was as effective as a column of prose by William Russell of *The Times*, who had stirred the nation's conscience with exposures of the troops' sufferings and the generals' blunders. (*Phillips Fine Art Auctioneers*)

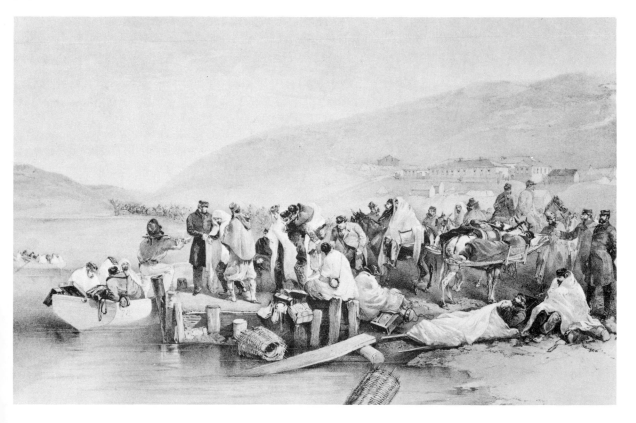

Lord Raglan, savaged by *The Times* of London for his part as one of the architects of Crimean mismanagement, nevertheless was sometimes a useful ally to Simpson in his search for the truth. On one occasion when the artist submitted a sketch of soldiers relaxing during a lull in the rifle pits, Sir George Brown, irascible commander of the light infantry and inveterate hater of correspondents, was with Raglan. A stickler for correct uniform dress, Brown was enraged by the fact that Simpson had drawn some of the soldiers wearing red stocking night-caps as they snatched a rest from the rigours of siege life. Did they really wear 'those damned things on their heads?' he demanded. Raglan smiled placatingly and assured Brown, 'Yes, anything that is comfortable.'

Simpson was fully aware of the advantages which accrued from such high-level patronage, advantages which were denied the writing correspondents of the press. Shortly after his arrival at the seat of the war, he met for the first time William Howard Russell, correspondent of *The Times*, whose despatches criticising the conduct of the campaign and the junketings of some generals while men went hungry had caused a furore at home and earned him the odium of the senior echelons in the Crimea. A profound mutual respect was immediately established between the tall, bearded, aquiline-nosed Scot who drew pictures and the stocky Irishman who traded in words. They were to meet many times in later years, usually in distant parts where the quarrels of nations and tribes had thrown men together in conflict. The reporting by such men as 'Billy' Russell, Edwin Lawrence Godkin of the London *Daily News*, and Thomas Chenery, *The Times* Constantinople man who exposed the squalid scandals of the hospital at Scutari (eventually Florence Nightingale's base), had had the effect of virtually banning reporters from areas under army control. It seemed to some senior officers that the Russians had no need of their much vaunted spy network when all they had to do was to read British army troop dispersements in detail in *The Times*. Victoria's consort, Prince Albert, called Russell 'that miserable scribbler'. Not only were correspondents barred from information, they were refused shelter and hospitality, often shunted unceremoniously out of army tent lines. Not so the artists like William Simpson: 'I was welcomed wherever I went,' he said.

Simpson was wined and dined by officers and given help at all times. Hospitality, however, had its drawbacks. The Crimea saw his baptism in the saddle, having been on a horse only once before when, as a child, he rode behind his uncle on a journey from Perth to Dundee. Early in his new riding career—he was to spend half his life in the saddle—he was loaned a huge black charger by a captain in the Rifle Brigade and he set off to tour the lines in front of besieged Sebastopol. For some reason, a distant bursting shell perhaps, the horse decided to take off and, emulating the Light Brigade, galloped headlong towards the Russian guns. Simpson had the greatest difficulty in deflecting his mount from the enemy trenches and capture—otherwise posterity might have had some interesting sketches of life on the other side of the lines. On another occasion he borrowed none other than Lord Lucan's horse, but it turned out to be an almost unmanageable creature with many of the traits of its owner—stubbornness, insensitivity and reluctance to accept guidance.

When he came to set down his life story, which he completed shortly before his death from bronchitis in 1899 at the age of seventy-five, Simpson remembered being intrigued in those early Crimean days by the difference between 'special correspondent' and 'special artist'. He decided:

The correspondent appeals to a larger number of persons [surely he was mistaken here?] and what he says may also have a political bearing, which brings him more prominently before the public than the artist. So the special correspondent receives a greater reputation than the artist. But at the seat of war the artist is in a more pleasant position than the other. If the correspondent blames any one, or any body of men, in the performance of duty, he is hated. If he praises any one there are always others who consider they have done equally well . . . and they abuse the correspondent for not noticing their merits. Of course, those who are praised are very friendly to the correspondent. The result is that the correspondent is much courted and much hated. I escaped all this. Every one was friendly to me. . . .

The experience of being under fire was to become commonplace to the war artists, but Simpson's early meetings with the facts of front-line life came as a shock. On his arrival he walked to the Sebastopol lines and sat down to sketch. What, he asked a soldier, were all these balls lying around? 'Them's the Rooshians' balls, sir,' he was told. 'I began to think the sooner I was away from the spot the better,' he later remarked. 'Here I had been sitting for nearly an hour where I might have been shot.' Before going into action aboard ship at the siege of Sebastopol harbour, the naval commander Lord Clarence Paget explained to Simpson the difference between the professional war maker and the war artist in the forthcoming fight. If a shell struck the admiral, who was doing his duty, he would be called a hero. If a shell struck Simpson, who had no business to be there, he would be called a fool. It was almost a paraphrase of Archibald Forbes's advice on the role of a special.

In the business of learning the mechanics of survival, the war artists received plentiful advice from the seasoned campaigners who manned the siege lines outside beleaguered Sebastopol. Thus men of the naval battery, a favourite sketching subject for the artists, told their visitors how to know if a Russian shell is coming straight at you. The advice went something like this: If a shell is coming at you it will be seen as a black speck against the white cannon smoke—and you will have plenty of time to take cover. If there is no speck to be seen, or if it disappears after a time, you can assume that the shell is going wide and there is no danger. Such advice, of course, is only effective if you keep your eyes open in the first place. Simpson discovered, as observer and artist, that mass death in war was not necessarily the gory affair that people imagined. Poets might talk about the crimson battlefield, armchair painters might scatter blood around the canvas in carmine copiousness, but the man on the spot quickly observed that the ground soaks up the blood of the fallen and men die in attitudes of life, as if holding their muskets or gesturing to comrades. Urban death—which Simpson and his colleagues saw in abundance in the Paris Commune—is another matter: city pavements leave the evidence of bloodshed in its full horror for the world to see.

It was an awareness of the need for such accurate observation that led the magazine artists in the Crimea to send home detailed pencilled notes with their drawings. Simpson had no need of such notes as he was despatching finished drawings whose publication was not nailed to a demanding weekly deadline, although later he adopted similar techniques in his career as a magazine 'special'. Attached to one sketch from Sebastopol were these instructions to the woodblock engravers from Constantin Guys: 'Pay attention to the uniforms just as I have drawn them. They are absolutely exact. But change the landscape at your choice; the same could well pass for a snowy day if you prefer.'

Guys, a globe-trotting dandy who sported a large white moustache, was a lover of women and horses, essentially a man of the city and its attractions, who had carved for himself an unlikely career in the wilder spots of the world. He was by the time of the Crimea probably the most seasoned of the *Illustrated London News* war artists. He soldiered with Byron in Greece and eagerly signed up with the lusty, thriving new British magazine when revolution broke out in Paris in 1848. His sketches from Paris helped double the *Illustrated London News* circulation of 66,000 in three months. Guys died workless and in penury after the Franco-Prussian war of 1870, which had produced changes to which he could not adapt. The Crimea, however, found him at the height of his powers, a skilled, hard-working artist who was, nevertheless, a soldier manqué. One of his sketches shows a military figure, head thrown back proudly, seated astride a charger which is picking its way through huddled corpses on a battlefield. At the bottom of the picture, in a corner, are the words 'Myself at Inkerman'.

For Guys and his colleagues, Edward Alfred Goodall, J. A. Crowe and Oswald Brierly (later knighted), all specials employed in the Crimea by the *Illustrated London News*, the editorial accolade was a two-page spread devoted to a drawing, a feature of the magazine which became characteristic throughout the nineteenth century and into the twentieth. Goodall, brother of Frederick, a Royal Academician, subsequently had a career in which he travelled the world with his sketch-book and he died at the ripe age of eighty-nine in 1908, six years before 'the war to end all wars'. His sketches from the Crimea caught the suffering of the sick and the wounded and brought home to the Victorian public that there was more to war than splendid ranks of lancers trotting gaily to battle. The team's efforts in the *Illustrated London News* were augmented by drawings by Gustave Doré—powerful, harsh representations. His retreat of the Russians from Sebastopol was a masterpiece of sculptured men and horses treading the bridge of escape against a background of holocaust; another in true Doré style was the fall of the Malakoff tower. Late in the war, the magazine sent out Robert Landells, who had been the first artist it had used to make eye-witness drawings when it commissioned him in 1841 to cover the State visit of Queen Victoria to Scotland. In the Baltic, where naval warfare was waged between the British and Russians, James Wilson Carmichael served the magazine as artist. Later, he made a reputation for himself in oils, and today his paintings of important Victorian occasions bring equally important prices in the London and New York salerooms. In the Baltic he found and pictured a strange war of blockade which was often lean on incident but sometimes rich in the unconscious humour of contemporary journalism: an unfortunate accident with a mine was drawn by him and captioned as 'a Russian submarine infernal machine' exploding aboard HMS *Exmouth* in the face of Admiral Seymour 'who was trying the spring'.

Although the *Illustrated London News* swept up the journalistic honours in the war, the French did field a distinguished artist with the much-hyphenated name of Jean-Baptiste-Henri Durand-Brager. In his lifetime he drew and painted wars and great events across the length and breadth of Europe and Africa. He covered the later stages of the Crimean war as a special artist for the Paris magazine *L'Illustration*, founded in 1843 as an imitator of the successful *Illustrated London News*. On the other side of the lines, there was little if any picture coverage. On 7 July 1855, the *Illustrated London News* quoted a nine-year resident of Russia as saying that St Petersburg, the capital, had but three Russian-language newspapers. These were the *Police Gazette*, filled with official announcements and trade adver-

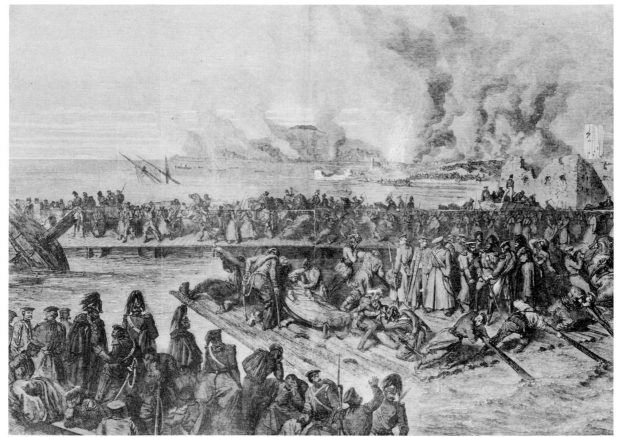

tisements, the *Invalide*, a naval and military journal, and the *Northern Bee* 'which enjoys a certain reputation for the violence with which it attacks whatever is offensive to the law of authority'. Somewhere behind the lines of the Crimea, however, a young photographer was operating with the approval of the Russian authorities. His name was Leo Tolstoy. Photography, the new weapon of war, had arrived.

Here, in the highly fallible dictum of 'the camera cannot lie' the authorities—particularly those of the Western Allies, plagued by a largely unfettered press—thought they had found the answer to the embarrassing revelations of outspoken war correspondents. Thus the new guardians of official credibility were despatched to the Crimea with an armoury of collodion plates and pyrogallic acid, specifically to seek out and record scenes to reassure the confidence of a disillusioned public.

The arrival at war of the photographer should have been a major threat to the special artist. That the challenge did not reach serious proportions was as much to do with the role and attitudes of the early photographers as it was to do with the technical limitations, such as heavy cumbersome equipment, the need for long exposure and the fact that no publication had block-making equipment to reproduce the half-tone pictures for many wars to come.

First on the scene was James Robertson, superintendent and chief engineer of the Turkish Imperial Mint in Constantinople. He took some photographs as the British army gathered at Varna on the Bulgarian Black Sea coast before embarking for the Crimea in September 1854. His efforts, and those of others including the French

For speed, the engraving of a double-page spread was divided into a number of small blocks on which the engravers worked simultaneously. Careful fitting was essential where the blocks met. Often, however, hasty workmanship showed in lines at the joins in the finished publication. This is an example from the *Illustrated London News:* Gustave Doré's retreat of the Russians from Sebastopol.

27

The camera fails to meet its challenge. Roger Fenton, sent to the Crimea with Prince Albert's blessing to restore official credibility in the face of criticisms by 'miserable scribblers', confined himself largely to photographing 'safe' subjects such as happy groups of comrades. A collector's item: Brigadier General Van Straubenzee and officers of the Buffs, salt print from a glass negative, $6\frac{3}{4} \times 6\frac{1}{4}$ inches. (*Sotheby's Belgravia*)

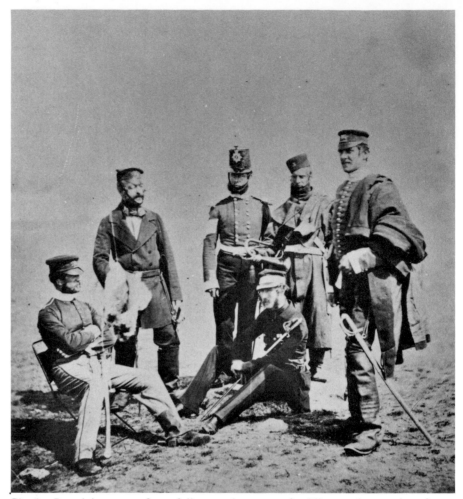

Charles Langlois, were of carefully posed groups of soldiers and portraits of generals. There is a remarkable photograph, by a British camera pioneer, of the remnants of the 13th Light Dragoons on the morning after the Charge of the Light Brigade (the 13th had only ten men mounted after the charge); so nonchalantly are they posed, with forage caps perched jauntily on their heads, that they might have been enjoying a break during manoeuvres on Salisbury Plain, rather than having just emerged from the hell of Balaclava.

Criticisms of the conditions of the army during the winter of 1854/5 convinced the powers in London that some strong counter-propaganda was needed with the coming of spring. Under the personal patronage of Prince Albert (whose views on war corrspondents were well known) Roger Fenton, a founder member of the Royal Photographic Society, was sent to the Crimea in February 1855 to help redress the balance. He produced and eventually published 360 photographs. They included allied leaders astride their chargers, artistically composed groups of officers and men, French, English and Turk in fraternal harmony; Brigadier van Straubenzee sat amid an admiring circle of sabred officers of the Buffs; the tents of the 23rd Welch Fusiliers stretched in reassuringly neat rows, giving the impression of order and comfort. The pictures were technically brilliant and endure today as

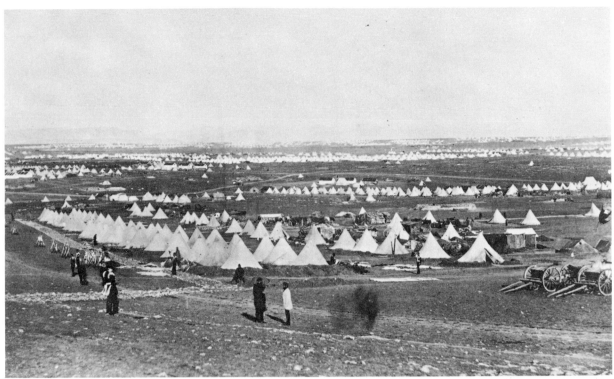

masterpieces of early photography. But they were, above all, *safe*. If technical difficulties limited Fenton to 'still life', it was there in abundance in the ranks of motionless wounded and sick awaiting shipment on the quay at Balaclava and in the half-buried skeletons which pitted the Light Brigade's valley of death. But Fenton's camera took in none of this. And as if to emphasise the supremacy of the traditional artist, when Fenton's work appeared eventually in the *Illustrated London News* it was in the form of engravers' drawings 'from the exhibition of photographic pictures taken in the Crimea by Roger Fenton'.

Photography, with its exciting potential and its fascinating novelty, met with fashionable acclaim. But the special artists emerged from their blooding in the Crimea with a tradition of speedy, professional coverage which was to set the pattern of pictorial war reportage up to the end of the century and beyond. A new breed of artist had been born, epitomised in the tough Scot, William Simpson, who breezed through nearly half a century of wars with a sketch-pad in his hand, a flask of rum in his pocket and one eye on the clock to note the time of the next bush runner, post-chaise, steam-packet, train or balloon back to the collection point and London. He returned from the Crimea, his appetite whetted for travel, to reap the fruits of his labours. Colnaghi's published two folios with a total of eighty of his Crimean sketches from 'The Seat of the War in the East', dedicated to Queen Victoria. Simpson reckoned later that the publishers must have made close on £12,000 out of the deal, being an establishment that was frequented by 'the upper ten thousand' who collected prints. The firm afterwards sold his originals 'and no doubt received as much as they gave for them, so that they had the copyright for nothing'. There were a few fringe benefits for Simpson, such as a commission from the Queen and others from the Duke of Newcastle to draw some Circassian pictures. The artist

Another Roger Fenton 'still-life' photograph. The photographer worked under obvious technical limitations, and this view of the camp of the 23rd Welch Fusiliers and the French division at Sebastopol needed an exposure of 15 seconds. The print measures 8¾ × 13¼ inches taken on collodion, developed in pyrogallic acid, lens by Ross, focal length 20 inches, diameter 4 inches, diaphragm 1 inch. (*Phillips Fine Art Auctioneers*)

returned with his reputation established and was known henceforth as 'Crimean Simpson', but he had costly travelling expenses to meet and he received from Colnaghi's no more than £20 a picture. It was hardly a princely financial reward for a man who risked all in joining the ranks of the infernal fools.

The war artists' achievements in the Crimea had widespread effects on journalism across the world. Copyists moved in to emulate the success of the *Illustrated London News* in Britain, *L'Illustration* in France and Germany's *Illustrierte Zeitung*, which had been established in 1843. By 1868, Russia had its own picture paper in St Petersburg, *Vsemirnaya Illyustratziya*. And across the Atlantic publishing tycoons eager to tap the spending power of a vibrant new nation launched *Frank Leslie's Illustrated Newspaper* in 1855 and *Harper's Weekly* in 1857; within a few years they were to assign platoons of special artists to cover the most illustrated conflict of the century, the American Civil War.

4 North and South

They have made the weary marches and dangerous voyages. They have shared the soldiers' fare; they have ridden and waded and climbed and floundered, always trusting in lead pencils and keeping their paper dry

Harper's Weekly *on the role of Civil War special artists, 3 June 1865*

About five months after the outbreak of the American Civil War, British-born Alfred Waud made hurried sketch notes in the saddle as his pony shied and splashed in water that ran belly deep. Bursting shells, the cause of the horse's alarm, peppered the surface of the Potomac River with shrapnel and showered a cascade of autumn leaves onto the heads of a small group of blue-coated cavalrymen who rode through the shoals near the bank.

Waud's 'shorthand' scribbles later served as the basis of a pencil sketch for his New York newspaper. It showed a reconnaissance column led by **Union general Daniel Sickles**, and by his side a tall bearded civilian in wide-brimmed hat and riding a large black horse. This was Frank Vizetelly, Waud's compatriot, adventurer and special artist, and now representing the interests of the *Illustrated London News* and the London *Daily News* with the Army of the Potomac.

Down river, Confederate batteries were trying to hit a fleet of small schooners engaged on supply runs in and out of Washington. Vizetelly, like most specials a reporter as well as artist, wrote: 'We on our side watched the little ships anxiously as they came within range of the enemy's guns, which they no sooner did than a terrible fire of shot and shell opened up on them, not one, however, being struck seriously, and all enabled to keep their course down river. We, the spectators, ran probably more risk than the vessels, for many of the shells came over to our neighbourhood, bursting in close proximity to where we stood.'

Not for the first time Vizetelly was under fire. He exulted when 'our turn came and we gave them a few rounds from the tiny Parrotts, pitching the 10-pound shells right into their works, and peppering a steamer.' The sympathies of the debonair Vizetelly were soon to shift towards the gentlemen of the South, however, and within a year he was across the Potomac, drawing the war as he saw it from that side, and fully committed to the cause of the Confederacy.

The Civil War was the high point of Frank Vizetelly's career. It found him, at the age of thirty-one, at the peak of his physical powers, tough enough to withstand the rigours of campaigning in all weathers and often without food or adequate shelter, and with a brilliant reputation as a war artist. His first experience of illustrated journalism was with the *Pictorial Times*, run by his brother Henry. He next helped at the birth of *Le Monde Illustré* in Paris, and then switched his allegiance to Henry's first love, the *Illustrated London News*, which appointed him as a special to cover war in Austria in 1857, and in Italy in 1859. When Garibaldi, the Italian liberator, stormed through Sicily in 1860, Vizetelly rode by his side.

General Sickles and Staff in a reconnoitring expedition along the banks of the Potomac.

Reconnaissance along the banks of the Potomac by General Sickles and staff, 1861. This pencil and chinese white drawing by Alfred Waud of the *New York Illustrated News* is notable as a rare picture of special artist Frank Vizetelly, seen riding on the right of Sickles at the head of the column. Vizetelly's pro-Southern feelings were soon to lead him to the other side in America's Civil War. (*Reproduced from the collection of Library of Congress*)

His nephew, Ernest Vizetelly, has written with awe of the fame attendant on his uncle's name. An aristocratic French fencing master took the young Ernest under his wing with the advice, 'if you mean to live in France and be a journalist, you must know how to use a sword,' adding with pride that he had taught Frank Vizetelly and his friend Gustave Doré how to fence years earlier.

On one occasion when Frank was enjoying a brief leave in London after sailing from the Confederacy through the blockading Northern fleet, Garibaldi arrived on a visit. Vizetelly took the young Ernest and his own son, Albert, to see the hero and was greeted by Garibaldi as an old and valued friend. 'I regarded him . . . with a kind of childish reverence,' Ernest wrote of his uncle. 'I can picture him still, a hale, bluff, tall and burly-looking man, with short dark hair, blue eyes and a big ruddy moustache. He was far away the best known member of our family in my younger days when anonymity in journalism was an almost universal rule. In the same way, however, as everybody had heard of William Howard Russell, the war correspondent of *The Times*, so most people had heard of Frank Vizetelly, the war artist of the *Illustrated*.'

The war in America should have been Vizetelly's greatest triumph. It certainly added to his stature as a special artist, but his choice of the Confederate side inevitably created difficulties for him in sending home his sketches, and much of his work failed to arrive in London. Thus, the man who ultimately became an infernal fool in the Sudan also, through no fault of his own, failed to observe that important tenet of the special artist which insists that lines of communication should be preserved.

On 21 July 1861, Vizetelly watched in horror the Northern stampede from the battlefield of Bull Run near Washington:

The terror-stricken soldiers threw away their arms and accoutrements herding along like a panic-stricken flock of sheep, with no order whatever in their flight. . . . Wounded men were crushed under the wheels of the heavy, lumbering chariots that dashed down the road at full speed. Light buggies, containing members of Congress [much of Washington's society had come out in picnic gaiety to watch the battle from nearby hills] were overturned or dashed to pieces in the horrible confusion of the panic.

It is not clear whether his experiences at Bull Run influenced the stand he subsequently took in favour of the South. At this early stage, however, we know that he was puzzled and deeply concerned that a nation was fighting among itself. Difficulties and obstruction placed in the way of war correspondents by the Northern authorities were soon to force him to a crucial decision. His main problem was in being unable to secure permanent accreditation to the Army of the Potomac, a running irritation that forced him for a time to seek news material in the western campaign of General Halleck. Here, too, he met military hostility and it irked him that he had to provide his own transport and rations. Once more refused permits to the Potomac area in the summer of 1862, he resolved to go to the South, which, he was increasingly convinced, was his home in spirit.

Risking execution as a spy, he persuaded a Negro to guide him across the Potomac under the noses of Union patrol boats. In Richmond he joined the Confederate army as a correspondent, and soon he was riding with General Robert E. Lee.

In the despatches which accompanied his sketches to the *Illustrated London News*, Vizetelly's pro-Southern feelings were clearly delineated. He sympathised with Lee's men over the poor equipment and weapons with which they had to fight, circumstances forced on them by the Northern blockade, and he presented the Confederacy's struggle as a heroic fight for survival. For long periods the material which reached his newspaper was reduced to a trickle and at times ceased altogether. But there was no lack of industry or output from Vizetelly: it was simply that the blockading Union fleet was sinking or capturing the ships that carried his sketches.

Thus Vizetelly, the champion of the South, unintentionally helped the mouth-pieces of the North—the New York picture newspapers which eagerly accepted those of his sketches that were captured by the Union navy. It was, after all, one of the very few sources open to them of war scenes from the Confederate side, an aspect of the conflict which was generally under-pictured throughout the duration. *Harper's Weekly* unashamedly pirated the sketches and reproduced them boldly. The *Illustrated London News* knew it was happening but could do very little about it. Vizetelly suspected it was happening and could do less. Sometimes *Harper's* passed his sketches on to his London newspapers, but only after it had used them itself. Such sketches might be subjected to a delay of up to six months before they finally appeared in the *Illustrated London News*.

On three occasions Vizetelly personally beat the blockade to visit London, returning by the same method in fast Confederate blockade runners whose daring captains became heroes of the naval war. During these visits he made up for sketches that had been lost or seized by providing his newspaper with bundles of illustrations of campaigns over the preceding months.

In the officers' messes of the Confederate camps Vizetelly was a popular figure. Major Heros von Borcke, a Prussian who served in the South, wrote: 'He was not long in becoming a general favourite at headquarters. Regularly after dinner, our whole family of officers, from the commander down to the youngest lieutenant, used to assemble in his tent, squeezing ourselves into narrow quarters to hear his entertaining narratives.' Vizetelly's rare attempts at camp cooking did not, apparently, meet the same approbation. A roast pig he prepared for mess dinner was burned to a cinder on one side and uncooked on the other.

In 1866, the year after the Civil War ended, he covered the Austro-Prussian war for the *Illustrated London News* (see Chapter 9) then devoted his energies to running with his brother James a London society journal called *Echoes of the Clubs*. Though the suave Vizetelly was at home in clubland, he longed for the life of campaigning. Once more he became a special and set out on the road which led him to Canada with General Wolseley's Red River expedition, the Carlist insurrection in Spain, French campaigning in Tunis—and his death in the Sudan.

The memorial to Frank Vizetelly stands today in the pages of bound files of the *Illustrated London News*, the *Graphic* and other newspapers and magazines to which he contributed, and in the traditions of a thrusting type of journalism he helped to found—a journalism that believed in going out to get the news wherever it might be found. There is a more tangible memorial to Vizetelly and his Civil War colleagues which stands on South Mountain in Gathland State Park, Maryland, where George Alfred Townsend built it on his own land in 1896. Townsend covered the Civil War for the *New York Herald*. On his War Correspondents Memorial Arch are carved the names of 157 reporters and artists of America's war, and this inscription:

TO THE ARMY CORRESPONDENTS
AND
ARTISTS
1861–65
WHOSE TOILS CHEERED THE FIRESIDE
EDUCATED PROVINCES OF RUSTICS INTO
A BRIGHT NATION
OF
READERS
AND GAVE INCENTIVE TO NARRATE
DISTANT WARS AND EXPLORE DARK LANDS

The American Civil War was essentially a 'newspaper war'. Not only was the telegraph available, but never before had a major war been fought so near to urban centres which housed a vast and growing newspaper-reading public. And never was there a war in which the soldiers participating in it had such ready access to those newspapers. After a battle the Army of the Potomac was usually able to read on the next day—sometimes the same day—newspaper accounts of the fighting in which they had taken part and in which their comrades had been killed. It meant that reporters and artists often had to face immediate critical analysis of their work by the men whose dangers they shared. The proximity of the war zone to the publishing centres of the North was emphasised by specials' sketches showing the newsvendors galloping into camps, bringing freshly printed papers which would be read as avidly as a home-going football crowd devours the special sports edition.

In the most pictured and reported war of the century, the statistics of newspaper

coverage speak for themselves. During the four years of conflict there were more than five hundred correspondents from the North alone. Southern coverage suffered because its newspapers were less wealthy and poorly organised, and its publishing centres were more likely to be affected by shifts in the battle lines. *Frank Leslie's Illustrated Newspaper* of New York, which employed eighty artists and published more than 3,000 illustrations in the war, announced in June 1861 that it was receiving twenty to forty sketches a day from artists in the field, adding for good measure that it carried 'the only correct and authentic pictorial illustrations of the war'.

Because of the uncertainties of campaigning in a civil war and the prevalence of literary piracy, *Leslie's* issued its specials with sketch-pads bearing the printed notice at bottom left: 'An actual sketch made on the spot by one of the Special Artists of *Frank Leslie's Illustrated Newspaper*. Mr Leslie holds the copyright and reserves the exclusive right of publication.'

There was fierce competition between the specials of the various New York newspapers, which also vied with each other to secure the best action drawings from serving soldiers. On 15 June 1861 the *New York Illustrated News* announced: 'Notice to artists, reporters, soldiers and others. Anyone, in any part of the country, who will send us faithful sketches of scenes and incidents connected with the war, however roughly they may be drawn, will be thanked by the proprietors of this newspaper. If the sketches be used, they will be liberally paid for.' The New York papers paid professionals and amateurs from $5 to $25 a picture. Some special artists were on a pay-if-used basis, but by the time the war was in full stride many had signed up salaried deals with their papers.

Tributes to the artists, whom *Harper's Weekly* called 'this noble army of men', flowed from the pens of editorial writers. Their torrent of words always included a 'commercial' for the excellence of their own newspaper's staff and coverage. In June 1862 the *New York Illustrated News* said of its specials, 'Their duty calls them into all sorts of dangerous places, and professional rivalry, and the eagerness to obtain news "exclusive" and in advance of the correspondents of other journals, keeps

A facsimile of a pencil drawing by Edwin Forbes of *Frank Leslie's Illustrated Newspaper* shows newsboys passing the picket post on the way to camp. For many Northern soldiers the proximity of the fighting zone to publishing centres meant that they were kept constantly supplied with newspapers. (*Reproduced from the collection of the Library of Congress*)

Special artist Alfred Waud, who soldiered through the Civil War with his British passport in his pocket in case of emergency, was photographed by Alexander Gardner as he sketched at Devil's Den, Gettysburg, on 4 July 1863. (*Reproduced from the collection of the Library of Congress*)

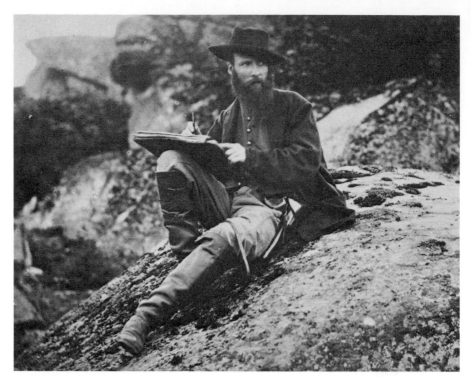

them constantly in the advance, and on the dangerous and disputed ground that has not yet been made safe by the onward march of our soldiers.'

At the close of the war *Harper's Weekly* proclaimed: 'They have made the weary marches and dangerous voyages. They have shared the soldiers' fare; they have ridden and waded, and climbed and floundered, always trusting in lead pencils and keeping their paper dry. When the battle began they were there. They drew the enemy's fire as well as our own. The fierce shock, the heaving tumult, the smoky sway of battle from side to side, the line, the assault, the victory—they were a part of all and their faithful fingers, depicting the scenes, have made us a part also.'

First among its 'noble army', *Harper's* placed Alfred Rudolph Waud, who covered every major action of the Army of the Potomac from Bull Run to the end. Waud was British, born in London on 2 October 1828, and descended from Swiss ancestors called Vaud (he pronounced his name 'Wode'). After studying art as a young man, Waud emigrated to New York in 1850 and obtained employment painting scenery, drawing on wood for various publishers, and contributing to a panoramic guide of the area between Niagara and Quebec (the finished print unfolded to over twelve feet in length).

In 1860 he was given a job as an illustrator on the *New York Illustrated News*, then a year old. His first paper did not survive the war, expiring in August 1864. On 4 May 1861 however, it announced with a flourish that 'Alfred Waud Esq., one of our most talented artists, and a special correspondent', was on his way to Washington to accompany the army.

When, in January of 1864, George Augustus Sala visited the Army of the Potomac on behalf of the London *Daily Telegraph*, Waud was as experienced in warfare as any serving soldier. Of him, Sala wrote in *My Diary in America in the Midst of War*:

There had galloped furiously by us, backwards and forwards during our journey, a tall man, mounted on a taller horse. Blue-eyed, fair-bearded, strapping and stalwart, full of loud, cheery laughs and comic songs, armed to the teeth, jack-booted, gauntleted, slouch-hatted, yet clad in the shooting-jacket of a civilian. I had puzzled myself many times during the afternoon and evening to know what manner of man this might inwardly be. He didn't look like an American; he was too well dressed to be a guerilla. I found him out at last, and struck up an alliance with him. The fair-bearded man was the 'war-artist' of *Harper's Weekly*. He had been with the Army of the Potomac, sketching, since its first organization, and doing for the principal pictorial journal of the United States that which Mr Frank Vizetelly, in the South, has done admirably for the *Illustrated London News*. He had been in every advance, every retreat, in every battle, and almost every reconnaissance. He probably knew more about the several campaigns, the rights and wrongs of the several fights, the merits and demerits of the commanders, than two out of three wearers of generals' shoulder-straps. But he was a prudent man, who could keep his own counsel, and went on sketching. Hence he had become a universal favorite. Commanding officers were glad to welcome in their tents the genial companion who could sing and tell stories, and imitate all the trumpet and bugle calls, who could transmit to posterity, through woodcuts, their features and exploits, but who was not charged with the invidious mission of commenting in print on their performances. He had been offered, time after time, a staff appointment in the Federal service; and, indeed, as an aide-de-camp, or an assistant-quartermaster, his minute knowledge of the theatre of war would have been invaluable. Often he had ventured beyond the picket-lines, and been chased by the guerillas; but the speed and mettle of his big brown steed had always enabled him to show these gentry a clean pair of heels. He was continually vaulting on this huge brown horse, and galloping off full split, like a Wild Horseman of the Prairie. The honors of the staff appointment he had civilly declined. The risk of being killed he did not seem to mind; but he had no relish for a possible captivity in the Libby or Castle Thunder. He was, indeed, an Englishman,—English to the backbone; and kept his Foreign Office passport in a secure side-pocket, in case of urgent need.

Like many other Civil War correspondents, Waud had 'innumerable difficulties in the way of passes', and in the face of military harassment he joined a group of colleagues whose collective bargaining might have greater success than one man's efforts. Thus the early July days of 1861 found him in the company of two reporters and the travelling 'circus' of Mathew Brady, the photographer.

Brady, born in 1823, was a successful New York portrait photographer who paid his own way to the war because 'I felt I had to go'. He left the nation a brilliant portfolio of war pictures, but it cost him $100,000 and he died in bankruptcy in 1896. He took the field with several assistants, some of whom became fine photographers in their own right, for example, Alexander Gardner and Timothy O'Sullivan. War had never been photographed the way Brady did it, but as in the case of Roger Fenton in the Crimea of the previous decade, technical difficulties worked against his achieving contemporary popular fame at the expense of the special artist. Complicated technical processes involving wet collodion plates necessitated cumbersome equipment, and this was the day of Brady's 'what-is-it-waggon', as the troops called his mobile darkroom. Similarly, the lack of equipment for making half-tone blocks

meant that newspapers had to redraw his photographs if they were going to be used for mass circulation. Indeed, Waud used some Brady photographs as the bases for sketches and, in time, he too became a proficient photographer.

A Brady studio photograph of Waud at this time shows him wearing a black, broad-brimmed hat, sketch-book and pencil in hand, bowie knife and revolver at his waist, blanket-roll and flask on belt, every inch an artist kitted out for the field.

Together, artist and photographer went to war at Manassas, near Washington, where the first battle of Bull Run on 21 July 1861 gave the Union a bitter taste of defeat and a devastating shock to its morale. Waud and Arthur Lumley, an Irish-born special artist of *Leslie's*, sketched all day until they were caught up in the headlong rout of Union soldiers and terrified socialites. Somewhere in the confusion was Frank Vizetelly. Waud tried vainly to rally some of the retreating Federals. Brady had great difficulty in saving his precious plates as his lumbering waggon was swept along at a rattling pace in the stream of retreat. At Centreville, Waud and Joe Glenn of the *Cincinnati Gazette* thought they could pause, but after a night's sleep, they found not a Union soldier in sight. Hastily pulling out, they caught up with the retreating army twenty miles away, and the flight did not stop until it reached Washington.

Waud drew himself 'in the foreground, sketching the exciting scene' as the Union guns opened up at the start of the battle. He also drew the aftermath, 'Panic on the road between Bull Run and Centreville'. When they appeared as engravings in the *New York Illustrated News*, many of Waud's sketches were signed by Thomas Nast, who moved to *Harper's* with editorial function shortly after Waud's own move late in 1861. Here was the genesis of a bitter feud between field and home artist that lasted through the Civil War and beyond.

The basis of their quarrel, as we have seen in Chapter 2, was Waud's belief that, in the course of preparation for engraving, his sketches were suffering unwarranted interference and alteration from Nast. Waud and others of his kind would readily admit that some of their quick 'shorthand' sketches on the battlefield benefited from more elaborate graphic treatment before they reached the public; indeed, his colleague and friend, Theodore Davis of *Harper's*, once noted: 'Probably my note-book of General Grant's Vicksburg campaign contains some of the very queerest specimens of hasty memoranda.' Nevertheless, specials who, like Waud, had just experienced hardships—'seven days almost without food or sleep, night and day being attacked by overwhelming masses of infuriated rebels thundering at us from all sides'—took very unkindly to some of the cavalier treatment meted out to their work by executives in the comfort and safety of New York.

The Library of Congress, which holds a superb collection of Waud originals, has evidence of a remarkable example of editorial interference. At Antietam in 1862 Waud sketched citizen volunteers helping the wounded on the field of battle, showing surgeons at work on the amputated leg of a victim, and other volunteers removing another man who has patently lost a leg. When Waud's drawing appeared as an engraving in *Harper's Weekly* there had been two significant alterations on behalf of the squeamish public: the first man had been tactfully turned round so that the bloody stump of his amputated leg did not appear; the second wounded man appeared with his good left leg crossed nonchalantly over the bandaged stump of the right. The editors of *Harper's* undoubtedly believed they were right in sheltering their readers from the more gory facts of the war, but to Waud this was a war of hideous truths, which in the end claimed the lives of two out of every nine men who

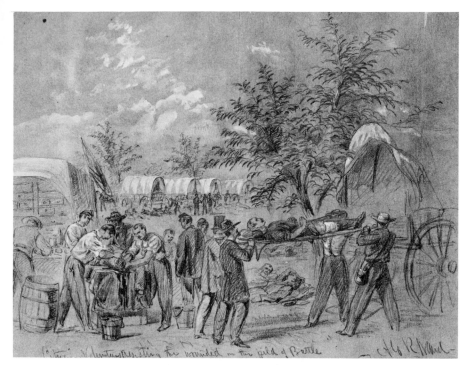

This is how Alfred Waud drew volunteers helping the wounded on the field of Antietam in 1862, in pencil highlighted by chinese white. On the operating table (left) he drew surgeons attending to the stump of a leg; on the right a wounded man was shown with newly amputated leg. When the illustration appeared as an engraving in *Harper's Weekly* of New York (*below*) the first man had been discreetly turned round and the second had his good leg crossed concealingly over the stump to protect readers' sensibilities. (*Both reproduced from the collection of the Library of Congress*)

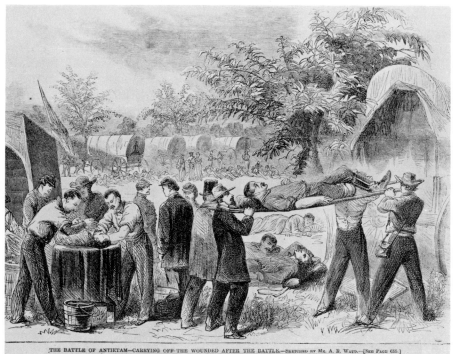

THE BATTLE OF ANTIETAM—CARRYING OFF THE WOUNDED AFTER THE BATTLE.—Sketched by Mr. A. R. Waud.—[See Page 655.]

fought, North and South, owing to the advance of weapons and the inexactitude of medicine.

Finding himself under fire became commonplace for Waud. He noted laconically on one sketch: 'This sketch was made at the request of General Meade, for his use—

from a tree used by the Signal officers. It took over an hour and a half—rebel sharp-shooters kept up a fire at me the whole time.' And on another occasion he reported, 'Your artist was the only person connected with newspapers permitted to go on the recent advance to the Rapidan. An order of General Meade's sent all the reporters back. It was a very wet and uncomfortable trip part of the time. I did not get dry for two days; and was shot at into the bargain, at Raccoon Ford, where I unconsciously left the cover and became the target for about twenty sharp-shooters. Luckily I was not touched; but I did some tall riding to get out of the way.'

Theodore Davis has left us with the story of an encounter between Waud and a group of general officers who had chosen a knoll from which to view the progress of a battle some hundreds of yards in front of them. When Waud rode up, General Horatio Wright commanded, 'Waud, you must get off that horse or else move away; you will draw fire over here, and there is quite enough of it already.'

'Good day, gentlemen,' said Waud, and galloped off to the line of battle below them. There he needed to stay only a short time under fire to get all the sketch material he wanted.

Two days later some of the officers, who had watched his moves through glasses, asked the artist haughtily why he had not stayed in the line of battle longer. Waud, as he put it, 'told these button wearers that had they been in my place they would not have gone there to begin with.'

Much of the record of Waud's day-by-day activities in the war we owe to the fact that he acted as war correspondent as well as special artist; his pictures were generally accompanied by text describing the course of the war and his own adventures in it. Thus even on 4 January 1862, some time after Waud had joined *Harper's*, his old paper, the *New York Illustrated News*, was able to publish his delayed account of campaign life for soldiers and artist.

For certain editorial reasons, Waud's sketch of the incident had appeared in the paper a week earlier. It showed the artist crouching behind a pile of cordwood in the company of members of the Garibaldi Guard, a unit named after the Italian patriot, while they watched a column of Confederate horsemen riding close by on scout. Waud explained that, having heard that the rebel pickets usually made 'a grand scout' when going off guard duty, he accepted an invitation from a Garibaldini officer to go with him to a spot where he would have a good view. This was a mile in front of the Northern lines in a nook of the woods among a pile of cordwood.

Soon after sunrise, Waud's hopes were rewarded by first the sound of hooves and and then by the appearance of about two hundred of the enemy. They went by, carbines at the ready, carefully glancing to right and left. Waud wrote: 'The Garibaldini could scarcely restrain a reckless desire to fire on them. If there had been a couple of dozen there they would, I am convinced, have let fly; but four of us, all told, were scarcely justified in making an attack on two companies.'

It represented a rare occasion when a Northern artist was able to observe Confederates at close hand. In September of 1862, however, Alfred Waud was able to give *Harper's* a scoop from right inside the Southern lines. History is somewhat vague on exactly how he was able to cross the battle line. There is a pass signed by Captain John T. Wilson, of the 50th Regiment Georgia Volunteers at Centreville, Virginia, which reads: 'The bearer Alfred R. Waud having entered the Confederate lines under a flag of truce has permission to return to the Federal lines.' Waud, in his subsequent report to his newspaper, referred to 'being detained within the enemy's lines', without any further elaboration.

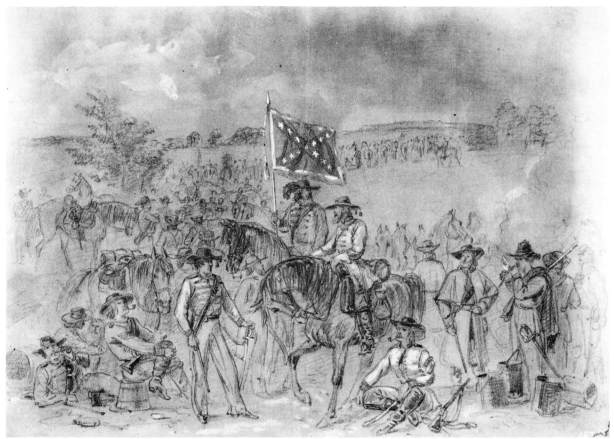

In the event, he drew and brought back with him an historic picture of the 1st Virginia Cavalry at halt, and wrote:

> They seemed to be of considerable social standing . . . for they were not only as a body handsome, athletic men, but generally polite and agreeable in manner. With the exception of the officers, there was little else but homespun among them, light drab-grey or butternut in colour, the drab predominating; although there were so many varieties of dress, half-citizen, half-military, that they could scarcely be said to have a uniform. . . . Their horses were good; in many cases, they told me, they provided their own. Their arms were the United States cavalry sabre, Sharp's carbine, and pistols. Some few of them had old swords of the Revolution, curved, and in broad, heavy scabbards. Their carbines, they said, were mostly captured from our own cavalry, for whom they expressed utter contempt—a feeling unfortunately shared by our own army. Finally, they bragged of having their own horses, and, in many cases of having drawn no pay from the Government, not needing the paltry remuneration of a private. The flag represented in the picture is the battle flag. White border, red ground, blue crosses, and white stars.

The experience was obviously educational for Waud, whose strong pro-Union tendencies led him frequently to describe the Confederates as 'rebel rabble' and 'devilish' in battle. His 'detention' gave him a new respect for the other side, particularly when he realised that the South's fighting men faced even greater

A rare glimpse by a Northern artist behind the Confederate lines: Alfred Waud's drawing for *Harper's* of the 1st Virginia Cavalry, which he was allowed to make and then take back to the Union side under flag of truce. Normally full of vitriolic comment about the Confederates in his despatches from the front, Waud on this occasion was much impressed by the fighting *élan* of the enemy cavalry. (*Reproduced from the collection of the Library of Congress*)

campaign hardships than those he shared through four years with the Federal soldiers.

If anyone doubts that the specials of the Civil War had a tough time, he has only to read the letters they wrote from the battlefields. During McClellan's Peninsular campaign, Alfred Waud sent a letter to a journalist friend in which he mentioned the experiences suffered by himself and his brother William (Will), an artist for *Frank Leslie's Illustrated Newspaper*. He wrote that William had been facing difficulties in gathering sketching material as he then had few contacts in the army, and explained that

> ... about this time I was down with an attack of the bilious remittent fever brought on by exposure to the damned climate in cussed swamps &c. For a month I could scarcely crawl dosed with mercury quinine iron whisky &c till I have learned to hate that fluid and cannot smoke without nausea. However I am well and almost as strong as before in which I am lucky, as numbers of the soldiers have died of the same fever. To return to Will—three weeks ago he had a sunstroke and fell insensible to the ground while visiting Sickles Brigade. Since that time he has been sick, a low fever having used him up ... Will talks of coming home soon, to save his health although he is better than he has been.

Things must have been very gloomy indeed for a man of Alfred Waud's enthusiasm and dedication then to write the following paragraph: 'To tell the truth, no amount of money can pay a man for going through what we have had to suffer lately, and being to my great astonishment alive, I feel a good deal like leaving myself.'

He did not, of course, leave, but saw the war through to the end in a career that has provided us with a unique historical record. His pencil, wash and chinese white impression of Fredericksburg, showing the charge of Humphrey's division on 13 December 1862, brilliantly catches the forward flood of battle into the holocaust of fire awaiting the Federal army. It provided incomparable working material for the engraver in New York; when it appeared in *Harper's* on 10 January 1863, it was to all intents the same illustration, a classic and all too rare example of the artist's line being reproduced faithfully—a tribute to Alfred Waud, master artist.

In the fifties William Waud had followed his brother to New York from London, where he had trained as an architect and helped Sir Joseph Paxton, designer of the Crystal Palace. When Alfred, before outbreak of war, joined the *New York Illustrated News*, William went to *Leslie's* (in the last year of the war, he found himself with Alfred, sketching the Petersburg campaign together for *Harper's*). William's commissions were rather more extensive than his brother's: there is, for instance, a self-portrait of William in 1862, wearing a bowler-hat and standing in the maintop of the USS *Mississippi*, sketching action during Farragut's expedition against New Orleans. In 1865, one of William's assignments was to draw the burial of Lincoln at Springfield, Illinois. He died in Jersey City in 1878. His war sketches lack the intuitive 'feel' for action possessed by his brother, but his eye for architectural detail, stemming from his early training, makes a valuable contribution to the war art of the sixties.

If anyone stands the equal of Alfred Waud in the pictorial coverage of the North during the Civil War, it is his lifelong friend and colleague on *Harper's*, Theodore R. Davis (1840–94). He was twice wounded and on one of these occasions he is reported to have held surgeons off at gunpoint from amputating his leg. He joined

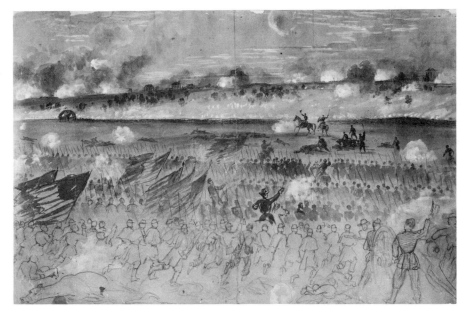

At the battle of Fredericksburg, artist Alfred Waud sketched the gallant charge of Humphrey's division on 13 December 1862. It was an 'outline' sketch of salient points as he saw them that day, but crammed with action and embodying enough detail to allow the home-based artists of *Harper's Weekly* to produce the second illustration (*below*), an engraving of the scene, about a month later. This was an outstanding example of faithful reproduction of an artist's line. (*Reproduced from the collection of the Library of Congress*)

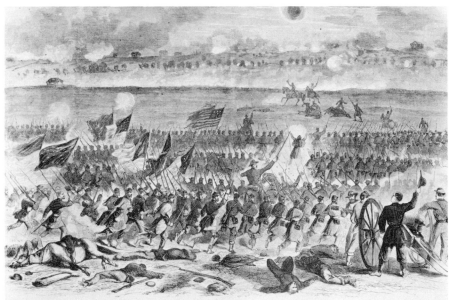

GALLANT CHARGE OF HUMPHREY'S DIVISION AT THE BATTLE OF FREDERICKSBURG.—Sketched by Mr. A. R. Waud.—[See Page 11.]

Harper's in March 1861, and before the outbreak of the war he went on an extensive journey through the South, which he claimed was the most dangerous journey he ever made, as feelings were running high against Northerners. *Harper's*, recalling this journey, later claimed that he made it in the company of William Howard Russell of *The Times* of London; Russell is said to have become angry with Davis for representing himself as a special artist of the *Illustrated London News*, a far safer newspaper than a New York weekly in the simmering and suspicious South of early 1861.

Davis saw the capture of Port Royal, the fight between the Monitor and the Merrimac, the battle of Shiloh, the taking of Corinth, the first bombardment of

Newspapers in Camp.

Edwin Forbes

Edwin Forbes, who produced many interesting scenes of camp life as well as battle illustrations for *Leslie's*, was responsible for this pencil drawing which showed the eagerness with which Union soldiers received the daily newspapers. The North alone is said to have fielded 500 correspondents during the war and *Leslie's* published 3,000 war illustrations. (*Reproduced from the collection of the Library of Congress*)

Vicksburg, the field of Antietam, the surrender of Vicksburg, the seizure of Morris Island, the battle of Chickamauga, the siege and battle of Chattanooga, the Atlanta campaign and the grand march to the sea and thence through the Carolinas. On occasion, notably at Vicksburg, he had his horse shot from under him. He was gregarious and enthusiastic, given to wearing a fringed buckskin suit with two pistols at the belt. He was a good journalist and though he lacked great artistic skills, he was asked in 1879 to plan the shapes and decoration of a state dinner service for the White House. The President's wife, Mrs Hayes, wanted to combine elegance with decoration in an American way. Davis used for his designs the plant and animal life he had known in his lifelong existence in the great outdoors. In six months he made over sixty watercolour drawings at a beach house he converted into a studio, and he kept on the premises a collection of animals, fish, birds and plants from which he drew.

The experience must have been an interesting change of pace for the veteran campaigner, whose career after the Civil War took him west armed with those two indispensable pieces of equipment for a frontier artist, his sketch-book and his rifle. Summing up the techniques and role of a special at war, Davis once observed that most people 'seem to have an idea that all battlefields have some elevated spot upon which the general is located, and that from this spot the commander can see his troops, direct all their manoeuvres and courteously furnish special artists with an opportunity of sketching the scene.'

44

His wartime competitor on *Leslie's*, Edwin Forbes, would have agreed with these words. At an early battle in the Shenandoah Valley Forbes had difficulty in getting near the action and had to make do with sketches of columns of troops marching towards the fight. Later in the war, however, he moved into his stride and noted: 'My idea of witnessing a battle underwent great change. To be a spectator was nearly as dangerous as being a participant.' At Second Bull Run and Antietam he did, in fact, find the legendary vantage-points about which Davis was talking and from them was able to command wide sweeps of the battle terrain. In the Bull Run action he had hurriedly to interrupt his sketching and take flight when the Confederates dramatically stormed the hill from which he was making a panoramic view. Such actions contributed a valuable series of battle scenes to the Forbes portfolio, but he was undoubtedly at his best picturing the soldier's life in camp.

From artists like Davis and Forbes have come not only the pictures, but vivid first-hand accounts of what war was really like. At the terrible carnage of Antietam, Frank Schell, special artist of *Leslie's*, reported finding a group of Confederate wounded, dying and dead on the edge of a cornfield. 'For the Lord's sake get me out of this,' pleaded one young man whose torn leg was fixed with an improvised tourniquet. The man was worried that the battle was about to resume and said: 'I don't want our own boys to ride over me.' Nearby, Schell recorded, 'a gaunt, tall boy sat with dazed and hopeless expression—his ankle shattered and near the corpse of his father, at whose side he had fought since leaving their Georgia home.'

There were, of course, many others, such as Arthur Lumley, Henri Lovie, Fred B. Schell and Winslow Homer, who spent a short time at the front for *Harper's*, but did most of his superb illustrations in New York. And, after Appomattox, when the guns were stilled the specials returned to their city art desks and studios. Frank Vizetelly sought war on three continents. Men like Theodore Davis and Alfred Waud began to look west.

5 Covering the West

Were I or the departmental commanders to send guards to every point where they are clamored for, we would need alone on the plains a hundred thousand men, mostly of cavalry. Each spot of every road, and each little settlement, along our five thousand miles of frontier, wants its regiment of cavalry or infantry to protect it against the combined power of all the Indians

General Sherman in a Congressional report, 1 July 1867

In what is indisputably the most famous incident in the Indian wars of the American West, George Armstrong Custer died with his boots on. That appears to be the only sartorial point on which there is universal agreement by the artists who have drawn, painted and engraved the disaster on the Little Bighorn in infinite variety since it took place on 25 June 1876.

Custer has been depicted in short blue jacket and long hair flowing over his shoulders, though there is evidence that he wore a buckskin riding coat and his hair had been cut shortly before the action. His officers and men have been shown in number one dress with gold cords and shoulder knots, but they were almost certainly in campaign fatigues. Some artists have him facing his final moments with a sabre, some with a revolver, others with both; historians have argued that neither sabres nor swords were carried by the Seventh Cavalry that day. but Two Moons of the Cheyenne afterwards talked about a soldier 'who fought with a big knife', a description corroborated by his Sioux comrade, Rain in the Face.

The point is, of course, that not only was there no special artist on the spot to record Custer's last stand, but there was no white man who survived it. Custer died with his 225 soldiers and the only witnesses to history were the Sioux, Cheyenne and their allies. In peaceful retirement, Two Moons told an interviewer: 'The shooting was quick—pop, pop, pop, very fast. Some of the soldiers were down on their knees, some standing. The smoke was like a great cloud, and everywhere the Sioux went the dust rose like smoke. We circled all around them—swirling like water round a stone. We shoot, we ride fast, we shoot again. Soldiers drop and horses fall on them. Soldiers in line drop, but one man rides up and down the line, all the time shouting . . . I don't know who he was . . . he was a brave man.'

His words have been eagerly grasped by artists who have otherwise relied heavily on imagination. Almost as an afterthought, Two Moons contributed a citation for the bugler, who 'kept blowing his commands . . . he was very brave too', a recollection that has been immortalised in paint and lithography on many a bar-room wall across the United States.

No single event before or since Custer so focused popular interest on the American frontier. For readers of popular newspapers here was the recipe that had whetted appetites before and was to do so again: a golden-haired hero butchered by savages. Custer's death was as shattering to the Americans as the murder of General

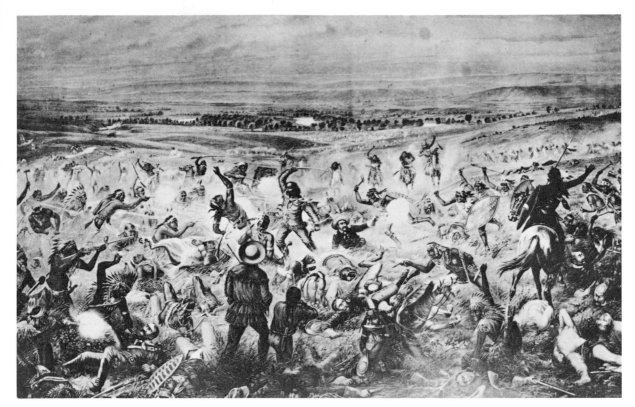

Gordon in Khartoum was to the British a few years later. The utterly unthinkable defeat of the dashing Seventh Cavalry was as traumatic as the massacre by Zulus of an entire British column at Isandlwana in the next decade.

The *Tribune* of Bismarck in the Dakota Territory, whose own correspondent Mark Kellogg died in the battle, headlined its first full account in a special edition: MASSACRED ... NO OFFICER OR MAN OF 5 COMPANIES LEFT TO TELL THE TALE ... SQUAWS MUTILATE AND ROB DEAD ... VICTIMS CAPTURED ALIVE, TORTURED IN FIENDISH MANNER. Atrocities. These were the stuff of circulation building. As the stories spread, elaborated by frontier gossip, the Eastern press hustled expeditions of writer–artist teams westward to catch up with what was happening in the Black Hills and out on the plains. But their efforts were nothing compared with the flood of imaginary accounts and drawings which flowed from pen and pencil.

Clearly, had there been a special artist on the Little Bighorn that summer's day in Montana the chances of any sketches surviving would have been slim indeed. However, judging from earlier experience, their chances might have been higher than those of the artist himself, who would surely have perished as did the soldiers and Mr Kellogg. The hypothesis is given weight by a strange incident some thirteen years before the Little Bighorn which tended to show that the Indian was capable of respecting the pictures the white man drew of the land they both disputed.

On that occasion, an artist who was accompanying a railroad survey, was among those slaughtered when Paiute Indians ambushed the team in Utah. His sketch-book contained much valuable topographical detail. When the authorities let it be known they were anxious to buy back the sketch-book—should it exist—some Indians took

After George Armstrong Custer's column was massacred by Indians on the Little Bighorn in June 1876, artists relied heavily on the spoken evidence of warriors who had taken part in the battle. American artist Cassily Adams depicted Indian savagery in full measure as shown in the detail of a scalping taken from the middle foreground. (*National Archives, US Signal Corps*)

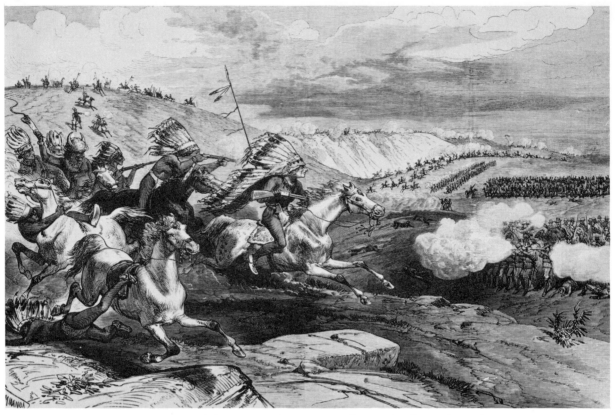

It took *Frank Leslie's Illustrated Newspaper* of New York nearly two months to publish this engraved sketch after General Crook's fight on the Rosebud River in June 1876. The artist, Charles St G. Stanley, patently drew on a contemporary soldier's description of Crook's Sioux assailants: 'They were in front, rear, flanks, and on every hilltop, far and near.' The proliferation of full war bonnets raises doubts as to whether artist or engraver ever saw Indians in action. (*Reproduced from the collection of the Library of Congress*)

it to a Mormon settlement near Salt Lake City. No such contemporary picture reportage remains from the Custer massacre. Any officer or enlisted man with artistic aptitude would have had little if any opportunity for sketching, so quick was the crucial onslaught of the tribes.

There might be every reason to suppose that the great picture newspapers such as *Harper's Weekly* and *Frank Leslie's Illustrated Newspaper* would keep large staffs in the West, particularly during the Indian troubles which followed the discovery of gold in the Black Hills. And, indeed, there was graphic, if at times over-imaginative, coverage of army forays, such as General Crook's manoeuvring in Sioux country in 1876. It was hardly surprising that artists' imagination flowered, so confused was the picture presented by the military authorities themselves. A colonel who took part in Crook's 'battle' on the Rosebud River in June 1876 conjured up a scene of mass carnage when he talked about the Sioux 'charging boldly through the soldiers, knocking them from their horses with lances and knives, dismounting and killing them, cutting off the arms of some at the elbows in the middle of the fight and carrying them away'. Yet Crook's dead in this fight numbered no more than twenty-eight out of a force of 1,200. The campaign was said to have cost the government of the United States one million dollars for every Indian killed, although this hardly tallies with the admission of Crazy Horse of the Sioux that he lost thirty-six warriors on the Rosebud alone. In any case, newspaper subscribers preferred to read versions such as the one by the horrified colonel to sobering economic and political facts, and artists drew their pictures accordingly.

To what degree, then, was there eye-witness newspaper coverage of the West?

48

Frontier reporting was no simple matter. The problems which faced the news and art desks were not unlike those voiced by General Sherman at the beginning of this chapter. It was all a question of being on the spot, in the right place at the right time. And with five thousand miles of moving frontier to cover for news and pictures, the editors' resources were always under strain.

Although the American western frontier was, so to speak, on the doorstep of the expanding centres of population, in many ways the British and other European picture newspapers had an easier task in illustrating remote campaigns in Africa and Asia. Once lines of communication had been established, the roles of a Simpson in Abyssinia or a Prior in Ashanti were relatively straightforward in accompanying military expeditions with simple and contained objectives. It was a different matter to watch a vast new territory, where news could bubble and explode anywhere at any moment.

Thus special artists' forays into the West tended to develop in a pattern established by some of the pioneers in the 1840s, a pattern of planned expeditions of limited duration and objective: the artist often accompanied an official or corporate mission or survey team. In picture-record terms these expeditions invariably produced a wealth of valuable social material for conteporaneous publication and for the archives, but whether they provided eye-witness reportage of Indian wars—which is the theme of this chapter—more often than not depended on the luck, or misfortune, of the particular expedition.

In the early years of the century artist George Catlin (1796–1872) roamed the great plains on a horse called Charlie, painting the Indian in what we now know was his vanishing glory. His works were not for magazines, however. He visited nearly fifty tribes and completed six hundred paintings which he exhibited in the East and in Europe. Lithographs were the nearest he achieved to mass circulation. But the groundwork he had accomplished was enough to excite wider interest in the vast territory and its inhabitants that lay west of the Mississippi. And the key to this land was the railroad.

There was not one mile of rail west of the Mississippi in 1850. A census in California revealed its population to be 93,000, of which two-thirds described themselves as miners; only seven thousand females were recorded. Between that west coast territory and the eastern states was a wild, largely uncharted expanse through which the coast-to-coast rails would eventually run, and it was the duty of survey teams, usually accompanied by a topographical artist, to explore these regions to plot the possible routes.

To this background, a survey artist, John Stanley (born in New York in 1814), found himself with the distinction of being one of North America's first war specials. As early as 1842 he had gone West to draw Indians. Four years later he was side-tracked into covering the Mexican war and he set off from Santa Fé with Colonel Stephen Kearny's column for California. There he sketched the battle of San Diego and several of his sketches were lithographed and reproduced in Kearny's report. The fifties found him on the plains, drawing endless herds of buffalo, whose own demise was prophetically pictured in the flag carried by one of the railroad survey parties which Stanley accompanied: it showed a locomotive running down a buffalo, with the slogan, 'Westward Ho!'

Like several fellow artists, Stanley had to find his own publishing outlets in those days before the rise of an organised illustrated press. A Cincinnati exhibition of his sketches in 1846 was advertised in these terms: 'This collection can be seen by gas

light as well as day light.' The year 1855 found him presenting a huge panorama based on his western sketches. It consisted of forty-two episodes and took two hours to view. In Washington, Baltimore and Boston, the public paid 25 cents to see the panorama and a further 10 cents for his handbook, *Scenes and Incidents of Stanley's Western Wilds*. In some ways, these panoramas were the precursors of the picture papers; certainly they were crowd pullers wherever they were staged. In New York, one panorama exhibitor invited the public to take 'the Overland Route to the Pacific in 40,000 feet of canvas'.

For any early artists of the West who had the slightest literary inclinations it was natural and inevitable that they would write about their experiences for the benefit of the growing readership back East. It was, sadly, a far from discriminating public, and fiction often outpaced fact in tales of how the West was being won. If, however, fiction was the literary stock in trade of artist and novelist Balduin Möllhausen (H. B. Möllhausen), who wrote forty-five books and has been called the German Fenimore Cooper, his own experiences on a sketching expedition to the Rocky Mountains in 1851 were as adventurous as some of those he invented for his novels.

In the teeth of a blizzard on the plains, the eastbound stagecoach for Independence, Missouri, came across Möllhausen and his companion, Prince Paul of Württemberg, a most unlikely pair to be found stranded and horseless in Indian country in the depths of winter. Their expedition to the Rockies having been prematurely abandoned, their horses killed by Indians or dead in snowdrifts, the two German travellers were trying to hitch a lift back to civilisation. There was unfortunately room only for one more person aboard the stage, and the prince won a draw of lots, leaving Möllhausen with the promise that he would bring help. It never materialised.

The artist spent two winter months encamped on the plains, fighting off and eating wolves. Two Pawnee Indians spotted his camp and crept in for the kill, but Möllhausen had arranged a clever ambush and shot them both dead from cover. Finally he was taken to safety by friendly Indians, together with his valuable sketch-books which contained a remarkable record of survival in the wilds. These he published as lithographs.

Richard Kern, the artist whose sketches were turned over to the Mormons by Indians, was less fortunate. He was in a group of twelve which had become detached from the main railroad survey party in Utah in 1853. In the dark before dawn the group was jumped by Paiute Indians who crawled up to the bivouac unseen and let fly with a shower of arrows and bullets. The leader of the party fell with fifteen arrows in him. Seven others were killed and mutilated, including Kern, who, incidentally, was one of three artist brothers, two of whom met their deaths at the hands of Indians. Today he might have been forgotten had it not been for the strange way in which his sketches were retrieved from the loot of the Paiute war party.

The West was poised for huge expansion in the early sixties when civil war broke out. Many special artists cut their teeth in the war and several of these naturally gravitated to the West in 1865 when a great tide of immigration, moving over the plains to the Rockies and beyond, gave promise of fresh and exciting copy. In the boom towns of the frontier, in the polyglot nature of the immigrants, in the lawlessness and lawmaking of the West, there was a wealth of material to be illustrated for the flourishing New York weeklies.

The sheer impact and diversity of the West's geography, the endless plains,

canyons, mountains and deserts, with their peculiar rock formations, were a heaven-sent backdrop for artists depicting the Indian. The country in which the Indian found his habitat was a constant source of as much wonderment to the reader as the activities of the savage himself. Thus British subscribers of the *Illustrated London News* were treated to a two-page spread of the jagged lava beds of Tule, northern California, during the Modoc Indian war of 1873, with the participants merely minute denizens in a moon landscape (the drawing was by William Simpson, who had become a full-time *Illustrated London News* artist in 1866, and had been des-patched to seek colour in North America).

American special artists such as Theodore Davis of *Harper's* looked to the West for the sort of action they had found in the Civil War: they knew it would not be difficult to find as the advance of an alien civilisation elbowed the Indian out of his traditional tribal lands.

A few months after the last shots of the Civil War had been fired, *Harper's* ordered Davis west in the early winter of 1865. Armed with his sketching materials and a Ballard rifle, he boarded the Butterfield stage at Atchison on the Missouri, which marked the westernmost limits of railroad expansion. In a party of four passengers—'four people entirely innocent of any knowledge of the plains,' said Davis—he was looking forward to any action they might meet on the scheduled five-day overland journey to the mining communities of Colorado territory. Fifteen days later when the battered Concord stage rolled into Denver, Davis and his compan-ions could justifiably claim to be seasoned veterans of the plains and he had a portfolio of sketches ready to be despatched to his art desk in New York. They showed graphically just what it was like to fight Indians at close quarters.

The bizarre moon landscape of the Lake Tule lava beds of California form the back-ground for William Simpson's engraved sketch of an incident in the Modoc Indian wars, published in the *Illustrated London News* in 1873. He wrote scathingly of his American competitors: 'Pictures have come out in the New York illustrated papers, but they are very unlike the reality of the Lava Beds. These illustrations may be said to be evolved out of inner consciousness of artists who have not been on the spot . . . for I was told on my arrival that there was no correspon-dent of an illustrated paper with the expedition.' (*Reproduced from the collection of the Library of Congress*)

The journey began uneventfully. Davis, whose Civil War foraging experience was quickly recognised by his companions, was voted cook. He discovered that dried buffalo strips made excellent fuel. At night, because of the cramped conditions inside the stagecoach, he slept on top as it bucked and jolted along the trails. Three days out, the party was joined by a *New York Times* reporter, L. K. Perrin, who had escaped when his own stagecoach was ambushed by marauding Indians, and after an uneasy night camping out in the open, the group moved off westward accompanied by a small cavalry detail and an ambulance waggon.

As the convoy approached Smoky Hill Springs, a Butterfield relay station, Davis shouted a warning; he had seen a war party bearing down on the coach, about sixty yards away. The reporter, Perrin, wrote his account of the subsequent action for the *New York Times*, but let us take Davis's story as he told it in the *Rocky Mountain News* of Denver a fortnight later. It is written partly in the third-person style preferred by some special artists in those days.

Mr D. [Davis], the moment he gave the alarm, picked up his rifle and sent its contents at the most gaudily gotten up Indian, who not liking the dose ran off. On the other side of the coach, Gen. Brewster (a Butterfield executive) was peppering away at a white man, who seemed to be the leader of the party, a half-breed. This reception the Indians did not like, so ran off. We had by this time reached the station with the coach, when we saw that another band of 'red skins' had gone for the stock. Seeing this, one of the stock herders, a brave man, had made an effort to drive the stock toward the station. While doing this, one of the Indians had charged on him, driving arrows at him in the meantime. The Indian was within a few paces of the stock herder when Mr Davis sent the interior arrangements of his Ballard rifle into Mr Indian's back, causing a series of very curious gyrations on the part of the Indian who was tied to his horse . . .

The incident was followed by a truly Western-style siege by the Indians which lasted all night and in which the passengers, crew and escort manned windows and loopholes at the stagecoach station. Rescue came, as it should, with daybreak and the sound of bugles heralding the arrival of the US Cavalry. It was the stuff of dreams for Davis's editors in New York, though communications difficulties and a certain lack of editorial pace (New York's illustrated press was not yet geared up to the swift publishing achievements of London's) accounted for a delay of nearly two months between the artist's arrival in Denver and the publication of the pictures in *Harper's Weekly*. One of his sketches was given a full page and was captioned, 'On the Plains—Indians Attacking Butterfield's Overland Dispatch Coach'.

For a campaigner like Davis, metropolitan assignments in New York were irksome and a few months after his return to the East he was glad to take the road again in the spring of 1866 when *Harper's* sent him to make a survey of the South in the aftermath of the Civil War. Throughout the war years Southern scenes had been comparatively little pictured in the Union newspapers. A measure of the interest in the former Confederacy was *Harper's* decision simultaneously to despatch Davis's old Civil War comrade, Alfred Waud, on a similar mission. Both crossed the Mississippi independently of each other and included Western pictures in their portfolio, some of which they relied on in later years to reconstruct Western scenes to order from their New York drawing-boards.

There was to be one more major excursion into the West for Davis. Shortly after he returned from his Southern assignment, he met Fletcher Harper, the magazine's

'commander-in-chief', on Broadway. Harper asked: 'Why are you not with General Hancock's Indian expedition?' Davis later claimed in a magazine article on his life on the plains that it took him only half an hour to pack his 'sketchbook, pet Ballard, and a few minor necessaries' and set off for Kansas.

There, in the spring of 1867, William Scott Hancock had mounted a show of force that was designed either to awe the tribes into peaceable ways or to quell them by arms. In the event, the operation turned into farce as heavily armed infantry, cavalry, artillery and waggon trains trundled across the endless plains in pursuit of will-o'-the-wisp Indians. 'Talk about regulars hunting Indians!' said a frontiersman, quoted in the *Weekly Union* newspaper of Junction City, Kansas. 'They go out, and when night comes they blow the bugle to let the Indians know they are going to sleep. In the morning they blow the bugle to let the Indians know they are going to get up. Between their bugle and their great trains, they manage to keep the red-skins out of sight.'

Davis caught up with the Hancock expedition after yet another stagecoach adventure (he was becoming something of a specialist in overland stage survival). This time his coach became stuck in a late snowfall and he and the 'shotgun' messenger decided to stay with it while the driver unhitched the mules and rode off for help at the next station. The marooned pair spent a night in freezing temperatures, sustained by 'corn in two states'—liquor and a can of solid, half-cooked corn—before rescue came.

In the theatrical military manoeuvres which followed on the plains, Davis was joined by the reporter Henry Morton Stanley, then working for the *New York Tribune*. Both did their best to report the pantomime being played out in Kansas and Nebraska, but the lack of close contact with Indians forced Davis to resort to that good old special's standby, 'scenes of camp life'. If the campaign had its ludicrous overtones, however, there were moments of tragic reality. Davis was with a column commanded by Custer when it discovered the remains of Lieutenant Lyman Kidder and ten men. They had been sent by General Sherman with messages for the Seventh Cavalry, then under orders to kill as many Indians as possible and to bring in as prisoners the wives and children. Kidder, surprised by Pawnee Killer of the Sioux, had made the mistake of trying to run for it, instead of standing and relying on the firepower of the troopers' carbines. The endurance of the Indian ponies had told in the end, and after ten miles every man of Kidder's party was brought down, butchered, scalped and mutilated. Kidder's men managed to kill two Sioux, the only 'victories' that Custer, the spearhead of Hancock's campaign, was able to claim after 1,400 troops had covered 1,000 miles searching for Indians. Meanwhile, two hundred whites were dead in homesteads and on the trails of Kansas.

This was the decade that produced the statement attributed to General Sheridan that 'the only good Indian is a dead Indian', a view that was much in favour on the frontier and among many in the East. A typical diatribe against the Indian was published in the *Topeka Weekly Leader* of 27 June 1867, as Hancock and Custer marched and counter-marched in Kansas and Nebraska. The Indian, hissed the leader writer, 'his squaws and papooses, and his relatives and tribe' were 'a set of miserable, dirty, lousy, blanketed, thieving, lying, sneaking, murdering, graceless, faithless, gut-eating skunks as the Lord ever permitted to infect the earth, and whose immediate and final extermination all men, except Indian agents and traders, should pray for . . .'

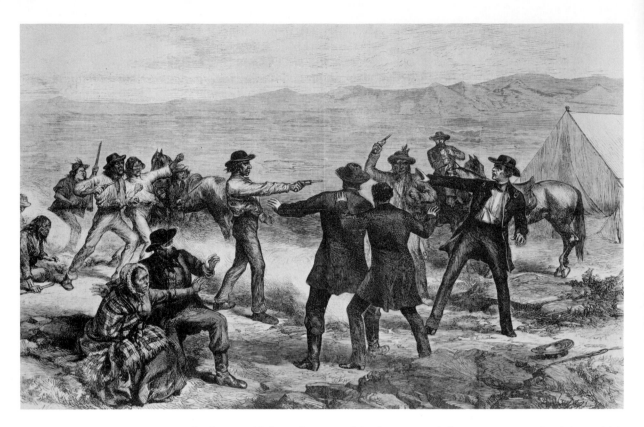

At peace talks aimed at settling a dispute with dissident Modoc Indians in the early 1870s the chief, Captain Jack, shot and killed General Canby. William Simpson reconstructed the event for the *Illustrated London News*. He covered the Modoc Indian wars on the spot, had seen the Indians, and drew them as they appeared—in rough trade store clothes and 'cowboy' hats, not buckskins and feathered war bonnets. (*Reproduced from the collection of the Library of Congress*)

Such genocidal sentiments might be expected from an organ of opinion which merely mirrored the outlook of its frontier readers, many of whom genuinely feared for their lives as the recalcitrant tribes struck time and again with apparent impunity. But the tenor of the *Topeka Leader* writer was often matched by the views of important East Coast dailies. The illustrated papers in America and abroad missed no opportunity to present evidence of Indian treachery and mayhem.

A typical example was a scene that went round the world of the murder of General Canby and the Reverend Thomas while attempting to hold peace talks with dissident Modoc tribesmen in 1873. It was drawn by William Simpson—'up to the present time I have had the field all to myself for artistic purposes.' He had been sent by the *Illustrated London News* to a strange war in which fewer than fifty Modocs kept 600 soldiers at bay in the lava beds of northern California.

So virulent was the lore of the 'savage red man', peddled by the news and pulp merchants of New York, that it was hardly surprising that the hatred of the Indian spread across the Atlantic. As late as 1891, a columnist who wrote 'Our Note Book' in the *Illustrated London News* fulminated in these terms:

An Indian brave, once famous on the warpath, has, we are told, become a Sunday-school teacher. He used to be called 'the terror of the West', but now he is the Rev. Mr Somebody. Everybody who is neither a child nor a teacher in the same academy is charmed with this intelligence. It is justly entitled 'a triumph of missionary enterprise'—so far as it goes. But this is just one of the cases when it is imprudent to halloa until you are out of the wood. 'Call no one happy,' says the classic proverb, 'till he is dead, and had a genteel burial.' If I were at that

Sunday-school I should never call myself happy until this gentleman had paid the debt of nature . . . One can never be sure that a gentleman of such pronounced habits will not 'break out again'.

To return to 1867, the Hancock débâcle on the plains was reflected in a fierce outcry in Western newspapers. The *Weekly Union* disparagingly referred to the return of the expedition as 'gameless, scalpless . . .' In Washington controversy raged over what the army's policy should be in Indian country. In the end, however, as many observers have pointed out, it was the buffalo killers, not the soldiers, who finally rid the great plains of the Indian.

Davis could not have escaped noticing the truth about Hancock's Indian war. But his drawings, as they appeared, captioned, in *Harper's* during the following months, had a palliative quality that was more in keeping with what *Harper's* editors felt the public *should* know, rather than what had actually happened on the plains that summer. 'The Coach in the Storm' was a valid contribution from personal experience of Western travel. On the other hand, issues portraying 'Lodges of the Chiefs in the Indian Village Captured by General Hancock' and 'Camp Pets of the Seventh United States Cavalry' undoubtedly gave rise to some ripe frontier epithets when they eventually arrived in the far reached of Kansas.

In the years following his excursion of 1867, Davis leaned on his memory and his sketch notes to produce many Western illustrations for *Harper's*, as did Alfred Waud. Waud's last sketches appeared in the magazines about 1882 and he spent his final years in failing health; he died in April 1891. His wartime colleague Davis survived him by three years, having contributed to *Harper's Weekly* until about 1884. As specials, they had been justly proud of their reputations as eye-witness reporters; when their battle scenes were described as having been 'sketched on the spot', the caption meant exactly what it said. In the seventies, when so much in the huge frontier canvas demanded pictorial interpretation, the sketches of city-bound artists were not always handled with the circumspection that could have been desired.

Davis, for example, included among his illustrations scenes from the battle of Washita which purported to show fierce hand-to-hand combat between Custer's men and the Indians on 27 November 1868. Actually, Custer had descended on a sleeping, unsuspecting village at dawn and routed the Indians, killing many women and children in the process, before organised resistance of any sort could be offered. Davis's view—which admittedly laid no claim to be an eye-witness version—must have come straight from his imagination. In any case, he was indisputably in the East about the time of the battle, producing a sketch of the scene of a murder in Philadelphia. Whatever codes of professional conduct the editors transgressed, however, their offence was mainly one of omission—in not making it clear to the public that the sketch was merely an imaginative impression of the incident. But more flagrant examples were to follow in the eighties when the craze for Western lore and illustration was at its most fevered pitch.

Robert Taft, a former professor at Kansas University who published a vast amount of research on frontier illustrators in the *Kansas Historical Quarterly* and later as a book, *Artists and Illustrators of the Old West*, has uncovered a blatant fake of this period. His revelations concern the artist Charles Graham (born in Illinois in 1852) who contributed often to *Harper's Weekly* in the eighties. Graham made many trips to the West, but he was most certainly not there when, in 1887, he produced a

Classic Western situation: Apache ambush of waggon, as depicted by the incomparable Frederic Remington who covered the frontier for *Harper's Weekly* with a photographic eye for detail. (*National Archives, US Bureau of Public Roads*)

front cover for the magazine, entitled 'In Pursuit of Colorow', a Ute chief on the warpath. Graham had been to Colorado, he knew the scenery and he had most obviously kept adequate sketch notes for future use. A few months later an entirely different incident was illustrated in almost the identical background, and this was labelled 'taken on the spot by one of our own artists'.

Taft, an indefatigable tracker of references and evidence, has similarly exposed a lapse involving the work of the great Frederic Remington, the special artist who illustrated the Western scene until after the close of the century. A Remington sketch of the burial of Apache victims appeared in *Harper's Weekly* on 25 September 1886, and was captioned as a drawing 'made on the spot', despite the fact that Remington did not arrive on the scene of that particular campaign until several months later, according to his diary. Nevertheless, when he did arrive, he found the Apache a perfect subject for his art, which he summed up in these terms: 'I paint for boys, from ten to seventy.'

Lapses in faith on the part of *Harper's* editors were certainly contrary to normal practice and the standards of illustrated journalism. In the historical context, as Taft points out, they are to be deplored, but were *Harper's* crimes any more regrettable than the system which flourished on both sides of the Atlantic and which allowed home-based artists to 'work up' specials' field sketches into glorified parodies of the original scenes and incidents depicted?

Change followed rapidly in the wake of the transcontinental railroads after the joining of the rails at Promontory Point, Utah, on 10 May 1869. Oddly enough,

56

there was no special artist on the scene from either *Leslie's* or *Harper's* on this historic occasion. But *Leslie's* was quick to make amends in entraining on a coast-to-coast assignment Joseph Becker, a former picture-desk messenger-boy who became a special in the Civil War. In the course of Becker's trip, *Leslie's* advised its readers: 'The numbers of *Frank Leslie's Illustrated Newspaper*, since the commencement of the publication in its pages of scenes and incidents met with by our artist in his journey to San Francisco, are especially valuable, and should be purchased and carefully filed for future reference by all who have an intelligent idea of the future of this continent.'

Four years later, the wheel had turned full circle and *Harper's* boasted that two artists, Paul Frenzeny and Jules Tavernier, on a journey to the Pacific would 'make long excursions on horseback into regions where railroads have not yet penetrated . . .'

In 1877 wealthy publishing tycoon Frank Leslie, whose *Illustrated Newspaper* was selling 400,000 copies, hired a whole train for a coast-to-coast expedition. He fitted it with a sumptuous Wagner sleeping-car and took with him his wife Miriam, and cohorts of writers, special artists and photographers. This was 'doing the West' in luxury. Those were the days of shooting buffalo from trains, the days of the Indians' vanishing paradise.

Everyone, it seemed, was 'going West'. There was the remarkable case of a special artist, William Rogers, who was assigned by *Harper's* to cover a presidential visit to Minnesota State Fair in St Paul in 1878; there, he fell under the spell of tales spun by a Westerner and, unauthorised by his editors, took off on his own initiative for the Dakotas. He went thousands of miles by stagecoach, train, river boat and horse, and finally reached Canada where a three-month-old telegram caught up with him: 'COME BACK AT ONCE'. Firing awaited him in New York, but when Fletcher Harper saw the mass of material from his trip—sketch after sketch of Indian and frontier life, which Rogers displayed on the editorial desk—the errant artist was forgiven, and his drawings formed the basis of a successful career. Not for the first time a young man had gone West and discovered fame and fortune.

The fact that William Rogers's travels took him to Canada cannot necessarily be attributed to the results of aimless wandering. There was plenty there to attract the Western artist. The aggressive thrust of American settlers and miners, supported by military force, pushed many Indians, including Sitting Bull of the Sioux, north of the 39th Parallel. It was as though the centre of gravity of Indian activity had moved up into the traditional grounds of the Canadian Blackfeet, Assiniboine and Cree.

Canada, too, was spawning a small but successful illustrated newspaper industry. The *Canadian Pictorial and Illustrated War News*, as it appeared in the final quarter of the century, left no one in doubt about the kind of war it purported to illustrate. The masthead, much more strident and adventurous in theme than any in Britain or the US, showed a military cannon being fired at a group of Indian tepees from which braves with rifles were emerging. Its pages dealt graphically with Canada's own problems as the western spread of civilisation was confronted with hostile Indians and rebellious half-breeds.

Henri Julien, a special artist for the *Canadian Illustrated News*, accompanied the Canadian Mounted Police on their march to the West in 1874 to bring the law to a wild and largely ungoverned territory. He travelled as far as the Sweet Grass Hills of southern Alberta and produced a useful, historical picture record of the Mounties' progress. From there, the pictorial record was taken up by Richard Barrington

Front page of the *Canadian Pictorial and Illustrated War News* on 23 May 1885, when the redcoats were taking the law Westwards to the slope of the Rocky Mountains. This engraved illustration was entitled 'A look-out on the Qu'Appelle Trail'.

THE CANADIAN PICTORIAL
& ILLUSTRATED WAR NEWS

PUBLISHED BY THE GRIP PRINTING AND PUBLISHING COMPANY, OF TORONTO.

VOL. I. · No. 8. · TORONTO, SATURDAY, MAY 23, 1885. · 15 CENTS PER COPY.

A LOOK-OUT ON THE QU'APPELLE TRAIL.

Nevitt, an assistant surgeon on the expedition with a talent for drawing and painting (born in Savannah, Georgia, 1850). After the harsh prairie, Nevitt found the Sweet Grass Hills and the land beyond a welcome relief. He wrote in a letter:

> We have passed through a country dry, desolate and barren, a very Sahara. It was the northern portion of the Great American Desert; but now we have, fortunately, come into a country that shows, even in this late season, evidence of great fertility. We are just near the base of the Rocky Mountains; their snow-capped summits rise up to our left in jagged rough peaks; the sun sinks behind them every night in a blaze of glory making the most gorgeous sunsets that I have ever seen.

He drew waggons piled high with buffalo robes, pulled by teams of ten oxen, Kootenay Indians resting on the prairie ('the central figure is engaged in the most disgusting operation of catching lice and eating them'), early forts, trappers and voyagers. Many appeared in the *Illustrated News* in due course. War scenes were not forthcoming on this trip. For action, Nevitt had to make do with white-helmeted Mounties smashing cases of whisky and pouring it away after the arrest of a gang accused of peddling spirits to the Indians. The law was moving West and, in Canada, where it was represented by the Queen Mother's red-coated Mounties, clashes between white man's rule and red man's independence furnished the stuff of special artists' illustrations through the eighties. But, slowly, the West was changing.

What, then, remained of the old frontier when Frederic Remington (1861–1909) came to draw it? He was aware that the frontier was fast disappearing: when he drew such pictures as 'The Last Stand', they were a requiem for the West itself. So at the age of nineteen he eagerly grasped the opportunity to see the West when he was left with a comfortable legacy on the death of his father, a newspaper owner in upstate New York. He tried sheep ranching in Kansas, worked with cowboys and learned to ride like an Indian. He had trained in art and liked sketching. His first work appeared in *Harper's* in 1882; he had sketched it on wrapping paper and it was redrawn by a staff artist, but it was a start. When he died he had completed 2,739 pictures, including illustrations for 142 books, eight of which were his own.

As a newspaper special artist he recorded the day-to-day transformation of the Western scene, the expansion of the railroads, the rise of the cities, the coming of the motor car. He hated metropolitan life and metropolitan art: turning down the suggestion of a European trip, he wrote to a friend, 'I should not try Europe again. I am not built right—I hate parks—collars—cuffs—foreign languages—cut and dried stuff'; and once, having let himself be waylaid into a New York art gallery exhibition of Impressionist paintings, he snapped as he left, 'Say, I've got two maiden aunts upstate who can *knit* better pictures than that.'

Life to Remington was riding with a scouting party after renegade Apaches in Arizona or following a herd on the plains. He was never happier than when in the saddle. When, much to his sorrow, his huge bulk scaled over 300 pounds and no mount could carry him, he had his studio built with barn doors large enough for horses to enter so that he could draw and paint them from life.

A vivid description of the horseback artist comes from Lieutenant Alvin Sydenham, a cavalry officer who met Remington while scouting for hostile Cheyenne on the Tongue River, Montana:

> We first became aware of his existence in camp by the unusual spectacle of a fat civilian dismounting from a tall troop horse at the head of a column of cavalry. The horse was glad to get rid of him, for he could not have trained down to two

Many special artists portrayed the Indian as a murdering savage. Frederic Remington was an outstanding exception. The dignity of a vanishing race shone through many of his pictures, such as this one which he called 'The Truce'. (*National Archives, US Bureau of Public Roads*)

hundred pounds in less than a month of cross country riding on a hot trail. Remington wore a brown canvas hunting coat, with swollen pockets that emphasised his rotundity. In contrast, his legs were cased in black cord riding breeches and shapely riding boots of the Prussian pattern, set off by a pair of long-shanked English spurs. Between his lips were the remains of an ample cigar.

Remington grabbed Sydenham's hand. 'Sorry to meet you, Mr Sydenham,' he barked. 'I don't like second lieutenants—never did. Captains are my style of people—they lend me horses.' Nevertheless, the two became friends, and the cavalry officer noted the artist's way of working in the field:

> There was no technique, no 'shop' about anything he did. No pencils, no notebooks, no 'Kodak'—nothing, indeed, but his big blue eyes rolling around at everything and into all sorts of queer places. Now and then an orderly would ride by, or a scout dash up in front of the commanding officer's tent. Then I would see him look intently for a moment with his eyes half-closed—only a moment and it gave me the impression that perhaps he was a trifle nearsighted.

> It all went into memory and later, by lamplight in a tent, Remington would sit down with a bottle of whisky—he was a prodigious drinker—and draw the West as only he could. And, above all, in drawing the West, he drew the Indian with the dignity he merited.

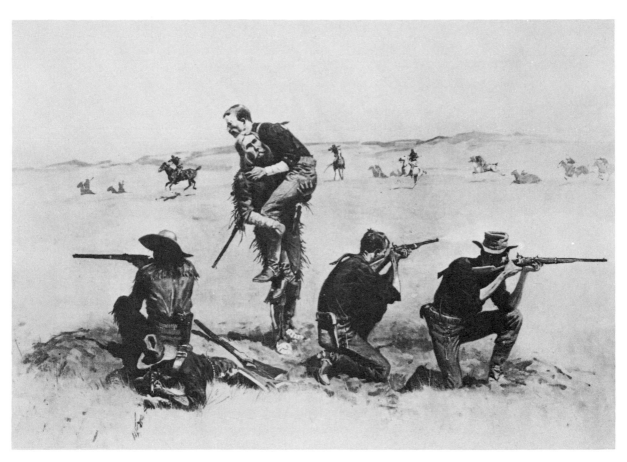

'The Last Stand': Frederic
Remington at his best in a
characteristic Western shoot-
out. 'I paint for boys, from
ten to seventy,' was how he
summed up his approach to
art. He brought the West to
life in a prolific output of
pictures, which had topped
2,700 when he died in 1909.
(*National Archives, US
Bureau of Public Roads*)

6 Artists Under Siege

If this reaches you it will apprise you that I sent off on Monday morning by a private balloon about half a dozen sketches . . . I have arranged to send all sketches in triplicate, in the hope that one out of three will come to hand

Special artist in Paris, October 1870

'The dreadful game has begun in earnest,' announced the *Illustrated London News* in the high summer of 1870. War had broken out between Prussia and France, 'a needless war commenced under false pretences', said the magazine. The fires of war were fuelled by the traditional rivalry of Europe's two great powers and stoked by a mindless dispute over succession to the Spanish throne, and now two of the largest and most sophisticated war machines in the world manoeuvred for advantage on the border of Germany and France.

There was little in correspondents' despatches from Paris in those early July days to foreshadow France's impending catastrophe. Under the heading 'Paris Fashions for July', the *Illustrated London News* gave this information: 'A favourite style of costume at the present moment consists of a light silk under *jupe à la frou-frou*—that is, with an innumerable quantity of small pinked flounces, and a low corsage of the same, covered with a short muslin tunic opening to a point at the breast, and having skirts either rounded off in front or else open at the sides, the trimming consisting of Valenciennes lace.' A month later the fashion report came from various *bains de mer*, not because of the war, but because of the season.

In less than six months, however, reporters inside besieged Paris were retailing drastically different facts. From the city where domestic and zoo animals were being shot for food, Henry Labouchère of the London *Daily News* advised his readers that cat tasted 'something between rabbit and squirrel' and that kittens smothered in onions were excellent; donkey was like mutton and even rats could be made palatable by resourceful cooking. Elephant from the zoo was a rare delicacy. 'I had to wait hours for my ration of horse, which I had to gobble raw, for want of fuel . . . For supper we tightened our belts and smoked,' wrote John Augustus O'Shea, another correspondent.

The intervening six months had seen France reel under a series of staggering defeats inflicted on its much trumpeted, but under-gunned and badly generalled army. There were reverses in Lorraine and Alsace, Metz fell under siege, an enormous French army capitulated at Sedan, Napoleon III was taken prisoner and the Prussian forces drew a ring of steel round Paris. The year ended with the besieged capital under a republican government of national defence and the spring saw war between the Commune and the Versailles forces.

War had proved how profitable it could be for newspapers during the American conflict which had ended half a decade earlier. As Prussia and France mobilised, the British and American press hastily commissioned and equipped an army of corre-

Jules Pelcoq was a French artist employed by the *Illustrated London News* to cover Paris under siege by the Prussians. He is believed to be the author of this sketch of the killing of a zoo elephant for food. It was sent out by balloon and appeared as a wood engraving in the winter of 1870. ('*Illustrated London News*')

spondents and special artists to cover a fight which had many attractions from a newspaper point of view. It was a war, the first of its kind since the Crimea, involving large European armies; it was safely away from the centres of American and British reading population—an event to feed vicarious interest at the breakfast table; and it was conveniently placed so that it could be recorded with all the advantages of improved communications, such as the increasingly used telegraph, fast trains and more efficient postal services, and, eventually, aerial transport in the form of balloons, widely employed to send news and pictures out once Paris was isolated.

Prussia, fired by the 'blood and iron' policies instilled into the nation by Bismarck, was eager to show off its modern army and extended a warm welcome and facilities to reporters and artists. Here was an opportunity to turn newspaper interest into a valuable propaganda weapon, and many correspondents fell into the trap of news management, as much a danger to press freedom as censorship itself. It was difficult to resist the temptations of a system which even went as far as giving reporters and artists notice of bombardments and attacks so that news and pictures could be prepared in advance to catch the deadlines for postal collection. On the other hand, the French army adopted a hostile attitude to correspondents. Spy mania was rife in the forward and rear areas and many artists, whose physical act of drawing made them vulnerable, were seized and beaten by French mobs or arrested as spies. One was arrested no fewer than eleven times.

In July 1870 few could visualise the outcome of the war, and it was necessary that both sides should be covered by the picture newspapers. William Simpson of the *Illustrated London News* chose the French side initially simply because he could speak that language; for the similar reason that he could understand German, Archibald Forbes, employed on a 'pay if used' basis by the *Morning Advertiser*, reported the war from the Prussian side. (Later he switched to the London *Daily News* at £20 a week, much to the lasting benefit of that newspaper whose circulation trebled in the war.)

The fivepenny *Illustrated London News* had no doubts about the circulation-building power of wars. It announced: 'The arrangements which have been made to supply this journal with illustrations of the war, by the employment of several artists whose ability to delineate military subjects has been proved in former campaigns, will ensure the full and faithful representation of its most remarkable scenes and incidents.' The newspaper's team included Simpson, Robert Landells (another Crimean veteran), George Andrews and C. J. Staniland; and there was Frenchman Jules Pelcoq, whose work, flown out of besieged Paris by balloon, was usually bordered with a mass of scribbled instructions to the engraver in French. The *Graphic* fielded, among others, Sydney Hall. Henry Mayhew, assigned as a war correspondent by the *Standard*, took along his son, barely out of his teens, to help him. The British shared billets and worked alongside specials from the American papers and when restrictions and clumsy censorship became too onerous on the French sector, the artists switched sides by the simple expedient of going to Belgium and joining the Prussian armies from there.

The attractions of the Prussian side were strong. It was not only a question of the welcome afforded to pressmen (this was typified in one incident when German troops captured the French correspondents of *Le Gaulois* and *Le Figaro*. The Frenchmen were held for a few days, then the Prussian authorities, conscious of the propaganda value of French newspaper reports on the might of their war machine, sent the correspondents back via Basle in neutral Switzerland with their scoops). There was, in addition, the advantage of covering the war from the winning side, with communications, facilities and food supply likely to be much better organised than those amid the chaos and demoralisation of retreat behind the French lines.

With Paris under siege in the winter of 1870, an artist attached to the encircling Prussian forces could hand his sketch to the military post office on the city's out-skirts, from where it would be speeded some two hundred miles by post train, through the former 'impregnable' French bastion of Metz to Saarbrücken. There it would be put on a train through Belgium or Holland and on to London to catch the weekend edition. For news it was even quicker, the despatches being telegraphed by a German operator in Saarbrücken. Thus the news took less than twenty-four hours from front line to London presses, and only a little longer to the printing centres of New York, Washington and Philadelphia as American correspondents indulged in the luxury of transatlantic telegraph at a dollar a word.

In the vernacular of a later age, the war artists had never had it so good. Indeed, sometimes it was almost as if they were being afforded a grandstand seat by the Prussians to watch and record the destruction of Napoleon III's empire.

Under such conditions, Simpson, having moved to the Prussian side, managed to scoop the world with an eye-witness sketch of the fall of Strasbourg, another much vaunted bulwark of France's defences. He described the incident in a despatch to his newspaper in October 1870:

William Simpson's front-page scoop, 8 October 1870, of the fall of Strasbourg. He had a genius for being in the right place at the right time. But that was not all: essentially, he looked after his lines of communication. He worked most of the night, snatched a few hours' sleep and at dawn took his sketch to the army field post office. Within twenty-four hours it was on his editor's desk. In the rush to publish, some of the joins between the composite wood blocks are revealed. (*Illustrated London News*')

I had been in one of the lunettes (fortified outposts) taken by the Germans for some time, sketching. I was on the point of saying 'Good evening' to my friends for it was just five o'clock and it was as well for one in bourgeois dress to be out of the trenches before it gets dark, when a man called our attention to a white flag just placed on one of the redoubts of the town in front of our position. Immediately after this another flag appeared more to the left.

Soon French troops and townsfolk appeared, waving, shouting and cheering and the Germans threw knapsacks of food to the hungry, besieged people of Strasbourg. Simpson was up at dawn the next morning to take his finished sketch to the German field post office, within walking distance at Mundalsheim. 'I calculated that if I sent it off that day it would reach Mr Jackson, the editor, in time for the "next Saturday", which it did.' His picture of the fall of Strasbourg was splashed on the front page and showed the Germans cheering as the white flags appeared above the city. By that time, however, Simpson was back on the job—inside the city of Strasbourg, picturing the sufferings of the people and discovering that France had withdrawn the best of its troops, leaving no more than a rabble inside to defend the stricken city. The disorganisation of the remaining garrison appalled him. 'This,' he wrote, 'supplied a striking illustration of the military capacity of Napoléon le Petit.'

The artist's contempt for French military capacity merely reflected the shading of a large part of public opinion in non-belligerent countries. In Britain, in particular, where old enmity of France died hard, sympathies were strongly pro-German and this was another contributory reason for the overwhelming coverage of the Prussian side. The *Illustrated London News* revealed a substantial Prussian bias in its editorials and this and other publications were full of advertisements for sheet music and public renderings of popular German-orientated war songs ('Prussian National Hymn, arranged for the Pianoforte by Franz Nava. Price 2s. 6d' . . . 'At the Crystal Palace, The Watch on the Rhine, by the full Choir, first in unison, and concluding with harmonised chorus.')

It was almost as if the rest of Europe and America wallowed in a feast of vicarious pleasure as Germany hammered and France yielded; and the special artists played a leading role in satisfying the appetite of the masses safely away from the battlefields and besieged cities. To this background a decidedly defensive note can be detected in a contemporary reference by a *Times* writer to the Crystal Palace, south London's glittering pleasure dome which currently included among its attractions an exhibition of war specials' drawings, and patently believed in the maxim that there's no business like war business. The reporter's introduction to his article is a masterpiece of double talk and today serves only to damn the motives of what must have been a highly valued advertiser in *The Times*:

> However the war may have thrown out the calculations of others, it found the managers of the most popular place of amusement in the world ready and prepared. To them it was only another string to an already well-thonged bow. With happy audacity, they added it to their programme, in no unscrupulous spirit of money-making, but in laudable consistency with their usual practice of studying and ministering, without in the least pandering, to the public taste. The Crystal Palace Company could, no doubt, have made the most objectionable capital out of the war had they so chosen. One very sensitive correspondent has, indeed, taken exception to a blaze of fireworks called the blowing up of the bridge of Kehl, but, in our opinion, he has run his head against a harmless matter.

The remainder of the article consisted of a review of a hundred and forty sketches of the war sent back by specials of the *Illustrated London News* and the *Graphic*. It contained this dissertation on the growing international rivalry between picture newspapers:

> . . . in few things can England boast a more decided superiority than in illustrated newspapers. America is far behind us in this respect. It is only necessary to turn

THE WAR! ARREST OF ENGLISH CORRESPONDENTS AT METZ.

William Simpson and other newspapermen arrested as 'spies' at Metz. Simpson (bearded), like other artists, exposed himself to the dangers of French spy mania by the simple act of taking out a sketch-book. In this incident, reproduced as an engraving in his newspaper of 20 August 1870, the crowd bayed for blood, but the correspondents were saved by official intervention—and expelled from the area. Understandably, newsmen preferred to work on the Prussian side, which consequently received a 'better press'. (*Illustrated London News*)

over, for instance, a file of *Frank Leslie's Illustrated Paper*, boasting itself to be incomparably the best in the New World, to see how fortunate we are both in our artists and engravers.

The Times concluded with this tribute:

The rude and hasty scrawl on a crumpled bit of paper of the capitulation of Sedan, with its terrible dashes for exploding shells and the scratches that do duty for outline, give us a better idea than did the engravings of the confusion and terror which enveloped that final scene. Besides this, it is reassuring to see with our own eyes that the illustrations served out to us every week are one and all actually from pictures taken abroad, for there have been unworthy suspicions that of a large proportion the originals were produced on the premises.

(The sketch of the capitulation of Sedan, dashed off on a scrap of paper, was the work of an *Illustrated London News* artist of French nationality, named Moullin; after the surrender of the French army at Sedan he was taken prisoner by the Prussians but quickly released under the army's shrewd press-relations policy.)

Here again was the hard-dying popular belief that war pictures were sketched in the safety and comparative quiet of metropolitan newspaper offices and not, as the exhibition catalogue pointed out, 'taken on the spot at the risk of life and limb'. That this risk was to some degree lessened by the very nature of warfare in 1870— set pieces with large professional forces engaging each other in 'organised' battles— was of little consolation to the specials on the French side, whose principal threat to life and limb came from the mob.

A sketch-book was a most dangerous article to be found in the possession of a foreigner. Simpson experimented with rough on-the-spot sketches made on a book of cigarette papers—'One could do a great deal with a book of this kind, and in the event of being apprehended, could make a cigarette of the sketch and smoke it before the eyes of one's accusers.' Another special had an astonishingly complicated recipe for beating the censor and the lynch mob. In a letter to a friend he explained

67

that he made notes and quick sketches on pieces of tissue paper, which 'I then roll up as pills and place them in my waistcoat pocket, to be chewed up or swallowed if in extremis.' Once inside his hotel room or bivouac he smoothed out the bits of tissue paper and pasted them face down on plain paper 'so that they can only be seen against the light'. He then wrote something innocent over the top. Having reached a place of safety beyond the battle zone the resourceful artist soaked the sheets in water, separating his sketch notes which became the basis of the drawing he would send to London.

Despite such precautions, however, the mere fact of being a foreigner, and an inquisitive one at that, was enough to land specials in trouble. Robert Landells of the *Illustrated London News* was one of the first Prussian-based artists to enter Paris on the government's capitulation, and he and Sydney Hall, of the *Graphic*, made the mistake of straying from the protection of the conquering forces in the search for subjects to draw. A mob which had just drowned a spy subject in the Seine apparently and illogically had its attention drawn to the two Britons by Landells's somewhat dark complexion. The crowd menacingly approached the pair and Hall's sketch-book was spotted. 'Prussian spies,' someone shouted. Landells and Hall took to their heels, narrowly escaping a lynching. There was worse in store for Archibald Forbes of the *Daily News*: he was dragged by his feet through the gutter by a mob and he saw a woman stripped and painted for talking to a Prussian drummer.

William Simpson, inevitably, fell victim to spy mania. His editors recorded on 20 August 1870:

We have to announce that Mr. Simpson, the Special Artist of this Journal, lately at the head-quarters of the French army, has been forced to leave Metz, with all the other newspaper correspondents, since the disasters suffered by that army on the 6th instant. Scarcely any of our countrymen, engaged there in the service of journalism, has escaped a temporary arrest. The turn came at last for our own Artist . . . We believe that he would never have been interfered with by the military authorities but for the excited state of the townspeople, who became quite wild on the day after the French defeats at Worth and Forbach, and insisted on regarding all strangers as Prussian spies.

Simpson's crime was that of taking out his sketch-book to draw Napoleon's carriage which he spotted at Forbach railway station on the morning after the French defeat outside the town. He, the *Standard*'s Henry Mayhew and his son, and R. M. Stuart, of the *Daily News*, had gone to the station to seek French wounded from the battle; the absence of wounded men told them, for the first time in the official French information blackout, that the Prussians had won. 'As the Prussians would hold the ground after the fighting, the wounded would be in their hands,' was how Simpson put it. The carriage, without the emperor, was waiting to be sent elsewhere by rail. Simpson believed a quick sketch might come in useful should he have to depict the carriage at a later date. No sooner had he begun to sketch than the four correspondents were surrounded by French artillery men, who marched them into town, followed by an angry crowd, shouting, 'Damned Prussians!' and 'Prussian pigs!'

In the local police station Simpson and his colleagues faced a series of denunciations by soldiers and townsfolk. There were wild accusations. One man pointed hysterically at Mayhew and screamed that he regularly came into a certain café and that 'he sat every night in the same seat'. A Forbach newspaper editor alleged that

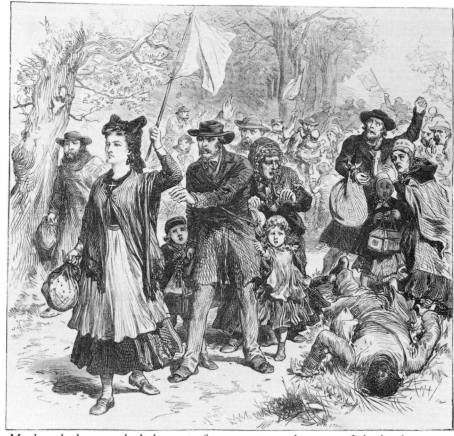

This incident, explained Simpson, 'takes longer to write, and much more to draw it, than the time which elapsed in its occurrence'. On 25 October 1870 he was with the outposts of the Prussian forces encircling Metz. A crowd of refugees, led by a woman carrying a white handkerchief on a stick, tried to leave the stricken city, but were stopped by the Prussian pickets. The Prussians fired on the crowd, killing a man. The rest fled in terror. Eleven days later Simpson's version of the event was front-paged in Britain. ('*Illustrated London News*')

Mayhew had even asked the cost of postage to send a copy of the local paper to London. As tempers became heated and the mob outside bayed for blood, the four correspondents were saved by the intervention of a senior officer. The next day they, and all other newspapermen, including several French, were packed off to Nancy, away from the battle zone. There, over drinks in a hotel, Simpson met a French naval officer who was on his way to join a gunboat on the Rhine. ('Of course, he never reached the Rhine, unless he did so as a prisoner of war.') The sailor, far gone with an attack of spy fever, said he, personally, would shoot any man suspected of spying. Then he bade *adieu* to Simpson and went out for an evening stroll. A short time later he was back in the hotel, breathless, having been chased by a mob as a spy. Simpson, of course, drew his own arrest and it appeared with his eye-witness story in his newspaper thirteen days after the incident.

Spy mania was above all a symptom of defeat. As France plunged deeper into its Prussian orchestrated *Götterdämmerung* the observers who were there to record it became increasingly the targets of French hostility. Perhaps the worst single defeat was the surrender of Metz, France's greatest fortress bastion, a cataclysmic event in November 1870, in which 173,000 men—including the Garde Impériale and three Marshals of France—capitulated to Bismarck's army. The foreign artists, who must have appeared to official French eyes as a flock of journalistic vultures, poised for the kill behind the safety of the Prussian guns, had already recorded pitiful attempts by refugees to leave the battered citadel; there was worldwide graphic coverage of one incident in which Prussian pickets fired on men, women and children in an

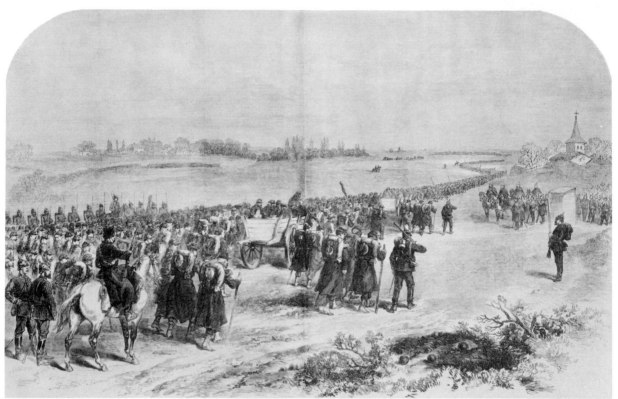

When a huge French army capitulated at Metz it reminded Simpson of the surrender of King Theodore's 'motley host' in Abyssinia two years earlier. The *Times* man wrote, 'We are not yet able thoroughly to realise the almost incredible scene we are witnessing. The more we think of it, the more does it seem like an impossible dream. Here are three field marshals, 50 generals, 6,000 officers and 173,000 of the flower of the French army, filing out, unarmed . . . and giving themselves up as prisoners of war.' Simpson's sketch told the story as an engraving across two pages. ('*Illustrated London News*')

attempt to turn them back to add to the growing chaos in the invested city. When Metz finally fell the once proud army which emerged from behind its fortifications was an underfed, demoralised rabble. The scene which William Simpson drew reminded him of Abyssinia two years earlier 'when King Theodore's motley host poured out of Magdala and spread far and wide over the country, no longer an organised force'.

As the course of the war changed, so did reporting techniques. Editors demanded news and pictures of Paris under siege. This meant that reporters and artists inside the city had to share the privations of the people—cold and near starvation. The correspondent John Augustus O'Shea wrote afterwards: 'I had to write wrapped up in bed, for want of fuel.' The problem now became how to get the news and sketches out through the encircling Prussian armies. Here the advice of veteran Archibald Forbes needs some qualification. 'However interesting a battle may be,' it goes, 'you must always get away before your communications are cut, for your material will be held up or never arrive.' But for the infernal fools who insisted in staying *inside* Paris, where a dozen people died a day from bombardments, there was no getting away. And so the day of the balloon scoop had arrived.

Typical of despatches of that time was this, which appeared in the *Illustrated London News* on 15 October under the heading 'From Inside Paris by Balloon Post':

I write this note under great doubt of its reaching you. You are of course aware that we are shut in and reduced to balloon communication. We treated with an aeronaut to take over ten letters for £50; but at the last moment he demanded £100, and we broke off the negotiation . . . If this reaches you it will apprise you that I sent off on Monday morning by a private balloon about half a dozen

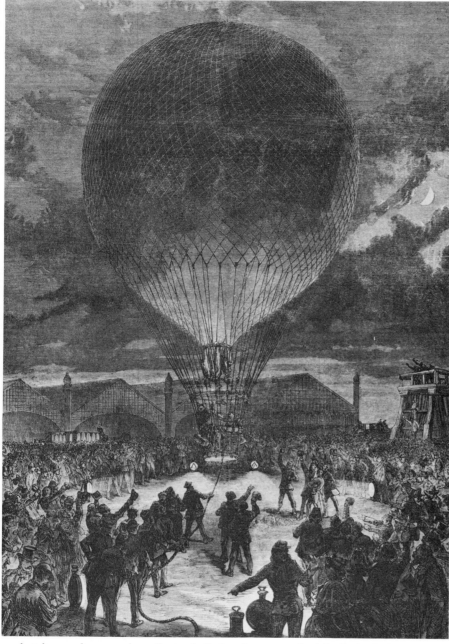

How artists got their pictures out of besieged Paris: a balloon takes off from the courtyard of a metropolitan rail station, by night to avoid the risks from Prussian gunners. Specials kept tracings and photographs of their sketches in case the balloon came down in enemy lines—as many did. ('*Illustrated London News*')

sketches and a complete diary of all that has transpired in Paris during the last fortnight ... I have arranged to send all sketches in triplicate, in the hope that one out of three will come to hand.

The destination for many of the balloons was Tours, beyond the ring of encircling Prussians, and to this city, 125 miles south-west of Paris, the aerial transport carried baskets of homing pigeons. An advertisement in British newspapers in the winter of 1870 advised that letters for Paris would be accepted if they consisted of twenty words only, in French, without envelope, at a cost of fivepence a word and sixpence

postage, a costly communication in those days. Once having arrived in Tours, the messages were forwarded to beleaguered Paris by the homing pigeons which had been shipped out by balloon. (One pigeon is reputed to have flown no fewer than eleven hundred message-carrying missions during the siege.) Sometimes the messages were reduced by photography so the pigeon could carry more, and in Paris the images were enlarged again.

Ironically, photography, which had even yet not presented its proper competition to pictorial war reporting, became an ally of the special artist. An artist whose balloon-borne drawings must have come down in Prussian lines 'or else gone all the way to Switzerland' on a shift of wind, wrote to his editors: 'I send you some duplicates of the former sketches, several of which I had photographed in fear of accident.'

Greedy 'aeronauts' and shifting winds were not the only hazards faced by the specials in getting their drawings out safely. The Prussians were developing a skilful if crude form of anti-aircraft fire. The days were soon past when a balloonist could recount that, as he rose from Paris on a favourable wind, he could distinctly see through his telescope the Prussian gunners below him. He watched them point their cannon at·him. Then he saw the balls rise in the air and, after exhausting their impetus, fall harmlessly to the ground. A nasty new weapon was being hastily mobilised to beat the balloonists; this was the fiery rocket, and the havoc it inflicted (more to morale than to actual balloon fabric) caused the Paris authorities increasingly to rely on night flights.

To be shot down was not necessarily fatal for a balloonist, but his aerial role laid him open to the charge of espionage if he fell into the hands of the Prussians. The *Illustrated London News* reported on 12 November 1870: 'The balloons from Paris have not in all cases been fortunate. Two or three were lately captured by the Prussians, with a quantity of letters, said to compromise some high diplomatic personages. The passengers in these balloons are to be tried by a court-martial.'

If the balloon post carried the news, it also made the news. Balloon departures and mishaps were a favourite standby illustration for the specials on quiet days by the Seine. One such illustration was of a night departure published in the *Illustrated London News* on New Year's Eve, 1870, and probably drawn by Jules Pelcoq. The accompanying account made compelling reading for Britons, fascinated by the scientific wonders of the age and eager to learn how these gas-filled monsters were beating the Prussian blockade.

As midnight nears, sailors finish their work of filling the fabric with gas and the balloon waits, tethered in the courtyard of a main line railway station; such stations were used because they were away from the centre of Paris and free from the encumbrance of nearby high buildings. A horse-drawn post office van arrives with sacks of mail (including correspondents' despatches and sketches) and copies of the *Official Journal* intended to serve as ballast. These are put in the car, to which is also attached a basket labelled 'Pigeons—to be immediately forwarded to Tours'. Monsieur Rampout, the post office director general, fusses around, supervising the arrangements—'and if the night be foggy and the wind favourable his countenance is beaming with satisfaction, for he knows that the balloon will both leave without being perceived by the enemy and will fall far outside the lines.'

The pilot, wearing a light-coloured fur coat, and a passenger climb into the car, the former carrying military despatches from the Paris commander. On the command, 'Let go!', the balloon soars majestically over the glass roof of the station and

spectators crane for a last glimpse until it disappears into the night sky—'but for a few moments after, they can still hear the *adieux* of the travellers, who are carrying with them into the outer world so many messages of love and hope from the sorrowful inhabitants of the beleaguered city.' It was a touching journalistic note on which to end the story as the new year 1871 dawned with aspirations of peace.

Alas, if the last six months of 1870 had been sorrowful for Paris, the events they had encompassed had merely been a curtain-raiser for the horror that was to engulf the city before the rest of the winter and a bloody spring had played themselves out. With military stalemate in the Franco-Prussian conflict, foreign news interest had waned, only spasmodically flickering into life again as Paris capitulated on 28 January and when the Prussians paraded down the Champs-Elysées on 1 March after the signing of peace in France. By the end of March, however, the Commune was formed and reporters and artists came flocking back to Paris to cover the civil war between the revolutionary and the Versailles forces, the latter sponsored and re-armed by the anxious Bismarck.

Like many other observers, Arthur Boyd Houghton, special artist of the *Graphic*, found the events of the Commune a severe test of his conscience. Houghton, painter, illustrator, caricaturist and pictorial journalist, was no stranger to dissent. His first overseas assignment as a special, to America for the newly founded *Graphic* during 1869–70, roused a gale of protests from the United States over the bitingly critical quality of his drawing pen. In what was undoubtedly the most important journalistic exercise of his life, his *Graphic America* probed under the surface of post-Civil War America and proved that cynicism, greed and exploitation were just as prevalent in the brave new world as they were in Victorian England. With the help of such artist veterans as William Waud (of *Harper's* Civil War fame), he received introductions which enabled him to take an inside look at social conditions in New York, Boston and the West.

He drew wretched wives talking to condemned husbands in the Tombs prison of New York, crippled war veterans begging in the snows of Boston, tough policemen and corrupt politicians. He saw nobility in the Indians of the West, but, disillusioned, depicted Pawnee drifters for what they were, broken, drunken flotsam left by the uncaring tide of civilisation's progress. When the complaints came in from the eastern states of the US, where the *Graphic* had significant sales, the paper's proprietor complained, 'He did us a lot of harm', while admitting that only the grumblers kicked up a fuss.

Thus, assigned to Paris, first in 1870 for the war and then in the spring of 1871 for the Commune and its aftermath, Houghton, around the age of thirty-five, had a liberal recognition of the inequalities, injustices and cruelties which had nurtured revolution in Paris. But, as Paul Hogarth, an artist–reporter himself, wrote in the introduction to an exhibition of Houghton's works at the Victoria and Albert Museum, London, in 1976, 'the Commune roused in him a revulsion that sprang from a fear that real or actual change would get out of hand, and the breakdown of civilised order would result'. Houghton respected the dignity of the people, but he drew the Paris mob at the barricades starkly, almost in caricature, with brutalised men and women urging comrades on to revolution and death. He believed in law and order, but once Versailles was triumphant and engaged in an orgy of blood letting, his treatment of the 'trials' exposed these for the mockeries of justice that they were; thus, in one drawing, Communards under trial faced a battery of accusers and judges whose faces reflected the inevitability of the verdict, whatever the evidence.

Arthur Boyd Houghton drew this dramatic scene at the barricade of Paris for the *Graphic* during the Commune's fight for survival. He was one of the few special artists who could, and did, draw them directly onto wood, thus ensuring that his original line and style appeared on publication. Houghton lost an eye as a child and the pressure on his remaining eye affected his colour judgement; his style of draughtsmanship, however, was clear, incisive and investigative.

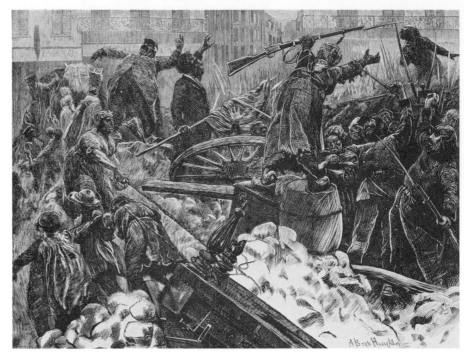

Gregarious, generous, and quick to see a joke, Houghton never lacked around him a circle of people who ranged from true friends to drinking companions who came and went with his fortunes of affluence and bouts of alcoholism. He habitually wore a black eye-patch, having lost an eye in childhood in an accident with a toy cannon charged with gunpowder (this handicap, coupled with migraine, put an excessive strain on his one eye and lowered his colour sense almost to the point of colour-blindness). After Paris, he became increasingly addicted to drink and in little over four years he died of cirrhosis at the age of thirty-nine.

The events of the Commune also had a profound effect on William Simpson. He had wintered in London, having been taken ill covering the Franco-Prussian fighting; as he put it, 'I had been for weeks knocking about with merely a plaid, and a small knapsack with my sketching materials.' Not yet fully recovered, he set off again for Paris in April, accompanied by his employer William Ingram, who was determined to see things for himself. Ingram stayed only a week or two, then returned to the responsibilities—and safety—of his editorial desk in the Strand. Simpson remained in the urban front line, often at real danger to his life, throughout most of the bitter fighting. The experience was a severe test of both his stamina and his conscience.

When the Versailles troops broke through into central Paris on 21 May, he found himself alone in the Rue Royale, pinned down by a hail of bullets. A Commune soldier appeared, grabbed Simpson and ordered him to take part in building a barricade. This, the foreign press corps had discovered, was a hazard to be avoided at all costs as it could involve one in enforced labour for hours, even days, with a bullet the penalty for attempted 'desertion'. The gunfire became so intense, however, that Simpson and a *Times* man named Austin were able to escape under its distractions. 'We could do little that day,' said Simpson. 'The fighting was going on close to us on three sides, and the danger of being pressed into the service of

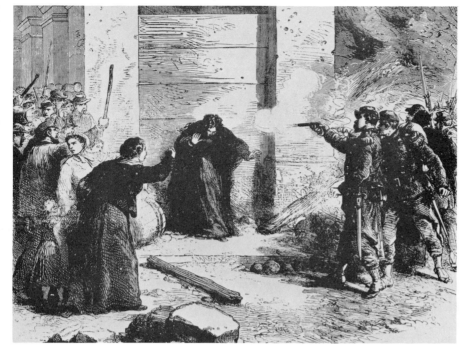

Lacking a credit, this *Illustrated London News* engraving has the hallmark of having come from an original sketch by Jules Pelcoq. It depicts the execution of an alleged fire-raiser, or *pétroleuse*, by the Versailles troops in Paris. The brutality of the victorious Right appalled many of the British journalists, including Houghton and Simpson.

barricade-making caused us correspondents to remain in close quarters.'

Four days later, in a quarter now dominated by the increasingly victorious Versailles forces, Simpson found himself single-handed storming a barricade newly vacated by the Communards. His friend, Austin, recorded the incident for readers of *The Times* (and note the Thunderer's view of the opposing sides in the terms used to describe them):

> I need say nothing about what I saw until I found myself in the Rue Vielle du Temple, between the regulars and the Reds. We had already been among the former, and were anxious to see something of the latter, but I confess I should hardly have ventured near them if my companion, Mr Simpson, an old campaigner, who sketches as coolly under fire as in his own room, had not fairly dragged me on. I had lost him for a moment in a desperate rush I had made out of the clutches of a colonel who was ordering all passers-by to be pressed into the service as amateur firemen, as a new fire had commenced. When I returned to look after my friend, I was not a little alarmed to see him far away at the other end of the Rue Vielle du Temple, in the enemy's line, on the other side of the barricade. The red flag was still floating over it, at the end of a bayonet, but its defenders had retreated—fortunately for the invader, or it might have gone hard with him.

Simpson's only complaint appears to have been that three sketches he sent off to London after this incident never arrived—the only drawings he ever lost 'in all my long connection with the *Illustrated London News*'.

The savagery of the Versailles retribution is a fact of history, and Simpson spared no pains in pictorially recording what he called 'the bloodthirsty tactics of the side which made such high pretensions to law and order', a matter of no small significance considering he was working for a newspaper whose political leanings were soundly bourgeois. He was horrified to see, for instance, 'a brutal, fat officer' seize a

Communard woman prisoner, tear a red cross from her arm and bundle her off to prison as a *pétroleuse* accused of fire-raising. Simpson argued afterwards that the accounts of the *pétroleuses* were grossly untrue. 'Where there had been hard fighting at barricades,' he said, 'it did not require women with petrol to do the damage.' Likewise, he argued that more destruction was caused by Versailles shelling than by wanton acts on the part of the Communards, who were subsequently blamed for laying waste the centre of Paris.

In his memoirs he wrote:

> History, so far as popular accounts of the Commune in Paris may be called history, has so misrepresented everything, that I should like to add a few words on the subject. I have no intention of defending the Commune. It was a blunder and a crime, and the guilty deserved punishment. But that is a very different thing from the cruel massacre of prisoners shot in thousands in cold blood. I do not know how many were shot; I have heard estimates that ranged from ten thousand to twenty thousand, and even as high as thirty thousand. It was war—civil war. The troops of the Commune were a regular army, and all the prisoners ought to have been treated as prisoners of war.

Simpson saw the results of those massacres. He saw the piled-up corpses in such masses that the numbers were uncountable. He saw the walls pitted by rifle fire on the hill of Chaumont, above Paris, where the stench of death and gunpowder marked the end of the Commune. And he, and others like him, drew it all.

History has a strange footnote to the happenings of 1870. Among the hundreds of drawings published by the *Illustrated London News* of the Franco-Prussian conflict was one which gave British readers a mildly mawkish sidelight on the downfall of Napoleon III. It was of the erstwhile playthings of Napoleon's young son, Louis, the Prince Imperial, who took refuge in Kent after his father was made prisoner. In the first month of the war readers had learned of little Louis's baptism of fire at the age of fourteen by his father's side at the front. It was described in a telegram from the Emperor to the Empress which told how 'the soldiers wept at beholding the courage of the gallant little lad'. In the issue of 12 November, however, the newspaper had a different story to tell:

> The third of our sketches from St Cloud (occupied by the Prussians) is a reminiscence of the Prince Imperial, young Louis Bonaparte . . . His little garden, in the grounds of the palace, contained several tokens of his taste for boyish sports and amusements, one of which was a circular railroad, with a model locomotive going by clockwork, a station, signal apparatus, and a bridge for the line over a piece of water. The Prussian soldier, like another Gulliver, has trodden upon this railway station of Lilliput and crushed it to pieces . . . the engine has lately come to a standstill in the absence of its juvenile conductor. It would, perhaps, be a kind thought of the Prussian staff at St Cloud to pick up this little fellow's playthings and send them to Chislehurst; but they have more urgent business in hand.

The Prince Imperial, exiled under the protection of Queen Victoria, had been a favourite subject of the special artists in the war. Within a few years they were again at hand to record the tragic sequel to this interlude—the discovery of his corpse, speared and hacked and left naked on an African hillside. But that was another war.

SIEGE OF PARIS: THE PRINCE IMPERIAL'S GARDEN, ST. CLOUD.

The reader of the *Illustrated London News* was expected to shed a tear over this sad scene: the toy railway abandoned in the garden of St Cloud by the boy Prince Imperial, son of the defeated Napoleon III. Little Louis found haven in England and later died in a faraway British colonial campaign, his death being the subject of floods of illustrations by special artists.

7 Blooding in Ashanti

If I had not killed them, they would certainly have killed me. It was only a matter of self-defence

 Melton Prior, special artist

It is a simple fact of life in the newspaper business, as in all competitive areas, that stars wane and today's unknown is tomorrow's star. It is, as they say, a young man's game. This is probably nowhere more true than in the arduous role that was demanded of a special artist in the field. If the mid-Victorian years to the 1870s had seen the establishment of William Simpson as the king of specials, a campaigner standing high above contemporaries in experience and achievement, lauded by royalty and a household name throughout Britain, it was now the turn of a brash, swashbuckling newcomer to be thrust into the limelight by the ever-thriving *Illustrated London News*.

When Simpson, in his late forties, was scooping the world in the Franco-Prussian war and dodging bullets and mobs in the Commune, Melton Prior was beavering away at home drawing ships being launched, a new dock being opened and fashionably gowned ladies at society bazaars. There was, let it be said, plenty of life still left in the old dog of Sebastopol, including some hair-raising exploits in Afghanistan when nearing the age of sixty. But for the next quarter of a century and more as Victoria's soldiers plunged time and again into imperial adventures, it was Melton Prior who grabbed laurels as the leading special artist of the era. His was an astonishing record: he covered no fewer than twenty-five campaigns and revolutions before his death in 1910, just before the 'war to end all wars'. What he might have done with the 'big one' is only surmise; perhaps it was as well that he never lived to see it, trammelled as its news recorders were by censorship and obstruction; indeed, his final war, the Russo-Japanese in 1904, broke the spirit of Prior, chained by officialdom in Tokyo and refused access to the fighting fronts.

Prior was twenty-eight with five years on the paper behind him, when Mason Jackson, the editor, sent for him in November 1873, and told him he was to go out as a special to Ashanti, a landlocked kingdom behind the Gold Coast in West Africa. Coffee Calcallee, the fat, barbarous king of Ashanti, with whom Britain had had an uneasy treaty for many years, had aroused the wrath of Victoria's government by overrunning the Fanti buffer states and threatening Britain's presence on the coast. Major-General Sir Garnet Wolseley, who had made his name dealing with the Red River halfbreeds' rebellion in Canada three years earlier, was being sent to lead an expedition of troops and bluejackets to subdue the Ashanti with Gatling guns and rockets. Wolseley—the very model of Gilbert and Sullivan's 'modern major-general'—was an outspoken, bull-at-a-gate soldier whose deeds matched his words. Good 'copy' was expected from his mission to punish the upstart black man for his impudence.

It was essentially a 'little war', or as a London leader writer described it, 'a tiny

eddy on the border of the general current of peace'. As Wolseley sailed from the shores of England and the old year ended, the expedition left behind a comfortable, complacent scene. There was, it is true, distant rumblings of a famine disaster in Britain's domain of Bengal, but at home the new year was opening on a fair promise of commercial prosperity, economic observers having opined that certain causes of depression in 1873 had been removed. Soon the country was to have a general election that would see the Conservatives in with a working majority. The latest returns showed that pauperism was considerably down in London, a city that went about its affairs confident that it was at the hub of the largest and most thriving industrial and commercial operation in the world. Steamships to Calcutta were advertised 'direct via the Suez Canal', the lifeline to the East opened a bare four years earlier. The Moore and Burgess (late Christy) Minstrels played to packed houses at St James's Hall, Piccadilly, theatre crowds joined in lustily to the hit tune of the day, *God Bless Our Sailor Prince* ('At the first bar the enormous audience rose to their feet,' said *The Times*), and Piero 'the one-legged dancer' was numbered among the attractions in Drury Lane. An unfortunate Mr Charles Fido was sentenced to six months' hard labour for recklessly driving his horse and cart in the Brompton Road. Messrs Gabriel, dentists, proclaimed their daily administrations of laughing gas in connection with their painless system of dentistry. Newspaper readers wondered afresh at the news of the deaths in North Carolina at the age of sixty-three of the Siamese Twins, Chang and Eng, whose erstwhile crowd-pulling capabilities had been demonstrated in London. And in the best-selling ranks was a cheap re-issue of *How I Found Livingstone* by H. M. Stanley, proving yet again that, though sensations might come and go, Africa and all that went on in the dark continent proved a source of continuing and obsessive interest for the Victorian public. It was therefore little wonder that people looked forward with eagerness to whatever might be revealed by Wolseley's military probe to King Coffee's capital of Coomassie, universally described by the press as 'the metropolis of murder' owing to the black monarch's notorious appetite for human sacrifices.

Shortly after landing in Africa at Cape Coast Castle, General Wolseley penned an order of the day, which was afterwards described by the *Illustrated London News* as 'inspiring battle words . . . one of those papers that are issued only by men who know what they are about'. The expedition was a mixed force of British, West Indian and locally recruited soldiers, but the commander's words were patently addressed to the Rifle Brigade, 42nd Highlanders, 23rd Welch Fusiliers and naval brigade. 'Providence,' intoned Wolseley, 'has implanted in the heart of every native of Africa a superstitious awe and dread of the white man, and this prevents the Negro from daring to meet him face to face in combat. A steady advance or charge means the defeat of the enemy. Soldiers and sailors! Remember that the black man holds you in superstitious awe. Be cool. Fire low. Fire slow. And charge home!'

At the outset Melton Prior, the artist, would probably have agreed with those sentiments. His first contact with black Africa was to witness a strike by boatmen at Sierra Leone, which led him to write: 'But how like a native! Treat him as a dog, and he will respect and serve you faithfully; show him any kindness, and he will immediately try to take advantage of you.' That these words were written later in life, for his memoirs, would tend to prove that Prior retained his attitudes throughout his many campaigns among 'the natives'; indeed, there is little doubt of this in the evidence of his despatches and the situations in which he often drew the black man. (Incidentally, from Prior and many another special artist, the Victorian illu-

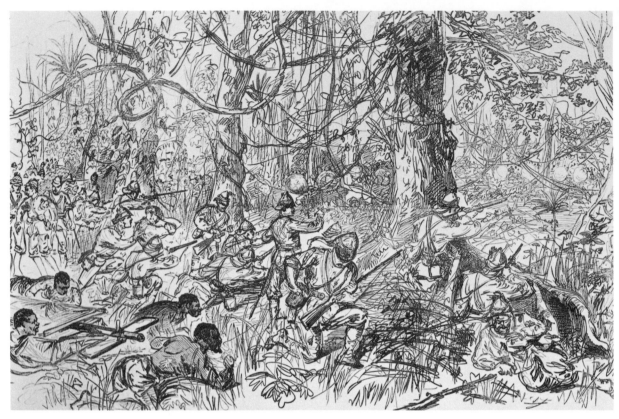

The black man, General Wolseley told his troops in Ashanti, has 'a superstitious awe and dread of the white man'. In this bloody forest encounter, drawn by Melton Prior, both troops and artist found the truth to be lethally different. Prior had to drop his sketch-books and pencil and take up his double-barrelled shotgun. At close range he killed two assailants. (*Illustrated London News*)

strated press—which otherwise portrayed woman, outside the bounds of 'fine art', decorously garbed in proper and concealing dress—accepted without question any number of bare bosoms, as long as they were black: nudity was permissible if it represented 'the native' in the state of innocence and ignorance ordained by God.) However, there came a point early in the Ashanti assignment when even Prior began to doubt the preconceived notions of the black man's fighting capacity, loftily promulgated by a general who by choice travelled in a cane armchair on bamboo poles held by four bearers. Prior's reappraisal followed a gruelling seven-hour trek through swamps and tangled undergrowth, every step of which had to be cut by engineers, constantly harassed by Ashantis armed with spears and ancient breech-loaders. Afterwards Prior wrote to his wife of 'much slaughter and casualties on both sides', of British losses of 250 dead and wounded out of 2,000 men. Not for the first time the ordinary private soldier, who had a healthily cynical regard for orders of the day, anyway, was discovering that the 'awe and dread' of the white man was something his adversary did not seem to have heard about.

From various sketches which included self-portraits (a contribution to the record which he frequently made in his campaigns), Prior in Ashanti presented a slimmer, more youthful figure than he did later in his career when posing for a photograph. This shows him with square-cut, slightly fattening features under a campaign hat set at a jaunty angle. His eyes are sharp and clear behind sensible, hook-on spectacles. A trimmed military moustache and neat sideburns tell that the photograph was taken during a home-based spell: in the field he often grew a beard as he did in Ashanti. His military-type corduroy jacket bears medal ribbons and is crossed by gleaming,

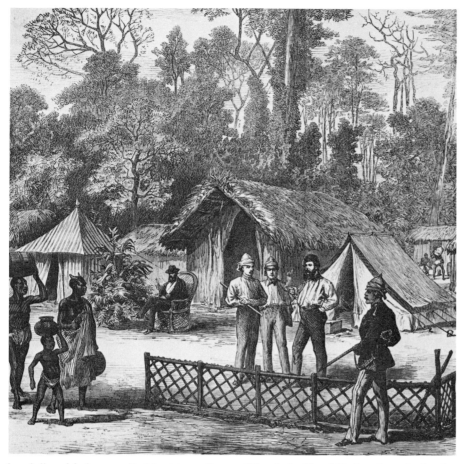

Special artist Melton Prior, the central figure in the group of three, in camp on the way to Coomassie. On his right is Henry Morton Stanley, of Livingstone fame and representing the *New York Herald*; on his left G. A. Henty, correspondent of the London *Standard* and author of boys' adventure stories. (*'Illustrated London News'*)

bandoliered belts supplied by his outfitters, Silver's in Cornhill, London. A sketch-pad is poised in one hand, and the finishing touch to the ensemble is provided by a large holstered revolver under his left arm. His whole appearance is not unlike that of Teddy Roosevelt in the Rough Riders.

Prior was similarly accoutred when, having bribed the chief officer of the SS *Volta* with a ten-pound note to secure the first available passage out of Liverpool, he arrived at Cape Coast Castle ahead of the expedition itself. There he met George Henty, representing the London *Standard*, a well-travelled correspondent who made a name for himself as G. A. Henty, elaborating his far-flung journalistic experiences into many a tale of derring-do for schoolboys. Henty, first on the scene, was actually holding court from a four-poster bed in a local merchant's house at that initial meeting with Prior. The two soon linked up with explorer Henry Morton Stanley, who was covering the war for the *New York Herald*, and their experiences together in West Africa cemented lasting friendships which were typical of many writer–artist relationships in the field.

Throughout the campaign the writers and specials sent their material back to their offices along a system which, although it appeared haphazard, owed more to clever organisation than to luck in the prevailing difficult conditions. From the start it was obvious that hazards such as defecting runners or the desertion of bearers must be overcome. To some extent Prior circumvented these difficulties by enclos-

ing his sketches in General Wolseley's official despatches whenever the opportunity offered itself. The West African mail-steamers took the newspaper material to the island of Madeira. There the steamers were met by Admiralty despatch boats, the fast paddle-steamers *Enchantress* and *Vigilant*, which churned off to Lisbon at high speed. Under its policy of telling readers 'How London received the news', the *Illustrated London News* in March 1874 related how agents of the main newspapers manned Lisbon bar with telescopes. Once the Admiralty paddle-steamer was sighted, the men of *The Times*, *Daily News*, *Daily Telegraph*, *Standard* and the picture papers each set out in a boat with four rowers to intercept the incoming vessel. Despatches and sketches having been collected, the rowboats raced for the shore. Words went over the telegraph, pictures by land or the first London-bound steamer. 'The Portuguese wonder at the expenses paid by the leading London journals for this service, as journalism in Lisbon is on a much smaller scale,' boasted Prior's newspaper.

On the advice of his more seasoned colleagues from London and New York, the fledgling war special added a double-barrelled gun firing large-bore cartridges to his armoury of pistol, pencils and sketch-pads as he set off with the expedition through the forest. It was soon put to use. Far from fleeing at the sight of the white man, the Ashanti was proving to be a dangerously persistent foe. In one ambush when the embattled press corps let fly with all they had Prior found himself face to face with two warriors. He fired the contents of the right barrel into the chest of the first Ashanti; the other turned and ran, 'but I got him in the back with my left, and so killed them both'. The thought weighed on his mind, and he asked himself later 'whether, not being a soldier, I committed murder or not'. But there always came the consoling reflection that 'if I had not killed them, they would certainly have killed me. It was only a matter of self-defence.'

Judging from Prior's eye-witness accounts, it was remarkable that he ever found time to draw. Not long after this first incident, he, Stanley and Henty sat down to breakfast on cold sausage and biscuit close by Wolseley and his staff, when the whole party found itself in 'a tornado of slugs', which appeared to be some form of heavy buckshot used in the Ashantis' breechloaders. Although the forest around them was later found to be teeming with enemy dead and wounded cut down by the army's Schneider bullets, the expedition had suffered some serious casualties. Prior was pressed into service in the field hospital: the artist had to hold down a man who smoked a pipe while the surgeon cut off the soldier's shattered leg. Prior noted in his diary: 'When I left England as a war artist I had never quite realised what fighting meant, and I remember only too well during the hottest moments of this battle declaring to myself most solemnly, "Prior, if you ever get out of this fight alive, you will never catch yourself coming of your own free will into another."' But he did, of course.

Barbarity piled upon barbarity as the little army chopped and fought its way across steaming rivers and corpse-filled swamps. A steady procession of litters trailed back from the expedition, filled with sick and wounded (when the campaign was over, half Wolseley's army returned to the coast incapacitated in hammocks). London was horrified to read a graphic description of the death of a Captain Baird, who was carried to the rear by bearers after being wounded; there, apparently, the bearers were attacked and fled, leaving Baird at the mercy of the ambushers who lopped off his head. The following week, however, a hasty correction reported that the remarkable Captain Baird had reached Cape Coast Castle intact and was now on

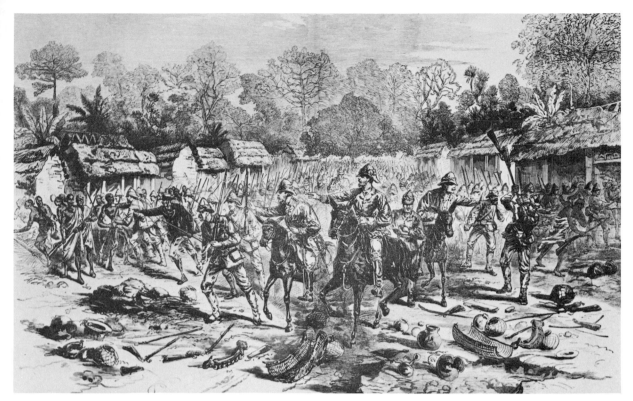

his way home to England. But much of the horror was only too real. Prior found the bodies of butchered 'friendlies', whose heads and genitals had been transposed in macabre surgical transplants by the retreating Ashantis.

Just before Coomassie, Prior, suffering much from prickly heat like many with him, faltered as he splashed through a swamp. He had become separated from his two bearers who carried his hammock and most of his sustenance and medical supplies. Fearing that he was about to go under, he seized the tail of a mule in front of him. The rider turned in the saddle. It was the commander-in-chief himself. 'Never mind, Prior,' barked Wolseley. 'Hold on and we two will drag you in.'

When it seemed that the threat to his capital city could no longer be averted, King Coffee sued for peace. His envoys were treated to an impressive display of firepower by the navy's Gatling guns, 'which frightened them so much that one of them went mad and shot himself in the night'. Wolseley ordered that the king should send his mother and brother as hostages to show his good faith. There was no reply to this demand, so after a pause—dictated by a tornado, anyway—the expedition moved on to Coomassie like an army of zombies, fevered, tired and without water to drink. Prior was with the forward troops and almost at the point of collapse. There had been fierce fighting outside the town, but by evening King Coffee had fled and the British were drawn up in the main square of the capital where they gave three hoarse cheers for Queen Victoria. Characteristically, the exhausted Prior had managed to carry two bottles of champagne and, on rediscovering his two bearers and his kit, he drank several celebratory glasses with his colleagues. And then, dramatically, the full horror of the 'metropolis of murder' began to dawn on the British contingent.

This is how Melton Prior drew himself trudging into the conquered capital of King Coffee, sketch-book in hand, following close behind General Wolseley's mule (earlier he had been literally dragged through a swamp clinging on to the mule's tail). Prior was exhausted and ill. He was temporarily revived by the only encumbrances he carried in his knapsack, two bottles of champagne. ('*Illustrated London News*')

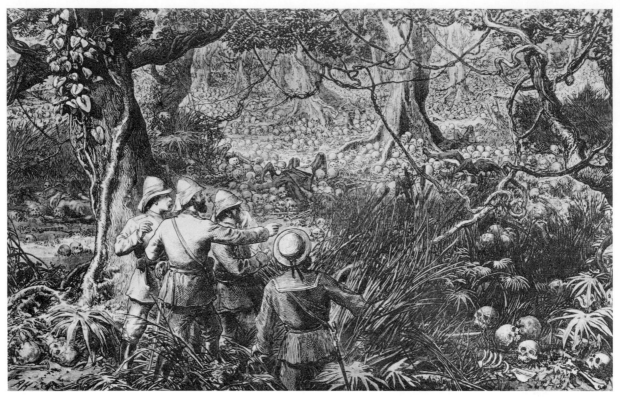

A scene that horrified the Victorian public. At the end of the Ashanti campaign, the *Illustrated London News* published this double-page engraving of Prior's sketch of the king's sacrificial slaughter place in the 'Metropolis of Murder'. Prior was able to stay only a few minutes at a time to make sketch notes of the 'utterly horrible and loathsome sight'.

On his way into Coomassie Prior had splashed through water running red with blood from human sacrifices, offered to the Ashanti gods in the hope of stemming the white man's advance. To this scene of carnage, reported the *Illustrated London News* artist, were added the bodies of warriors whose heads had been blown off by the explosion of their ancient firearms; the king had apparently ordered them to use double charges of powder because the white men were reputed to have thick skins. The ghastly climax to it all came, however, in a grove behind the main street of the town—'an utterly horrible and loathsome sight', said Prior. It was the king's fetish slaughter place, containing thousands of piled-up skulls and more than thirty decapitated bodies, the results of Coffee's thirst for human sacrifice.

Prior could stay only a few minutes at a time to sketch the grove of death, the sight of which he knew would convince all at home of the right and justness of Wolseley's mission (not that many in Victorian England lacked that conviction). The victims had been kept well fed till the time for sacrifice came, like geese being fattened for Christmas. Indeed, the horrified English soldiery found a dungeon full of prisoners who refused freedom, saying that they had been fed up for sacrifice therefore they could not go.

Close by the charnel house was the king's palace, the only stone building in town and two storeys high. Prior found the interior 'like a series of second-hand shops out of Wardour Street'. He drew the royal bedroom, draped with blue-striped calico, and the French tent bedstead used by the black Caligula. Leaning against the bed was a sword bearing the inscription, 'From Queen Victoria to the King of Ashanti' and presented to Coffee two years earlier. The sword was impounded and went home as part of Sir Garnet Wolseley's personal war booty. Prior, defying an edict

against looting on pain of hanging—aimed largely at the blacks, anyway—pocketed two gold slipper buckles belonging to the king's principal wife, and a handful of other trinkets.

But time was pressing: Wolseley had ordered the sacking of the palace and the burning of Coomassie before the expedition's retirement down the forest trails, and there was much for Prior to sketch in this weird and murderous city. (Later King Coffee was ordered to pay 50,000 ounces of gold, the first part of a series of indemnities, and was forced to guarantee that there would be no more territorial expansion, that the road to Coomassie would remain open and that human sacrifices would cease.) Prior was so busy sketching that he was almost left behind. Suddenly he found himself alone in a street with smoke billowing around him and clumps of burning straw thatch blowing past his head. Hastily he packed up his sketching materials and chased after the rearguard, revolver in hand. Some days later he was carried aboard a boat at Cape Coast Castle suffering from fever and sunstroke. In his baggage he carried the visual evidence of King Coffee's reign of terror.

8 Zulu

Were I a general and had I an independent command in war offered me, I should accept it only on condition that I should have the charter to shoot every war correspondent found within fifty miles of my headquarters
Archibald Forbes, war correspondent

In 1878 special artist Melton Prior overheard a conversation at the British military headquarters in Kingwilliamstown, Cape Colony, which appalled him. Lieutenant-General the Honourable Sir Frederic Augustus Thesiger, C.B., soon to be the second Baron Chelmsford, was talking to a group of tough Boer fighters, whose uncompromising outlook, fine marksmanship, hard work and tenacity had carved for them and their families a farming existence in the teeth of long and bitter native opposition.

It was about the middle of the year and Thesiger, as British Commander-in-Chief in South Africa, had just completed a successful if unsatisfying campaign against a series of native uprisings which became known as the Ninth Kaffir War. He was soon to report back to the Duke of Cambridge, the Commander-in-Chief in London, the results of his labours, adding the rider: 'It is still, however, more than probable that active steps will have to be taken to check the arrogance of Cetywayo, Chief of the Zulus.'

Cetewayo, as he was more commonly known to the newspaper-reading public, commanded some 50,000 warriors organised in an elaborate system of regiments, a legacy of his redoubtable uncle, Shaka. Several of Queen Victoria's civil and military representatives in Cape Colony believed he was behind the recent tribal unrest. He now threatened, in a context of recurrent hostility and uneasy partnership between Boer and British, to set alight the frontiers joining rich, white-settled Natal and Zululand to the north.

The Boer farmers, pioneering Dutch stock, knew their Zulus. To fight them, they argued with Thesiger, it was essential to form at every halt a defensive laager of waggons, similar to the tactics adopted by Western settlers against the Indians. 'At every halt. Breakfast, dinner, for the night, for anything,'—a long-bearded, bandoliered veteran of many skirmishes emphasised his point by thumping the table for the benefit of the tall, lanky Englishman, a man of retiring, well-bred disposition and to whom such outbursts were anathema. 'Oh, British troops are all right,' Thesiger replied airily. '*We* do not laager—*we* have a different formation.'

The words filled Melton Prior with gloom. He was sure that a clash with Cetewayo's *impis* was imminent, and equally convinced that, if war came, Thesiger would be in command. On his return to London after covering the Kaffir war, the special artist went to see his editor, William Ingram, and expressed a third convic-

tion: 'You take my word for it, if we do have a war with the Zulus, the first news we shall get will be that of a disaster.'

Melton Prior was right in all three forecasts.

Cetewayo contemptuously ignored the main demands of Britain's High Commissioner, Sir Bartle Frere; these were that a British resident should be accepted in independent Zululand and that the Zulu military machine should be dismantled. On 11 January 1879 Frere announced: 'The British forces are crossing into Zululand to exact from Cetywayo reparation for violations of British territory . . . and to enforce compliance with the promises, made by Cetywayo at his coronation, for the better government of his people.' Frere decreed that when the war was finished, 'the British government will make the best arrangements in its power for the future good government of the Zulus in their own country, in peace and quietness, and will not permit the killing and oppression they have suffered from Cetywayo to continue.'

In charge of the invasion was the new Lord Chelmsford, who had succeeded to the title on the death of his father in the previous autumn, and within eleven days he sent an entire British column to annihilation at the hands of Cetewayo's warriors.

That the Zulu king, from his kraal at Ulundi, ruled his nation with a tyrannical and brutal hand was beyond argument. Execution for disciplinary offences in his crack regiments was common. Retribution was swift and final for anyone who brooked his authority. If Britain, however, expected the Zulu people gratefully to seize the opportunity which—they were told—was being offered to free themselves from an abominable yoke, the premise on which such expectations was based was sadly ill informed. It reflected the arrogance of Victoria's representatives such as Frere and their lack of understanding of Zulu pride and character. While Frere's ultimatum hung in the balance, a Zulu emissary to whom the praises of liberation were being sung, retorted: 'Have the Zulus complained?' And so the 'oppressed' regiments of Cetewayo poured out in eager battle array on the undulating uplands and 'washed their spears' in the blood of the redcoats at a place called Isandlwana.

It was almost the classic Custer's Last Stand situation all over again: a modern, sophisticated army divided its forces in hostile territory, in the close presence of overwhelming numbers of the enemy, with disastrous results. Convinced that Cetewayo would hold his impis near his capital, thus offering the opportunity of destroying them in open battle, Chelmsford split his forces into three spearhead columns, aiming at Ulundi, with two others in reserve. The Zulus came out, however, and the central column of nearly 1,000 British troops and 800 native auxiliaries, was caught in its straggling (and un-laagered) camp at Islandlwana on 22 January. All but fifty British and three hundred blacks were slaughtered. Fourteen thousand Zulus had hit the British column. Four thousand of them, many armed with captured Martini-Henry rifles, now swept down on the little mission station and farm of Rorke's Drift, held by 140 soldiers. There they were held off in a fierce twelve-hour action that earned fame and a fistful of Victoria Crosses for the 24th Foot, the South Wales Borderers, a regiment that had lost six hundred dead at Islandlwana.

News of the Zululand catastrophe spread like a shock wave across Britain. It was the worst defeat to strike a British army in a colonial war. 'Unbelievable disaster' was the tenor of the headlines screamed at a public which had been none too sure of the wisdom of going to war against the Zulus at a time when Britain's army and resources were involved in an Afghan conflict. Indeed, during the earlier decade

The death of Lieutenant
Frederick Cockayne-Frith in
a skirmish in Zululand in
1879. The *Illustrated London
News* front-paged this engrav-
ing which shows the unfortu-
nate Frith being supported by
a cavalry colonel and (on the
left of the picture) Francis
Francis, war correspondent of
The Times, drawn with note-
book and pencil in top pocket.

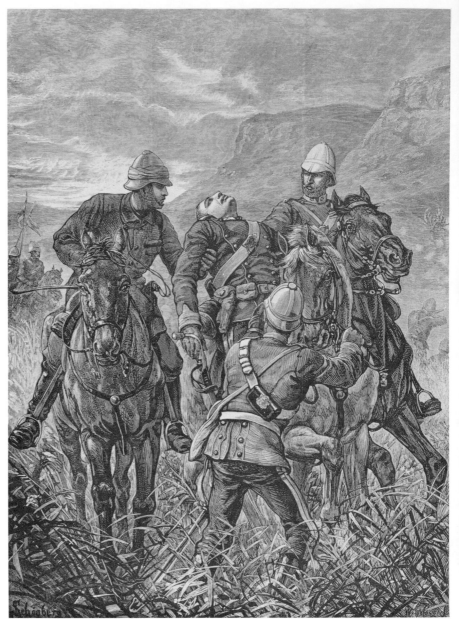

Britain had supported Zulu border claims against the Boers and Cetewayo's power
was popularly regarded as a useful counter against aggressive Boer expansion, a
means of 'keeping the Boer in check'.

Nevertheless the calls for retribution could not be ignored and reinforcements
were gathered together to feed a fresh invasion of Zululand. The public furore
caused by Isandlwana (or Sandula as it was known to troops and populace), the
desire to settle scores and his own determination to restore his reputation clearly
influenced Chelmsford's subsequent strategy. He ignored Cetewayo's peace over-
tures, thrust aside the advice and commands of superiors and ruthlessly pursued a
burning ambition to destroy Zulu power in its heartland.

The first invasion of Zululand had caught the British press unprepared. By March 1879, however, the principal news and picture papers had equipped their correspondents and artists for the fray. It was to be fluid warfare in wild country and the dangers to newsmen were ever present. They went well equipped with weapons to protect themselves. Francis Francis, a war correspondent, told his *Times* readers how a Zulu bullet struck down a lieutenant of the 17th Lancers as he rode by his side in a skirmish. The *Illustrated London News* front-paged the incident in a dramatic picture.

There was added news interest in the campaign because Louis Napoleon, the twenty-three-year-old Prince Imperial and exiled son of Napoleon III, was accompanying the army in Zululand. The British public had always been fascinated by 'Lou-Lou' following his arrival in Kent in the Franco-Prussian war and throughout his military education at Woolwich. Now, after intense lobbying by his mother, Eugénie, he was being allowed to ride as an observer with Chelmsford's troops. His presence in the war attracted French press attention and *Le Figaro* of Paris sent a correspondent called Deléage to keep an eye on the prince.

The *Graphic* assigned its special artist Charles Fripp, a wiry, agile little man of twenty-five with a keenness for action that led him into some tight scrapes and a mercurial temper that flared when he came up against obstructive military rules.

Melton Prior was sent by the *Illustrated London News*. He was by this time a special with some noteworthy war experience behind him. Besides Ashanti, he had covered a Balkan revolt against Turkish rule in 1876, the Russo-Turk war of 1877, and had only recently returned from the Kaffir war. His most hair-raising experience in this last assignment came as he sat conversing with a group of officers. It was a sultry evening and the windows and shutters of the room were thrown wide open to catch whatever breath of air there might be. He recalled later: 'Suddenly, with a swish, an assegai came through the window and stuck straight upright in the middle of our table.' The guard turned out, but no trace was found of the man who threw the spear.

From all these campaigns, Prior learned that the special artist had to take into the field his own comforts if he were to avoid the intense hardships of front-line life.

After Ashanti, his first war, he vowed never again to be caught with only the contents of a knapsack to sustain himself. For Zululand he bought himself a smart new khaki sun helmet, size six and seven-eighths (it was later retained by the *Illustrated London News* as a museum piece when he left it behind in the office to rush out to another war in 1896). A shotgun and a pistol were packed along with his sketching materials for the long voyage to the Cape, and several cases of whisky and brandy, and a soda-making machine, or seltzogene, were crated and labelled FRAGILE.

It was, however, his mode of transport in South Africa which aroused the greatest envy among colleagues and officers alike. 'I had no fewer than five horses,' he has told us, 'two in the shafts of my American waggon, one for myself, one for my servant and one spare horse. I followed the army through all its marches in my travelling carriage, and on the eve of the Battle of Ulundi I was the only man who had a tent; all the others lay down in the open.'

On arrival in the Cape, Prior, never one to turn down the opportunity of seeing action, made an uncharacteristic decision. The disaster to Chelmsford's central column at Isandlwana in late January had pinned down the right-hand column,

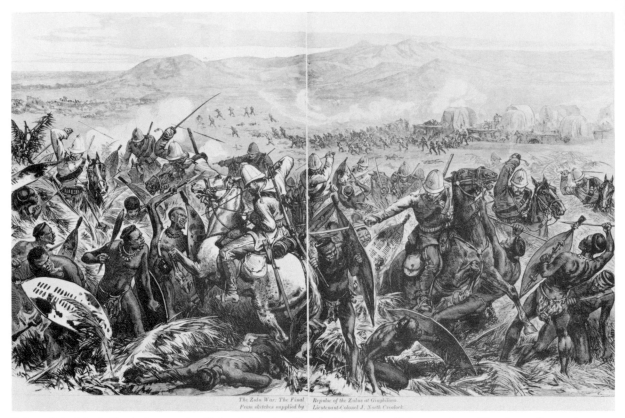

The Zulu War: The Final Repulse of the Zulus at Ginghilovo.
From sketches supplied by Lieutenant-Colonel J. North Crealock.

Colonel John North Crealock soldiered in many parts of the world and sent a steady supply of sketches to the London illustrated newspapers. His sketch of a fight with Zulus at Ginghilovo formed the basis of this two-page engraving in the *Illustrated London News*; much of his own style was 'steamrollered' out in translation by artists and engravers at home.

under Colonel Charles Knight Pearson, at Eshowe, about fifty-five miles to the east. The arrival of reinforcements enabled Chelmsford to launch a relief expedition, and Prior had the opportunity of joining it. While the expedition was being mounted, however, he had a vivid dream that he would be buried at Eshowe, which was a small mission station on its lonely plateau above the tumbled hills and forests of south eastern Zululand.

He wrote of it later in these terms: 'I am now going to mention a subject of which I am not particularly proud. I had been through several campaigns, some of them very disagreeable ones. I had run many risks and fear had never entered into my mind, but unfortunately, on my journey out on this occasion, I had a bad dream. I call it a dream, but I think it must have been a nightmare. It took place after I had arrived at Durban.'

He was of too practical a nature to let such a premonition easily deter him from joining an expedition which promised excellent picture material and copy. But before he could take the road he received a letter from his mother in Britain and she too expressed deep fears for his safety following a similar presentiment she had had about his early death in Africa. Prior decided not to go with the relief column.

However, his newspaper would have to be represented at the forthcoming engagement. Prior explained: 'I succeeded in enlisting the services of Colonel Crealock [John North Crealock, who had considerable artistic talent and often drew for the *Illustrated London News*], the chief of staff, and also engaged the services of a private individual named Porter. When the fighting did take place . . . my specially appointed artist was one of the first killed.' (Prior meant Porter). Crealock's illustra-

tion of the fight subsequently appeared in the *Illustrated London News*.

The incident had a profound effect on Prior and he was to play his hunch again a few years later in the Sudan when he thought 'the game was up'; on the second occasion his action almost led to the death he was most studiously trying to avoid.

In the base areas of Natal the correspondents and artists busily prepared themselves for another newsworthy foray. Some four months after Isandlwana, the battleground had still not been visited by a major British burial party; the dead lay rotting where Cetewayo's impis had caught them and the full story of the disaster remained to be told in the shambles of the battlefield. The army was now going to send a strong force to the scene.

Chelmsford, who believed in keeping strict controls on newspapermen, ordered the issue of press passes in order to exclude the presence of unauthorised persons in the war zone. The artists and reporters applied themselves to the task of becoming accredited. But for Prior there was another, and pressing, problem. The waggon he had bought from a country burgher for an extortionate sum overturned with a sickening crash of splintering whisky bottles. He discovered that a wheel was rotten and it had given way under the weight of his belongings. Anxious not to be left behind, he quickly found £40 to buy the 'American buggy' that was to see him through the campaign. Then he transferred his equipment, including the still considerable remains of his liquor store, and set off for the field of Isandlwana.

They found the dead scattered up and over the saddle of a hill in a straggling pattern that told its own story of the disaster. Here and there knots of corpses revealed where groups of soldiers had made a last desperate stand around a waggon. They were thick on the crest of a rise. It was, in the words of Archibald Forbes of the *Daily News*, a classic example of the results of 'employing loose formations against masses'; a resolute square based on the ammunition waggons, he opined, might have lasted until help arrived. Frantically shattered ammunition boxes and, particularly, the dearth of them around the fighting knots were in themselves clues to the roots of disaster on 22 January. Most of the soldiers had been separated from the vital ammunition waggons and had run short of cartridges for their Martini-Henry rifles when they most needed them.

In drawing the picture for the *Illustrated London News*, Prior was conscious of the susceptibilities of his readers. The full horror of the scene was not for the squeamish. Here, however, he was helped by nature. Four months of sun and rain had clothed the dead in a concealing shroud of grass. In places grain from the broken waggons had sprouted in a bizarre harvest covering the men of the 24th.

Down a precipitous ravine he found a jumble of wrecked waggons. In and around them were soldiers, their faces black and skin toughened like leather, flesh wasted away, almost skeletons. Some were held together only by their red coats. Many had been mercifully left alone by the vultures, so feasted were they on the horses, mules and oxen. Prior found letters and photographs, military documents and maps everywhere, the characteristic ephemera of death in battle, strewn like a macabre paper chase over the hill. Here, a skull was transfixed to the earth by an assegai through the mouth, there, he found evidence of dismemberment where the Zulus had collected boots.

Lancers picked their way carefully through the carnage, probing tunics for identification and moving bodies with the tips of their lances. The prevalence of hand sores among the searching soldiers made handling the putrescent corpses dangerous. Slowly, the dead were gathered together and the wreckage of the waggons burned.

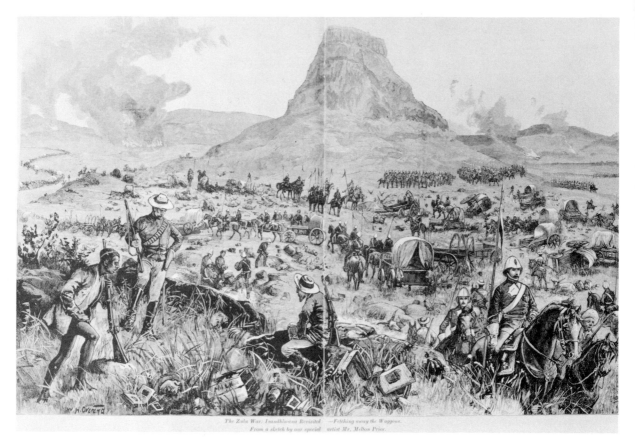

The Zulu War: Isandhlwana Revisited —Fetching away the Waggons.
From a sketch by our special artist Mr. Melton Prior.

When Melton Prior reached the field of the battle of Isandlwana four months had elapsed since an entire British column had been annihilated there. Long grass and sprouting corn—from the supply waggons—covered much of the evidence of disaster. His detailed sketch notes gave the engravers at home all they needed to know to produce this panoramic picture entitled 'Fetching away the Waggons'. ('*Illustrated London News*')

The smoke drifted over the grassland and mingled with that of nearby burning kraals, abandoned by the Zulus, until it seemed to Prior that the whole plain was become a funeral pyre for the dead of Isndlwana.

Chelmsford's operations, meanwhile, were concentrated on the build-up that was necessary for the final push to Ulundi, where he hoped January's massacre would be avenged by the destruction of Cetewayo's army in an assault on the king's kraal. Everything the army did moved towards this end. The decisive battle eventually came on 4 July, but a month before that an event occurred of such shattering calamity that it wholly occupied the attentions of the military commanders, created an international furore and became a bigger press sensation even than the defeat at Isandlwana.

Louis Napoleon, the Prince Imperial, had arrived in South Africa with a boyish enthusiasm to take part in the fighting. This, Chelmsford decided, was something to be avoided at all costs. As a boy, Lou-Lou was surrounded by military trappings. His baptism of fire by his father's side on the fringe of the action at Saarbrücken in the Franco-Prussian war had excited him beyond measure. Despite his training as an officer at the Military Academy, Woolwich, which prepared him for the artillery, the prospects of military service seemed remote. Neither Britain nor France wanted a Bonaparte serving under Queen Victoria's colours. In 1874, the year after his father's death, 6,000 Bonapartists descended on Chislehurst in Kent to honour Louis at his coming of age, on his eighteenth birthday. Now, as official head of the Bonapartist party, he was an even greater embarrassment to Victoria, who, although deeply

92

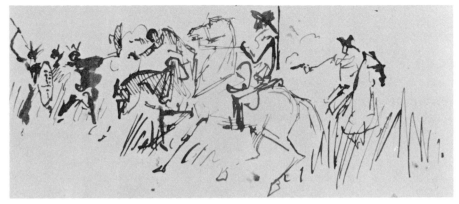

Louis Napoleon, the Prince Imperial, made this ink sketch in Colonel Crealock's tent shortly before his fatal meeting with a roving band of warriors. It shows irregular cavalry engaged with Zulus, though up to this time Louis had seen little of the enemy. (*National Army Museum*)

attached to the Empress Eugénie, nevertheless recognised the anomaly of Britain's providing an exile haven for Napoleon's great-nephew.

After Isandlwana, Louis begged the Duke of Cambridge, Commander-in-Chief of the British army, to let him go to Zululand. To the Prime Minister, Disraeli, this was unthinkable: how could a French prince serve with the British army? The Prime Minister had not allowed, however, for the persuasive powers of Lou-Lou's mother, Eugénie. She felt there could be no harm in her darling boy going out to look at a campaign which she regarded as nothing more than a disciplinary action against a few wayward blacks. Her blandishments won, and Cambridge wrote to Chelmsford saying that Louis was on his way 'on his own account to see as much as he can of the coming campaign in Zululand'.

Not at all sure what to do with his fragile charge, Chelmsford put him on the staff as an extra aide. Prince Louis delighted in even the most distant whiff of action and he displayed a touching enthusiasm for the most menial tasks, such as topographical sketching, that would take him out on patrol. He had some artistic ability and sent home some scrawled ink drawings of patrol work in the field as the columns moved towards Ulundi. Among the pressmen, the artists Fripp of the *Graphic* and Prior found him a friendly companion, as well as being a ready subject of material on quiet days: whatever the Prince Imperial did was news, and his dashing figure formed the nucleus of several drawings sent home from the front.

On the morning of 1 June, Prior was standing by his waggon, which was on the edge of the laager of General Evelyn Wood's flying column near Itelezi. A small troop of horse came riding through the perimeter defences, on its way out to the bush. Leading it were Louis and Lieutenant Jahleel Carey. With six mounted volunteers of Bettington's Natal Horse and a native scout, they were going to survey and sketch a proposed camping ground in the nearby hills, not necessarily a dangerous operation, but previous sightings of and light skirmishes with roving bands of Zulus dictated that the Prince Imperial should have a small but well-armed escort of experienced troopers.

An officer shouted to Louis: 'Take care of yourself and don't get shot.' The prince, delighted with the prospect of going out into the field, waved and replied: 'Oh, no. Carey will take very good care that nothing happens to me.' Prior said that he was the last man the prince spoke to before leaving camp. 'Good morning, Mr Prior,' said Louis. 'Goodbye, sir,' answered Prior. 'I hope you have a jolly good morning.'

In the evening of that day, Prior watched General Wood and Colonel Redvers

Buller trotting out with an escort of a few troopers to inspect a pool which, it was thought, might ease the strain on the camp's water supplies. The senior officers halted some distance away, but near enough for Prior to detect their consternation as a single rider galloped furiously towards them from the direction of the bush. It was Lieutenant Carey. Within minutes the small group rode back to camp and quickly the news spread through the column. The unthinkable had happened. The Prince Imperial had been killed.

Archibald Forbes was dining with some senior officers and newspapermen in the tent of the cavalry commander. A colonel put his head into the tent and exclaimed: 'Good God! The Prince Imperial is killed.' No one, at first, took him seriously. The party was drinking well and several of the officers laughed; one threw a piece of bread at the colonel. But it was true enough. Carey blubbered out the news of the disaster to the appalled General Wood. The party had been jumped by a marauding band of Zulus. Louis was caught before he had time to mount. He was one of three men missing. The remainder rode for their lives.

At first light 1,000 men were organised to search for the Prince's body. The newspapermen—Prior, Fripp, Forbes, Francis of *The Times*, Mackenzie of the *Standard*, and, of course, Deléage of *Le Figaro*—were given permission to ride with the searchers, who spread far and wide over the countryside.

Prior was riding alongside Forbes, when they saw a soldier holding up a rifle. 'There it is, Prior. Come on, ride for it!' shouted Forbes, who galloped off furiously on his huge horse. An ex-Dragoon, Forbes was a fine horseman, and he was the first of the newspapermen to reach the soldier in a shallow gully.

Prior wrote:

I saw the Prince Imperial lying on his back, stark naked, with a thin gold chain round his neck, to which was attached a locket containing the portrait of his father, the later Emperor Napoleon the Third. The Zulus had stripped him, and taken away every particle of clothing, but looking on the gold chain and locket as a fetish, had respected it, and left it still around his neck. The French correspondent, leaning over with tears streaming down his face, took an English penny from his pocket and placed it over the Prince's eye (the one which had received a spear thrust) in the hopes of closing it.

Louis, dismounted, was last seen pursued by about a dozen Zulus. Realising the futility of flight, he had turned and faced his attackers. The odds were too high. The assegai through his eye penetrated his brain. He was found with his hacked arms over his lacerated chest. There were other wounds; these had been inflicted after death. His sword, once carried by Napoleon Bonaparte in battle, was missing (it was later returned by Cetewayo as a token of reparations). The cavalry scouts who found him made a stretcher of blankets over their bamboo lances, and this is how they brought the Prince Imperial back to camp.

His death was clearly an event of such news importance that Prior could waste no time in sending to London pictures of the search for and the discovery of the body; the army had already sent a despatch rider to the nearest telegraph point to relay the news to Britain. Strict blackout regulations were imposed in the flying column's camp, but Prior requested and received permission to light his tent and he worked through the night until 5 am, preparing nine sketches of the Prince Imperial's death. At dawn the artist's best horse was saddled and a Kaffir galloped to Landman's Drift, some thirty miles away, with Prior's sketches. From there, they travelled to

After the death of the Prince Imperial, Melton Prior sketched the return of his body to camp. It appeared as an engraving in his newspaper a month after the event, having started its long journey to London in the saddlebag of a Kaffir rider. (*National Army Museum*)

the Cape and eventually made a scoop for the *Illustrated London News*.

It took about a month for Prior's sketches to arrive for publication. In the meantime the press had treated the news of the Prince Imperial's death like a major national disaster. The *Illustrated London News*, for instance, ran column after column of extra-width measure, recounting the life story of Louis and the circumstances of his death in Zululand. Until Prior's sketches arrived—and when they did, their publication coincided with the prince's funeral, as the drawings had kept pace with the royal body on its journey half-way across the world—the *Illustrated London News* relied for pictorial coverage on illustrations of scenes from Louis's life.

There was a view of him in baby clothes, even a drawing of an assegai—'The weapon which slew the Prince Imperial.' And, of course, Richard Caton Woodville contributed his obligatory artist's impression, dredged largely from imagination: a two-page spread showed the gallant prince in a highly romanticised pose, facing the onset of the Zulus with his back to the wall of the gully; the caption was 'AT BAY'.

It becomes apparent from the study of special artists' diaries in the field that each one would develop a pattern of working based on close personal co-operation with a reporter colleague who was nearly always employed by a newspaper not directly in competition with the artist's own. Thus, in Zululand, as in other campaigns, a rapport and working arrangement flourished between Melton Prior and Archibald Forbes of the London *Daily News*. It was sensible to operate in harness like this, for what the writer discovered often complemented the work of the special artist, and vice versa.

As the *Graphic* was in keen competition with the *Illustrated London News*, co-operation between Charles Fripp and Melton Prior was essentially limited to routine coverage. It is a sound and tested maxim among journalists that there is little point in making the job more difficult by excessive emphasis on independent operation, especially in routine matters. On the other hand, a scoop is a scoop. If Prior was experienced and shrewd enough to organise his lines of communication better than

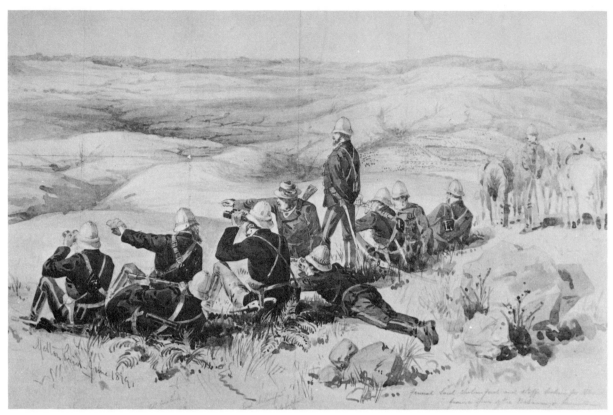

In monochrome watercolour, Melton Prior sketched General Chelmsford and staff plotting out the location of Ulundi, the Zulu king's capital. The squared grid which can be seen on the picture was superimposed to allow the engravers to transfer the scene to a wood block section by section. (*National Army Museum*)

the younger Fripp's, he was entitled to the pleasure and kudos of having his pictures published first in London.

Two incidents which occurred during the army's preparations for the battle of Ulundi underlined the growing and, at some times, acerbic rivalry between the two specials. In the first incident, the authorities had ordered that all unnecessary encumbrances should be dispensed with on the final approach stages to Cetewayo's kraal at Ulundi. Patrols of military police were therefore posted to turn back war correspondents' carts as they queued to cross a small ford. The resourceful Prior, who had recently injured a knee in a riding fall, begged permission to keep his 'American buggy' as, he argued, he was not yet fit enough to take to the saddle. By a series of highly suspect pretences that he had senior authority for this, he did, in fact, manage to retain his travelling outfit intact—hence his boast that he was the only man on the eve of battle to sleep under canvas.

His achievement was a matter of comment and even jealousy among his press colleagues. Never one to hide his luck under a bushel, he could not resist at one point in the final march calling from his waggon to a surgeon acquaintance: 'How about a brandy and soda, Major—or would you prefer a whisky?' The major could not believe his ears. But there, inside Prior's cart, as the two armies manoeuvred for position on the plain of Ulundi, the major was served with 'sundowners' by Prior. The artist's only regret was that his boy could not provide ice. Thus, in comparative luxury, Prior enjoyed a leisured approach to the big battle and was able to indulge himself in some fine watercolour work of the reconnaissance patrols in front of Ulundi.

Fripp was determined to outdo his rival. In an excess of zeal, he lingered on the Zulu bank of the White Umvaloosi river after the cavalry reconnaissance patrol he was accompanying had retired under enthusiastic but inaccurate fire. Redvers Buller, from the safety of the British bank, snatched up his field glasses and focused them on the short, lonely figure still sketching on the enemy side. This senior officer had little patience with newspapermen. He had threatened to horsewhip a correspondent on the Gold Coast and had thrown another out of the mess tent for what he considered an offensive remark.

'Come back this instant or be sent as a prisoner to the rear,' Buller shouted to Fripp. Fripp obeyed, but he was furious. The quick-tempered artist demanded to know by what authority Buller had given him such a severe public dressing down. For a moment it looked as though he was going to assault the officer. At that moment, however, Lord William Beresford, a brave and popular officer, rode by, his tunic covered in blood from a brush with a Zulu scouting party. Beresford was amused to see the bantam-sized Fripp squaring up for a fight; he threatened, good humouredly, to horsewhip Fripp if he did not speak with more respect of a senior officer. Fripp launched into him, arms flailing in fury, and it took the combined strengths of Melton Prior and Archibald Forbes to drag the pair apart and carry off the struggling artist.

The ensuing battle, the climax to months of campaigning, the peak of Chelmsford's immediate objectives in Zululand, was quick and decisive. Archibald Forbes described the scene for his readers: 'Over the green face of the great flat there flitted what, seen through the heat haze, seemed dark shadows, but with the field glasses these were revealed as the impis of Cetewayo practising their manoeuvres.'

Almost quixotically the Zulus held their fire while the British formed up their troops and collected their extended supply trains, which were scattered in dislocation over the broken ground leading to the plain of Ulundi. It was, said Forbes, as if the Zulus were saying: 'Are you quite ready now, gentlemen?' Then, in their traditional buffalo-horn formation, the impis flowed across the plain 'like ripe corn in the wind'. Thundering their short stabbing spears against their hide shields, Cetewayo's men stamped forward to their doom. The power of artillery and Gatling guns, the resolute use of trained riflemen and the right choice of when to unleash the lancers, all this smashed the might of 20,000 Zulus in little over half an hour.

In the course of the fight Prior found himself actually weeping. They were tears of anger and frustration; to his horror he discovered he had lost his drawing book containing valuable sketch notes. As the Zulu bullets whizzed around him, he blundered wildly through lines of advancing redcoats to seek his horse. He was sure he had left his sketches in the saddle holster. But they were nowhere to be found. Not only were the preliminary scenes of the battle missing, but also a mass of sketch notes of the whole campaign. Had they been stolen? Was Prior a victim of jealousy? Later he posted a £25 reward for his sketch-book, but it never turned up. Somewhere, if it exists to this day, it would be a valuable and historic find.

Meanwhile, Cetewayo had fled his now burning kraal (he was captured just over seven weeks later), and there was an eager race by the British to be first inside the Zulu capital, where rumour said there was a treasure trove. The soldiers, however, discovered in the king's house no more than a seedy hoard of long emptied champagne and gin bottles, a tin chest full of old blacking brushes, the miserable bric-à-brac of a ruler whose wealth had lain in men and muscle.

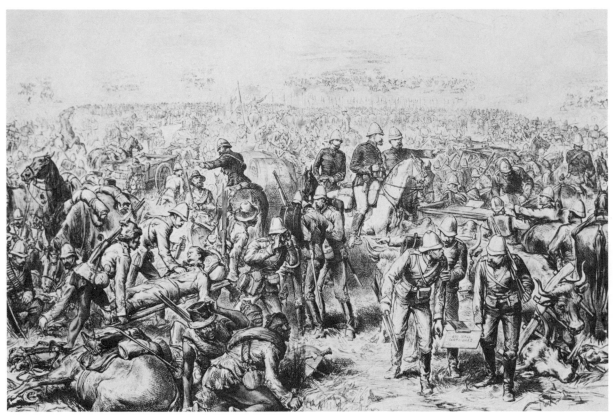

From a sketch by Melton Prior—inside the square at the battle of Ulundi. Prior wept during the battle because he lost his sketchbooks. Later, he drew the scenes again and gave them to war reporter Archibald Forbes, who rode through Zulu-infested territory at night to speed the drawings and news despatches on their way to London. (*National Army Museum*)

Prior, his disastrous loss temporarily forgotten in the desire to be in at the kill, joined the mad rush for the kraal. He was busy sketching amid the holocaust of flames when he saw a Zulu sneaking towards him, assegai in hand. He thrust his sketching materials in his pocket, spurred his horse and cleared a blazing fence on his way out to safety. That evening he had only half an hour to complete his drawing of the battle of Ulundi in order to take advantage of a remarkable offer by his colleague and friend, Archibald Forbes.

Forbes considered that one of the prime duties of a war correspondent was to wage unceasing war against military obstruction and ineptitude. After many campaigns in far away climes, he had no illusions about the way his ilk were regarded by the military commanders in the field. 'Were I a general,' he wrote in later life, 'and had I an independent command in war offered me, I should accept it only on condition that I should have the charter to shoot every war correspondent found within fifty miles of my headquarters.'

In these words Forbes revealed his enduring credo that the attitude of commander and correspondent towards the dissemination of information were often totally opposed. When, therefore, he went to Lord Chelmsford after the battle to demand some means to send out his despatch he was aware that he might find an unsympathetic response, and was in no mood to brook such a refusal.

Chelmsford, not unreasonably, pointed out that the country around and behind the army—the country through which any courier would have to ride—was still seething with roaming bands of Zulus which had not been dealt with by the mopping-up operations. He had no intention, he informed the reporter, of sending a

military courier with the news of the victory until the following morning.

Forbes had written his account of the battle; Prior had handed to him his sketch. They had seen the most decisive confrontation of the campaign and the reporter argued that the people in London deserved the right to know about it as quickly as possible. Quite apart from that, the High Commissioner, Sir Bartle Frere, should be given the news in Cape Town and Sir Garnet Wolseley, now on his way to take over as commander in Zululand, should be informed. Chelmsford's refusal to send a courier was point blank: he was awaiting further details of the action and its after-math.

'Then, sir, I will start myself at once!' Forbes exploded. Afterwards he admitted: 'I was sorry for myself the moment I had spoken.' Between Ulundi and Landman's Drift, the nearest telegraph point, lay a hundred miles of Zulu-infested territory, seventeen hours of rough riding where an ambush might be waiting in every gully and behind every outcrop on the way. 'I rode out of Umvaloosi laager that night because I have a quick temper and a disgust for military ineptitude,' admitted Forbes. He rode with the knowledge that two messengers, a lieutenant and a cor-poral, had been hacked to death on this route only hours before.

In the face of Forbes's insistence, Chelmsford gave in and allowed him his grudging permission to ride. In addition to his own story and Prior's sketch, he carried certain staff messages, although the detailed report of the battle was not yet ready. An aide bet Forbes a fiver he would not get through to Landman's Drift, and when Forbes accepted the bet the officer wisely suggested that Forbes should put his stake down. 'So,' wrote Forbes, 'I posted my fiver and rode away into the dense, all but trackless bush, just as the great red sun touched the westward ridge over-hanging the Umvaloosi gorge.'

It was a nightmare ride over broken ground where thorn bushes tore his clothes to shreds. After little over half the way, horse and rider were covered in blood from scratches and weals. Several times Forbes had to halt in shadows thrown by the moon as Zulus passed nearby. 'I could see dark figures of Zulus up against the blaze of the fires in the destroyed kraals and their shouts came to me on the still night air . . . The longest 20 minutes of my life while lost and waiting for the moon to rise in a glade to show the way . . .' Forbes made a mental note of the incidents and realised as he ploughed on to Landman's Drift that he was making news as well as carrying it.

Landman's Drift was reached at sunrise. The news was telegraphed to Frere in Cape Town and Wolseley, on his way to Zululand. The message to Frere was relayed to London and was read in the Commons, the first inkling Britain had of the victory. At Landman's Drift Forbes also sent off his first short despatch to the *Daily News*. Then he changed mount and rode a further three hundred miles to Pietermaritzburg to catch the mail with his full account and Prior's sketch. Prior made it into print a full week before any other on-the-spot picture reached the London blockmakers. Afterwards, Forbes waged a long and bitter campaign to receive the South Africa Medal, which would have meant official recognition for his carrying military despatches on his famous ride. He failed. To the top command he was to remain, like any other newspaperman at war, an outsider. He was, after all, merely a war correspondent, one of a band of men once described by Wolseley as 'the curse of modern armies'.

9 Balkan Tragedy

With the greatest difficulty I strove to keep the little beast under me from being impaled on the bayonets of the reckless soldiers as they stumbled over the deeply rutted fields in the gloom of the coming night

Frederic Villiers, special artist

Little wars set in the exotic environment of the British Empire were fertile ground for the talents of the special artists. They furnished a ready and regular source of news and pictures, and when Victoria's soldiers temporarily rested on their laurels editors always had the shifting map of central Europe to fall back on.

American newspapers, in the aftermath of the Civil War, were generally pre-occupied with national problems and the reconstruction of their nation. Remote battlefields of Europe had little significance to them and their readers. On the other hand, the *Illustrated London News* and—after its birth in 1869—the *Graphic* of London fed their public a steady diet of European wars when peace reigned over the empire on which the sun never set.

When Prussia went to war with Austria in 1866, the *Illustrated London News* had no fewer than three specials operating in the war zone. From its man in the mountains with the troops of the publicity-conscious Garibaldi, there was a prolific flow of pictures of the 'sideshow' at Austria's back door. The man with the Prussian armies in Bohemia was restricted in his movements by the authorities, had great difficulties in getting to the front line, and sometimes relied on sketches provided by Prussian officers.

In Vienna similar restrictions irked Frank Vizetelly. 'I began to fear that there would be no powder burnt in any of my illustrations,' he wrote home to his paper in near despair. But by diligent lobbying of the Archduke Albert's staff he finally found his war and depicted the gaily decked lancers and hussars of the two German nations slaughtering each other in battle. In the meantime he filled in his time by drawing a multitude of behind-the-lines activities in wartime Austria, and achieved front-page prominence with a picture of some unusual prisoners of war: a cartload of Prussian *vivandières*, or camp-following sutlers, seized by the Austrian hussars.

From London, Paris and other publishing centres newspaper artists were constantly on the move as the clouds of war drifted across Europe and ultimately settled in semi-permanence over the troubled Balkans. Here, for a quarter of a century, the specials found regular employment. The craft of the special artist was by this time in full flower and many practitioners had their first experience of war in the Balkan killing ground, the most distinguished of these being Britain's Frederic Villiers.

When Villiers, in retirement and nearing the age of seventy, looked back over his 'five decades of adventure', he wrote: 'It is a coincidence worthy of note that my first sketches which appeared in any illustrated paper were of fire and smoke; for half a

century thereafter fire and smoke, though of a slightly different character, have been the "local colour" of the principal subjects to fill my sketch-books.'

Through the half-century, Villiers soldiered as a special artist on many foreign fields, but his baptism of fire was on a hill above north London, where the Victorian exhibition centre and pleasure-grounds of Alexandra Palace had just had its royal opening. Villiers was a young art student. He had freshly returned from Paris where, after the Franco-Prussian war and the Commune, he had been engaged in drawings for a panorama depicting France's struggle. The experience had left him with an awakening taste for movement and adventure. In art school the daily routine of anatomical drawing he found 'tiresome and uninteresting' (it is, incidentally, unfortunate that he did not persevere at this basic training, as figure drawing throughout his career was not one of his strongest subjects; when he died *The Times* described him as 'an artist of moderate ability').

Thus one fine day found him, having abandoned his art classes, climbing the hill to Alexandra Palace where there was a loan exhibition of modern art. There, he was first to spot a small flame and a whisp of smoke under the great dome. In no time the dome was filled with dense smoke and the fire was rapidly gaining the upper hand.

'I first thought to make a sketch, but quickly changed my mind,' Villiers explained. He decided it was his duty to try to rescue the valuable paintings in the main gallery, and to this end he swiftly organised a crew of gardeners and labourers,

Even when censors and military obstruction prevented Frank Vizetelly from reaching the battle lines, his eye for the interesting and unusual succeeded in seizing front-page attention. Temporarily barred from the Austrian front in 1866, he produced the sketch that formed the basis of this *Illustrated London News* engraving: Prussian *vivandières*, women sutlers, captured and transported through Vienna to the amusement of the public.

and led them through the billowing smoke to save the collection, which was then piled in heaps on the lawns outside.

With a panache that was to see him through many tough spots later in his life, he went on to dispense to his exhausted and thirsty crew of amateur firemen several bottles of Moët et Chandon champagne which had been carried out of the burning refreshment room. The palace caterers later sent him a hefty bill for the champagne, which Villiers haughtily ignored.

When all the paintings were safe Villiers took out his sketch-book and made several drawings of the blazing palace, whose great dome had collapsed in a holocaust of flames and sparks. He sent the drawings to the *Graphic* weekly which published them in the next edition. It was his first contact with illustrated journalism.

A short time later, in the early summer of 1876, he read in an evening paper that the Christian Prince Milan of Serbia had declared war on Turkey. Milan was acting as champion for his neighbours, the oppressed Bulgarians, who were suffering under the yoke of the creaking but still powerful Moslem empire. It was for newspaper readers a David and Goliath situation, but everyone knew that from such a Balkan spark a flame could grow and involve the continental powers of Europe in a major conflict.

Villiers wrote to the *Graphic* 'offering my services in the coming campaign'. The next day he received a telegram asking him to call on the manager, William Thomas.

'Can you speak French or German?' asked Thomas.

'I can get along fairly well with French,' said Villiers.

'That will do. When can you go?'

'At once.'

'Then please start by this evening's mail.'

At the age of twenty-four Frederic Villiers fancied himself 'the luckiest and happiest of mortals'. That evening he left his mother in tears at Charing Cross Station and, with a bag of gold sovereigns in his pocket and a letter of introduction from his editor to the war correspondent Archibald Forbes of the *Daily News*, he was off to war.

The veteran Forbes was already in the war theatre and was soon to write brilliant despatches about the gallant fight of a raw militia against the overwhelming Turkish odds. News of Turkish atrocities against the Bulgarians had percolated through to western Europe. The Turks were naturally extremely sensitive about these reports and attempts by correspondents and artists to cover the Bulgarian sufferings had met with obstruction and arrests in the early months of 1876. An anonymous special artist of the *Illustrated London News* had drawn his own arrest by a squad of fez-wearing Turks and such incidents fuelled anti-Turkish feeling in the West. Understandably, British and American newspapers concentrated on coverage of the Serbian side, where a principality of one and a half million Christians was fighting for its life and the independence of its neighbours against a Moslem giant.

An outstanding champion of the Bulgarians was an American correspondent of Irish extraction, Januarius Aloysius MacGahan, who had worked for the *New York Herald* and was commissioned by the London *Daily News* to report on the Balkan troubles. He pulled no punches in his revelations of Turkish atrocities, describing in close detail how 12,000 Bulgarian men, women and children were murdered by the Turkish mercenaries, the Bashi-Bazouks and Kurds. 'I fear I am no longer impartial, and I am certainly no longer cool,' he wrote to the *Daily News* in the summer of

1876. 'There are things too horrible to allow anything like calm inquiry; things the vileness of which the eye refuses to look upon, and which the mind refuses to contemplate.' His despatches caused indignation across the world, undoubtedly influenced Russia's intervention in the war in the following year, and led to Bulgaria's eventual independence.

The four-month campaign of 1876 was a nasty, fluid war, which offered war correspondents and artists plenty of scope for the deployment of individual initiative. This and its immediate sequel were also most dangerous wars for them. Of twelve who saw the Balkan campaigns through, four died and four were wounded. MacGahan himself became a victim and died from typhus. Villiers was racked by fever and exhaustion. None came out of the fighting without physical or mental scars they were to bear all their lives.

It was the most demanding introduction to war for a novice special artist and hardly surprising then that Frederic Villiers sought out the experienced Forbes as a first priority when he arrived in Belgrade, the Serbian capital. Villiers confessed: 'I added to my outfit riding boots, spurs and a moderately-sized bulldog revolver to prove myself in his eyes, directly he saw me, a determined young fellow out for adventure.'

Forbes had moved up to the front and Villiers set off after him by stagecoach. At the Serbian army headquarters in a small provincial town, the war artist found a

As in many other European wars, arrests of correspondents were a common occurrence in the Balkan troubles. An anonymous artist of the *Illustrated London News* drew himself being detained by Turks in the Bulgarian town of Rustchuk in 1876.

scene of exotic colour and movement. Peasant warriors strutted around amid a profusion of cattle, pigs, donkeys and geese in the market square; some of the fighters carried knives and silver-mounted pistols stuck in their belts. White linen tunics were set off by red sashes, and headgear ranged from the fez to fur bonnets. 'But,' wrote Villiers, 'the most striking figure in the whole of this busy scene, sauntering along, elbowing his way through the motley crowd, was a tall, well-knit man in knickers and jacket of homespun with tam-o'-shanter bonnet cocked over his handsome, sunburnt face and a short cherry-wood pipe protruding from beneath his tawny moustache.'

It was, of course, Archibald Forbes, who immediately invited Villiers to a schnitzel and a bottle of beer. That evening some wounded Bulgarian refugees limped into town. Forbes wrote the story of their ordeal at the hands of the Turks, adding a footnote that Villiers of the *Graphic* had arrived on the scene and soon the public would have pictures to illustrate what he had written. Villiers remembers: 'Those simple words in Forbes's telegram established me in the eyes of my editor as a worthy representative of the *Graphic*.' A friendship had been born that was to last all their lives.

When permits to join the forces in the field were issued, Forbes and Villiers found they had been allotted respectively two different sectors of the line. They embraced and parted. Villiers was once more on his own. Later their paths crossed again and they saw much action together.

Forbes has told how, later in the campaign, they engaged a servant called Andreas, an experienced brigand in the game of survival, a seasoned bargainer and a passable cook. Villiers found Andreas shifty and failed to get on with him; nevertheless he recognised Andreas's indisputable qualities of resourcefulness. Once, detained by Turkish soldiers, Forbes was rescued by the fast-talking Andreas who donned a fez for the occasion.

The strange trio travelled through the Balkan war zone in a cart which they had bought and covered with a leather awning. Andreas bought two grey horses, one of which was blind. This, explained Andreas, was no problem as it made him steadier in a crowd. They travelled with a stew pan and a frying pan. At night they slept on the floor of the cart on a bed made out of cushions and chickens trussed at the legs. Forbes complained: 'Villiers is an excellent fellow, but he had, like the rest of us, his weak points. Perhaps his weakest point was that he imagined going to bed in his spurs contributed to his martial aspect. He may have been right, but as I shared his bed-place on the floor of a narrow waggon, I did not see the matter quite in that light.'

The obtaining of permits and embryo attempts at censorship were a constant harassment to correspondents during the Balkan wars of 1876, 1877 and later. In the Russo-Turkish war of 1877, Melton Prior covered the fighting from the Turkish side (much to his proprietor's annoyance, he insisted on taking his wife out with him to Constantinople), and ran into serious trouble with Mehemet Ali's censors. He discovered, after a series of anxious telegrams from London, that the Turkish officer in charge of censorship had held up six weeks' consignments of sketches because the army authorities considered that they showed the Turkish cause in a poor light. Prior countered by drawing six sketches of Turkish atrocities and defiantly submitted them to the censor. The officer refused to pass them. Prior threatened that if things did not improve, he would pack his bags, leave the war zone and return home to draw twelve, twenty or more, telling the whole truth about Turkish brutality.

Johann (John) Schönberg, an Austrian artist whose name often appeared on finished engravings, had considerable experience in the field as a special. In the Serbia–Bulgarian war of 1886 he did two 'shop' drawings for the *Illustrated London News*: inspection by censors of correspondents' letters and sketches (*above*) and war correspondents reconnoitring the lines by night.

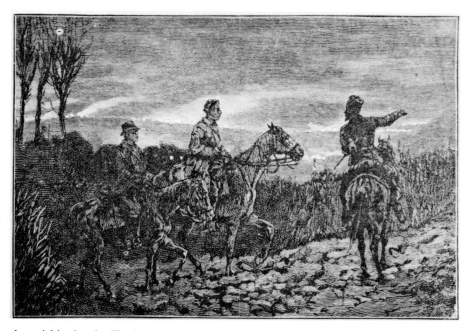

Astonishingly, the Turk relented and passed Prior's material; but a few months later he took his revenge on Prior by having him arrested.

Johann (John) Schönberg, an Austrian artist formerly working for the French *Le Monde Illustré*, and employed by the *Illustrated London News* in the various Balkan campaigns, in South Africa and in the 1900 Boxer rebellion in China, believed in telling the public at home of the difficulties under which artists and reporters worked. When Bulgaria went to war with its erstwhile champion Serbia in 1886, his London newspaper illustrated newspapermen having their sketches and letters

inspected by Serbian censors, and war correspondents reconnoitring the lines on horseback at night.

For the young Villiers, however, as he headed alone into the mountain war zone of Serbia in the summer of 1876, the problems of censorship and military obstruction were difficulties he still had to meet, and if he thought about them at all, they were but a minor irritation in his eagerness to experience his first action.

His blooding came on a mountainside above the river Ebar, where the Serbians, with more enthusiasm than military ability, were poised to invade Turkish territory. Like many war artists earlier and later he discovered a simple fact of battle life: that once the guns start firing, you cannot see for smoke. In Villiers's words, the smoke formed a perfect fog, long in lifting. He was to experience many battles in his career, but his recollection of this first action in Serbia is worth quoting in detail:

Soon the air was filled with a curious rushing sound, like that of a low-toned foghorn, followed by a terrible explosion and a yellow flash of fire. Then the top of a pine tree on our left flew in splinters. The noise from that mutilated pine was as if a huge tuning fork had been struck, the vibration making the ground tremble where we stood.

The Turks were returning the fire of our battery and this was their first attempt to get the range. For some time the pines were the only sufferers; therefore I was surprised to see our gunners suddenly limber up and begin to retire. This was done slowly at first, then the horses broke into a trot, and at last, under the lashes of their drivers, galloped furiously toward the road up which we had advanced. I was watching with astonishment this rather—as I thought—premature movement, when my reverie was broken by a sudden rush of infantry coming through the fog of cannon smoke which was now lifting from the earth.

As these men crowded together on entering the forest road, one of the enemy's shells, instead of striking the pines, burst right in the midst of the retreating crowd. Then, for the first time, my eyes were opened to the ghastly realities of war. Before the report of that exploded shell had passed away at least half a dozen poor fellows lay writhing, almost torn to fragments with its splintered segments, drenching the turf with blood. At the sight a faintness crept over me and for a moment paralysis seemed to hold my limbs. But only for a moment, for now the air was charged with a noise like that of the buzzing of mosquitoes or the lash of a fine whip, Whit! Whit! Ping! And then, straight in front of me, a few feet above the ground, little puffs of smoke floated upward like soap bubbles. Behind these puffs of smoke, waving through the scrub like poppies in a cornfield, flashed the red fez of the Turk.

Villiers had no chance to make any sketches. Now he realised that there was nothing between him and the enemy except 'a few boulders and about a hundred yards of space'. He did the only sensible thing and fled, joining the headlong rout of the Serbian army. There was a nightmare scramble down through wooded paths towards the town of Alexinatz. Torrential rain drenched the retreating Serbians, now a disorganised jumble of infantry, baggage waggons, ambulances, cavalry and guns. Turkish gunfire fed the nightlong panic, and wounded and exhausted stragglers were trampled under the hooves of a herd of cattle that blundered at a gallop through the broken army.

In Alexinatz, a bastion which held out against the Turks, Villiers was relieved to

find Forbes. The artist was all for quitting the town before the Turks captured it. Forbes, the professional, calmed him: 'Plenty of time. They are just playing up to the grand finale and that's when we ought to be there. Come, sit down now and eat your dinner.'

The 'finale', Villiers found, did not come for some days. In the meantime, he and Forbes were kept busy at a makeshift hospital run by a British medical team under a Dr MacKellar. Through long nights Villiers swabbed and bathed and bandaged an ever-growing tide of wounded Serbians. He learned to recognise the moment of death, the moment when the incumbent of a bed or stretcher could be tipped out onto a pile of corpses to make way for new wounded. He poured brandy down the throat of a man without a face. He many times collapsed with fatigue over the wounded he was tending. Once he went up to the Serbian outposts with Forbes and a Russian war correspondent, where they found three Russian women, Red Cross volunteers, working 'up to their armpits in blood' in a field hospital. The correspondents had a cart and Villiers tried to persuade the Russian women to leave for a place of safety. One of them, in Cossack jacket with a pistol slung across her shoulders, snapped at him: 'Sir, who are you?'

'I am a war artist,' explained Villiers.

'Then, as a non-combatant, seek a place of safety and leave us alone.' The nurse dismissed him and returned to her work.

It was now clear that the Turks were about to break through the remaining defences. Once more Villiers joined the retreat towards Alexinatz. In the disorder he lost contact with the Russian war correspondent. Later that evening he found him in a roadside medical post, laid out for burial, a bandage over his neck where a stray shot had killed him.

In one of those inexplicable lulls that happen in warfare, the Turks held their hand and the town of Alexinatz received a temporary reprieve. Forbes decided to ride to Belgrade with his despatches and Villiers's sketches. The two comrades agreed to rendezvous in the embattled town on the correspondent's return. Villiers was, in any case, too weak from exhaustion to travel and Forbes left him in the care of the British medical team. On his return to the front some days later, Forbes was told that the town had fallen. Where on earth was Villiers?

No one in the throng of panic-stricken humanity that filled the road wanted to stop to answer questions, until Forbes, by chance, came up with some of the British doctors. They had been forced to swim a river to escape from Alexinatz. Villiers, somewhat recovered from his exhaustion, had decided to stay in the town—'to finish my dinner and wait for Forbes', he had explained. Then Forbes came across the servant Andreas, driving the waggon; Villiers, he said, had dismissed him and had then gone to bed at a hostelry known as The Crown in Alexinatz. Forbes ploughed disconsolately through the mass of oncoming refugees and was about to give up his search when he met Villiers, walking along, smoking a cigarette. What, asked Villiers, was all the fuss about? Had they not agreed to meet in Alexinatz? He had left the town only because he had run out of food. It had not yet fallen to the Turks, but the Serbians were discouraging all civilians from staying.

The two friends strolled back into the disputed town and found it singularly quiet. A band of dishevelled Serbian soldiery stopped them and boasted loudly about the number of Turks they had killed. Forbes and Villiers unwisely pointed out that their rifle barrels were clean, and narrowly escaped a lynching by the braggarts. It was, the two Britons decided, time after all to seek new pastures, and

WITH A GREAT ARMY

In Turkish-held territory, when Frederic Villiers was concerned about his hosts' reaction to his pictures of Turkish atrocities, he was grateful for his comparative anonymity. The Balkans helped make his reputation, however, and within a few years his name was a household word and he had world fame through special 'treatments' like this in the *Graphic* during the Boer War.

they left the area by mountain paths as the Bashi-Bazouk scouts of the Turkish army surrounded and infiltrated the town.

By one of the strange turns of fate that later became commonplace to Villiers as a newsman, he re-entered Alexinatz a few weeks later, but this time from Turkish lines. Ordered back to Vienna by the *Graphic*, which cabled that it wanted him to go to India, Villiers was there given fresh instructions. India was to be covered by someone else. Intervention by the great powers had brought about an armistice between Serbia and Turkey, and now his editor wanted him to take a steamer along the Danube and look at the Turkish side. Aboard the steamer he met a young Irish soldier of fortune, Frank Le Poer Power, who later became a special artist in the Sudan and died while trying to escape down the Nile from beleaguered Khartoum.

In territory under Turkish army sway, Villiers was concerned lest sketches he had drawn of Turkish atrocities in the recent war would bring retribution on his head. He consoled himself with the thought that 'in those days the names of artists were seldom published below their sketches, so I was known but little even to the English fraternity'. As he drew near to the scenes of the recent Serbian fighting more evidence of Turkish military harshness became apparent in the horror of half-buried corpses in roadside fields.

At the request of a British friend he agreed to oversee the safe passage to Serbian lines of a Serbian manservant (during the armistice a certain amount of to-and-fro traffic was allowed under letters of safe conduct). He had misgivings about this, however, when his friend delivered a parting warning: 'I forgot to tell you that the Turks don't at all love you in Alexinatz. Hafuz Pasha, the governor, has threatened to hang the correspondent of the *Graphic* on sight on account of the bad impression he caused in England by sending a sketch depicting the cruelty of the Turks towards Serbian prisoners; so just you look after yourself.' Nevertheless, Villiers made the journey into Turkish-occupied Alexinatz, across the Serbian lines with his charge, and back, without harm.

The armistice developed into what appeared to be a more permanent settlement, but Villiers, convinced that Russia was planning to strike at the Turks, smuggled

himself across the Russian frontier disguised as a commercial traveller, to seek evidence of war preparations. Using a sketch-book was out of the question and he made sketch notes on his shirt-cuffs. He found military activity in plenty and no one was less surprised than he when, in London the following April, in 1877, he heard that the Russians had declared war on Turkey ostensibly in support of Bulgaria.

During the ensuing war, correspondents were treated with the utmost courtesy and hospitality by the high-born Russian officers. But press and military relations had got off to a bad start when the Russians announced that all newspapermen would have to be accredited and wear brass badges on their arms, something like those carried by rail porters. The French were particularly outraged by this affront to their aesthetic standards, and they refused to wear the brassards, whereupon the gentlemanly Russians compromised by issuing a more dainty brassard consisting of a two-headed eagle worked in silver lace on a yellow silk background.

Melton Prior was on the Turkish side, where he found himself involved in, and drawing, many skirmishes. He was once taken for a surgeon by a group of Turks who pulled him into a tent and led him to an officer, writhing with pain on a bed. The officer had been wounded in the ankle and the bullet was protruding about half an inch. Prior could not explain himself to the excited Turkish soldiers, so he yanked out the bullet with his fingers, motioned to the Turks to apply a bandage, and left in a hurry.

In London Villiers cajoled a letter of accreditation from the Russian ambassador, Count Schouvaloff, took the night mail across Europe to Rumania, and caught up with the Tsar's army as its advance guard crossed the river Pruth to do battle with the Turks.

His war started with a battle of attrition—drinking toast for toast with senior Russian officers at a banquet, throughout a long afternoon and well into the night. Villiers swapped vodka for vodka, moved on to French and Rhenish wines, curaçao and kümmel, but his downfall was the final tribute produced 'for the Englishman'. It was a basket containing half a dozen quarts of Guinness. Utterly drunk, he was propped on his horse and guided back to his billet by an escort of Cossacks who kept him in his saddle by prodding him, none too gently, with the butt ends of their lances. Archibald Forbes found him in the morning on the floor of his room, sleeping—as was his custom—in his spurs.

Within a week, correspondent and special artist found themselves shoulder to shoulder in one of the bloodiest actions of the campaign, the battle of Plevna. Caught in a hail of shellfire on a ridge, Villiers was unable to persuade his horse to budge. 'Leave your horse and come away,' shouted Forbes. Villiers stayed with his mount, however, and finally the animal slowly ambled to the safety of a corn stack below the ridge, where two Cossacks who had watched the incident kissed the artist 'in true Russian style' on both cheeks.

Villiers and Forbes then crawled back to the ridge and, as a murderous daylong battle opened, Villiers made notes on his sketch-pad. He watched wave after wave of Russian infantry advance into the blanket of smoke thrown up by the artillery barrages of both sides: 'Presently from out of the stifling fog came limping men with torn and bloody clothes, many without their caps, and not a few without their rifles ... Here and there were little groups of men carrying maimed colleagues.' The Russians threw in countless battalions until the field below was covered with the dead in their green tunics and white trousers. To this point the initiative had been with the Russians, but now the battle was turning, and soon a rabble of demoralised

soldiers was fleeing back to the Russian staff positions.

Villiers, mounted once more on his pony, was caught in the current of retreat: 'With the greatest difficulty I strove to keep the little beast under me from being impaled on the bayonets of the reckless soldiery as they stumbled over the deeply rutted fields in the gloom of the coming night.' Behind him he could heard the shrieks of the wounded as the Bashi-Bazouks followed the Tsar's retreating army, bayoneting and shooting any Russians who were still living.

He had long since lost contact with Forbes, and now he fell in with a small convoy of ambulance carts, the escort of which skirmished through the night with roving bands of Bashi-Bazouks looking for easy kills in the terror-stricken retreat of the Russians. 'Have you seen Forbes? Have you seen Forbes?' Villiers asked the question of every officer acquaintance he met. Always the answer was a shake of the head. Villiers turned his horse towards the Danube—'for I must now hurry off with my budget of war sketches'.

It took him three days of hard riding to make Bucharest, passing the head of the retreating Russian army on the way. He arrived mud-spattered, exhausted and weak with hunger, 'the uppers of my boots almost worn through my riding breeches', and staggered into the pretty garden of Brofft's hotel. And there at dinner was Forbes. Both Forbes and his dinner companion, W. Beatty Kingston of the *Daily Telegraph*, had given Villiers up for dead. 'For goodness' sake, give me something to eat and drink. I am starving,' gasped Villiers. Forbes looked at him and said: 'Pass the wine. By Jove! He does look faint!'

Afterwards Villiers ascribed his survival to the skittishness of his pony. He had intended to join a medical unit in the village of Radeshova and offer his services to the wounded when he came down from the embattled ridge. As the runaway tide of soldiers caught up with him, however, some bandsmen threw away their regimental drum, and the flash of a shell explosion, reflected in the drum's brass trappings, caused his pony to shy and career in a headlong dash that took Villiers away from the village of Radeshova. In the full flood of the army's retreat there was no way for him to retrace his steps. Later that night the Bashi-Bazouks descended on the village and slaughtered everyone in it, wounded, nurses and doctors.

Hunger, sickness and bitter cold added to the risks faced by soldiers and newspapermen alike as the harsh Danubian winter closed in, bringing with it an uneasy peace. For Villiers the campaign of 1877 ended in a personal tragedy. He crossed the plain between the stalemated but by now technically victorious Russian armies and the city of Constantinople to seek out the reporter MacGahan, with whom he had struck up a strong friendship during their acquaintance of the past two years. He had last seen MacGahan in a debilitated state and, having heard nothing from his friend, feared the worst in a country in which typhus and cholera were rife.

He found that MacGahan had died from typhus, and had to break the news to the Russian general Skobeleff, a mutual friend who highly esteemed the American reporter, and who arrived in Constantinople shortly after Villiers. No one was allowed to see the body, because of the fear of spreading the disease. But Skobeleff thrust aside the guard at the door of the death chamber and knelt beside the dead MacGahan in tears. There he stayed until Villiers came in and gently led him away.

Villiers was again in the Balkans in 1885–6 when Milan of Serbia made an ill-judged attempt to 'readjust' his frontiers at Bulgaria's expense. It was a short, sharp fiasco of a war, mercifully ended by Austrian intervention. Both Villiers and John Schönberg of the *Illustrated London News* pictured the sufferings of the ordinary

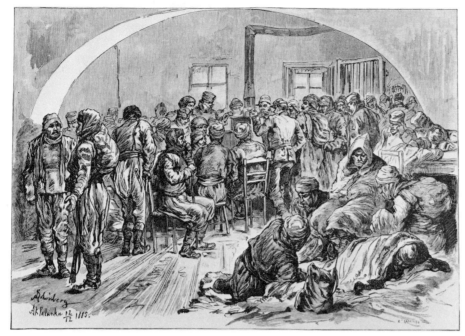

Sick and wounded soldiers at Palanka: John Schönberg captured the misery of a peasant people caught up in the war and the suffering in the bitter Balkan winter of 1885/6. The woodcut in the *Illustrated London News* gives the impression that Schönberg personally took part in the engraving on his return from the battle zone.

people of these Balkan kingdoms, the peasants caught up in the horrors of a midwinter campaign and the wounded soldiers crammed into farmhouses, with scant medical attention, inadequate food and little in the way of blankets or heating to shield them from the freezing cold.

Even the enthusiastic Villiers found little of interest in the campaign. He soldiered through it with an irrepressible servant called Jim, posing for a time as a rich American businessman and his valet, as to be British was temporarily to be unpopular in Serbia. After dispiriting foraging for news and pictures in what he considered to be a needless 'little war', no one was happier than Villiers when he received an assignment in Burma where a local potentate had been causing the British government some annoyance on the road to Mandalay. By this time, however, both the Balkans and Burma had become but interludes in a long scenario which increasingly engaged the attention of Villiers and other special artists in the deserts of the Nile.

Nevertheless, before the century was out the simmering stewpot of the Balkans boiled over again and claimed the interest of the world's press when Greece went to war in 1897 over that age-old question of Turkish dominion in Europe. Villiers, who appears to have become somewhat exasperated with Balkan assignments, reported that Greece 'seemed especially anxious to get into difficulties with her great Mussulman neighbour on the off chance of success, knowing full well that her bigger Christian sisters would see that she was not too much spanked by the Turks if she failed.'

With a penchant he had developed for choosing the side in retreat, he found himself in the eastern Greek port of Volos through which a rabble of refugees, deserters and wounded soldiers were fleeing from the steadily encroaching Turks. Among his baggage were a bicycle and a crude, hand-cranked cinema camera he was anxious to try out. Soon he was to play a key role in the surrender of the city, but in the meantime, as the Greek defenders temporarily stabilised the line on the heights

outside the city, he evolved a daily working pattern that sounds, in his own description, a model of organisational, nine-till-five routine:

> Luckily I was well housed during the fighting in front of Volo [Volos], for the British consul insisted on my residing at the consulate. To me it was campaigning in luxury. From the balcony of the residence I could always see when the Turks opened fire on the Velestino Plateau; then I would drive with my cinema outfit to the battlefield, taking my bicycle with me in the carriage. After I had secured a few reels of movies, if the Turks pressed too hard on our lines I would throw the camera into the vehicle and send it out of action, and at nightfall, after the fight, I would trundle back down the hill to dinner.

His camera was obviously far too precious to risk in any mêlée or in the chaos of rout, a threat which constantly loomed large in the hard-pressed Greek army.

Inevitably the day came when Volos was abandoned by the military, the municipal authorities and the government. Amid a general climate of panic over what the Turks would do to the unarmed population, Villiers proposed to the British consul that they 'should beard the lion in his den and go boldly into the Moslem lines to intercede with Edhem Pasha on behalf of the remaining inhabitants'. The French consul agreed that it should be a joint venture, and, in two carriages with a small escort of British bluejackets and French sailors prominently displaying their national flags, Villiers and the two consuls rode out towards the Turkish front line.

The Turkish army gazed in wonderment as the little party disembarked from the carriages and marched in procession through the outposts on its way to headquarters. In front came the English and French sailors 'struggling to keep their respective flags in line so that one should not by a foot precede the other'. Then came the consuls, the French a very short man in silk hat and white gloves, the English a good two feet taller in deerstalker cap and muffler round his neck. At the rear, acting as secretary to the mission, walked Villiers wearing a black coat and a white solar topee 'in virtue of my office'. Such a mission could not help but succeed. It was received with civility and assurances that the population of Volos would be unharmed.

Villiers shared a morning meal with an English war correspondent, George Warrington Steevens, who was covering the war from the Turkish side. (Three years later Steevens died of enteric fever while representing the *Daily Mail* in the Boer War.) Then the little party returned to Volos with Turkish emissaries to give the people the news that they would be safe.

The Turks were as good as their word. Volos was spared, and Villiers was permitted safe conduct to Athens by the newly appointed military governor, Enver Bey. A journalist and opportunist to the end, Villiers asked one more favour of the Turk before leaving. He said to Enver Bey: 'I want to know when and where the next fight will take place. You Turks will take the initiative, for the Greeks can now only be on the defensive.'

Enver Bey was staggered by his impudence. He looked at Villiers steadily, and said at last: 'You are an Englishman and I can trust you. I will tell you this: take this steamer to Athens, then get another to Lamia, the port of Domokos, and don't fail to be at the latter place by Monday noon. Now, Mr Villiers, goodbye.'

With the excitement of knowing he had a scoop under his belt, Villiers made it to Domokos in the nick of time. It meant a journey to Athens in the south of the mainland and then retracing his steps northwards. He arrived on an escarpment overlooking the plains of Pharsala as the guns opened up and the Turkish infantry

stormed into and smashed the Greek front. His hired coachman, Dmitri, whipped the two horses into a gallop and Villiers reached the telegraph office at Lamia at one in the morning, only to find it was closed. In addition to acting as special artist he was representing the London *Standard* as a war correspondent.

Now, he was faced with a three-day journey to Athens, the nearest available telegraph point. Before he could start, however, Greek soldiers seized the carriage, announcing that it was commandeered for army use. Dmitri remonstrated with an officer who proceeded to pummel the coachman unmercifully. Villiers flung his arms round the officer to restrain him. Dmitri drew a revolver—and a mob of soldiers threw themselves on him and dragged him to the town prison, where he was condemned to be shot within the hour. In the longest hour of Villiers's life, he pleaded for his coachman to be spared, finally persuading the authorities to release him, a feat which he put down to the power of the press.

'The delay over my servant's fate was almost disastrous to my plan of being first in England with my copy,' said Villiers. He abandoned the idea of getting to Athens by land. On his trusty bicycle, which he had providently brought with him, he rode a dozen miles to the little harbour of Stelitz where a steamer was about to leave for the seventy-mile journey to the port of Chalkis. 'At midnight we arrived at the famous gate of the Greek inland sea and a few minutes later I was seated in a fly, driving like mad for Athens. At three the following afternoon I sighted the Acropolis.' By seven that evening, after his copy had been given the necessary signature of the prime minister himself, the news of the Turkish victory was being telegraphed to the *Standard*.

Villiers arrived home in triumph, with one more card to play: his movies from the battlefront. He explained in his memoirs, 'It was a laborious business in those early days to arrange the spools and change the films; and I sweated a good deal at the work, but managed to get touches of real warfare.' He was in for a bitter disappointment.

London was eager and ready to see war scenes projected on the cinematograph screen, but a French firm had seized the market with a series of horrifying 'atrocity' productions staged and filmed in a studio outside Paris. One showed Turks dragging a beautiful Athenian maid from a cottage and slicing off the head of her aged father—a skilful piece of early stunt filming. Nobody, Villiers discovered, wanted to see his flickering, muddy footage of real war as it was. 'Barnum and Bailey, those wonderful American showmen, correctly averred that the public liked to be fooled,' he ruefully noted.

10 Rivalry on the Nile

You must go to Egypt tonight by the 8 o'clock mail. We will let your wife know and send your baggage on

Publisher to Melton Prior

Through seventeen years from 1882 to 1899, discounting a middle period of uneasy, hostile stalemate, the River Nile was the focus of bitter and bloody warfare, and what Frederic Villiers, special artist of the *Graphic*, called 'a happy hunting ground for the war correspondents'. His description owes more to professional insouciance than to accurate reporting. For it was a war in which the special artist or the reporter, if he was to do his job properly, had to share the hardships and dangers of the fighting soldier through exhausting desert marches, ambushes, night skirmishes and, occasionally, major confrontations between large armies.

If the newsman was lucky in battle he gathered his copy head down amid the stink, noise and disorder of the tethered baggage camels in the centre of an embattled British square, hoping and praying a stray bullet would not make him an infernal fool. Some, like Frank Vizetelly and Edmond O'Donovan, became the victims of military incompetence. Some took the most astonishing risks and survived. Others met their deaths or received wounds through the silliest of mistakes: one lost his life because he wore an officer's scarlet tunic in a savage, close fight. The proportion of casualties among the reporters and artists taking part in these campaigns was larger than in any wars before or since.

To this violent background, the sands of the Nile became a cockpit for an intense rivalry between Villiers—a freelance who worked in Egypt initially for the *Graphic*—and Melton Prior of the *Illustrated London News*. They frequently worked and fought side by side during the campaigns in Egypt and the Sudan, and, sharing the dangers, they unquestionably felt for each other the comradeship that bound all men of the press corps. However, such was the competition between them—even at times when Villiers was supplying the *Illustrated London News*—that they each tried constantly to outsmart the other in being first at the scene of action and in getting their sketches home by the swiftest means. As neither made much mention of the other in his memoirs, while liberally sprinkling them with references to reporter colleagues, there is reason to suggest that their professional rivalry extended, to some degree, to personal competitiveness.

When they set foot in Egypt in the early summer of 1882, Villiers was thirty-one, a special schooled in his tough experience of the Balkans where, of course, he had been fortunate to have the reporter Archibald Forbes as his mentor. He was stocky, cocky and brimming over with confidence that he could meet the challenge of any opponent, even the fearsome Melton Prior. He constantly talked, in the vernacular of popular newspapers, of 'getting a beat over the opposition'. A furrowed brow over

sharply penetrating eyes gave him the permanent air of a ruffled, angry bantam; waxed moustaches and a neatly trimmed beard added a military dash to his features. Behind all this, however, was a bright sense of humour and a fund of boyish enthusiasm. Under stress he found solace in tobacco and he appreciated the pleasures of drink and good food.

'The belligerent instinct was observed in me at the early age of eight,' he later recalled, 'when I fought with another boy (and I am proud to say a bigger boy) who would insist upon obstructing my view of the home-coming of that gallant soldier, Sir Colin Campbell, after the Indian mutiny. A broken finger of my left hand still testifies to the fierceness of that encounter.' At the age of ten, as a cadet in a volunteer corps, he bit his cartridge 'like a man, poured in the powder, and rammed the bullet home in the little Brown Bess, and then, with a cap on its nipple, snapped the hammer, and mostly missed the target.' His marksmanship—and weaponry— improved. In Egypt he carried strapped to his leg a six-shooter which became as important to him as his sketching materials. Compared with Prior's, his draughtsmanship was poor, but he had the essential nose for news.

Melton Prior was six years older, already bald, and a tubby five foot six and a half inches (we know this statistic from his identity card at Ladysmith in the Boer War). His side whiskers and small, round spectacles gave him an avuncular appearance that belied the ruthlessness which had won him scoop after scoop in Europe and Africa. His baldness and shrill voice earned him the nickname of 'the screeching billiard ball'. Fourteen years on the *Illustrated London News*, nine of them spent sketching under fire, outwitting censors, and organising lines of communication by enterprise, bribery and sheer skulduggery, had earned him the reputation as the leading special artist in his profession. Fellaheen bullets, Fuzzy-Wuzzy spears, heat, flies, exhaustion and the competition of 'young Freddie Villiers' were something to be taken in his stride. To Prior, a more pressing problem would be how to transport his whisky. His brilliantly detailed sketches in Egypt and the Sudan have left us with a unique record of military campaigning in the eighties and nineties, not only in the depiction of battles but in the minutiae of field life, such as the care of the wounded in ambulance boats and in camel-borne ambulance chairs and the logistics of moving men and arms across vast tracts of desert.

Prior's departure from Britain for the war zone was characteristically hurried. The newspaper's proprietor, Ingram, sent for him at four o'clock one afternoon and said simply: 'You must go to Egypt tonight by the eight o'clock mail. We will let your wife know and send your baggage on.' Marriage to a special artist had taught Prior's wife to expect such hurried partings; in the end, however, his long absences abroad, the uncertainties, the anxieties, and her own loneliness all contributed to the collapse of the marriage. Prior had time only to pack a valise with a few toilet articles and his sketching materials and set off for Alexandria.

The Suez Canal, opened in 1869 as a vital new route to the Far East, was at the core of the troubles brewing in Egypt and Britain's long involvement in the Sudan. Egypt, nominally still part of the Ottoman Empire, was bankrupt, ruled by the Khedive Tewfik. It was a corrupt, cruel regime in a country ripe for revolt, which duly took place when nationalist feelings mounted against Anglo-French control of Egyptian finances. The rebels rallied around Arabi Pasha, once a trusted minister of the Khedive. In a rapid sequence of events in 1882 over fifty Europeans were butchered by rioters in Alexandria, the Khedive took refuge with the British fleet, Admiral Sir Beauchamp Seymour put the city to flame with a bombardment which

The value to military history of Melton Prior's contribution was not only in the vast output of action pictures, but in scenes such as these, depicting the background to campaigning in the desert. Ambulance boats are seen on the Sweetwater Canal in Egypt in 1882 (*above*).
After the battle of Abu Kru in the Sudan in January 1885, Prior sketched the care of the wounded, showing camels fitted with ambulance chairs, and the mortally wounded General Herbert Stewart lying beneath an umbrella. (*National Army Museum*)

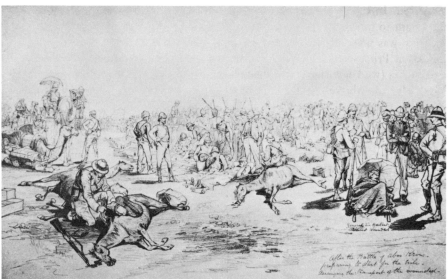

was ostensibly to protect British commercial and financial interests, the French withdrew from all commitments and an expedition led by General Sir Garnet Wolseley destroyed Arabi's rebel army at Tel-el-Kebir. The Khedive's tottering throne was shored up, but Britain had unwillingly inherited the stewardship of a ramshackle empire that was the bane of Victoria's governments for nearly two decades (involvement was succeeded by complete withdrawal, then renewed involvement). In the Egyptian north unrest festered under villainous administrators schooled in the despotic ways of the Turkish empire. In the Sudanese south revolt blazed under the religious leader known as the Mahdi.

This was the pattern of tragedy over the next few years, but when Frederic Villiers landed at Alexandria in June 1882, he found a strange, uneasy lull which preceded the storm.

Arabi Pasha's men had entered the city ostensibly to protect the lives and property of the Europeans after the bloody riots of the previous week. However, the Europeans were leaving daily to seek refuge with the British fleet lying in the harbour, its guns trained on the Egyptian fortifications. Matters came to a head when Admiral Seymour decided that Arabi Pasha had defied a British ultimatum to stop fortifying the harbour defences. On 11 July the British ships opened fire.

The incident, the subject of Villiers's sketches in the *Graphic*, provided one of the rare instances when a nineteenth-century special artist was employed in depicting shipborne action. In the Crimean war the Baltic furnished the opportunity to produce sketches of naval actions, and in the American Civil War artists did some excellent work with the blockading Northern fleets and in the river campaigns. Generally, however, the illustrated newspapers found themselves covering warfare on land: the conflicts of the last half of the century, the heyday of the picture papers, tended to be between continental neighbours, civil wars or colonial campaigns.

After the devastating bombardment of Alexandria, which exceeded Admiral Seymour's directive, Villiers claimed the doubtful distinction of having been 'the indirect cause of precipitating matters'. He had found himself lodgings aboard the *Condor*, a British gunboat of draught shallow enough to allow it to lie nearest to the Egyptian harbour forts. From her innards every piece of scrap iron and chain was dredged and hung over her bulwarks as protection on the side facing the harbour, so that she had a drunken list.

Villiers landed one morning at the quay, where he met a Scots storekeeper, a resident of the port, who supplied the British ships with fresh beef and coal. He told Villiers that Arabi Pasha had mounted additional guns on the forts in defiance of Seymour's threat that if the Egyptians did so he would immediately resort to bombardment.

'What are your proofs?' Villiers asked the storekeeper.

'You will soon have them,' said the Scot. 'If you drive to my brother's house, overlooking the old harbour, you will see from the balcony what the Arab gunners have been doing during the night.'

Then, as Villiers told it,

I hurried to the address given me, and with the assistance of a telescope I sketched the cannon that had been dragged into position under cover of darkness and had been deserted by the gunners as soon as daylight disclosed their movements. I returned to the marina and rowed out to the *Condor*, whose commander promptly carried the important tidings to the Admiral. A smart young officer disguised himself as an Arab boatman and volunteered to corroborate my information. To test his disguise he attempted to board the American warship [part of the international contingent, which also included French and German ships] but the make-up was so perfect that the Yankees turned the deck hose on him. Luckily he was in full retreat down the side of the vessel when this happened. He then rowed ashore and was able to prove the treachery of Arabi. Then the order was given for the British ships to clear for action.

Some of the scenes that Villiers subsequently witnessed, drew and described were not unlike the naval warfare of Nelson's day, nearly eighty years earlier. On the eve of the bombardment, all available canvas was draped on the inboard side of the *Condor*'s bulwarks and hammocks were slung round the wheel to protect the men and steering gear from flying splinters. The topmasts were lowered, the bowsprit was run in, and the Gatling gun in the maintop was canvased round.

Before dawn the furnaces of the coal boilers were stoked high and the little gunboat steamed out of the harbour to join the rest of the fleet at bombardment stations. The *Condor*'s crew fretted impatiently as the larger ships began shelling their allotted targets. At last, the *Condor* was ordered to sail in and attack at close range Fort Marabout which 'was playing long bowls with the Admiral's ship'. The

men stripped their jackets, the racers of the guns were oiled, the deck was sanded to pristine hardness to cut down fire risk, and the gunboat steamed in under the Egyptian fort guns. The muzzle-loaders ran out 'all a-port' and blazed away. From the bridge the captain watched through a telescope and shouted from time to time to the gunners.

'What was that, my men?'

'Sixteen hundred yards, sir.'

'Give them eighteen this time, and drop it in.'

'Aye, aye, sir.'

The gunners, black with powder, continually dipped their heads in the sponge buckets to keep the grit from their eyes. They paused to cheer when a shout from the maintop told them one of their shots had fallen within the enemy's gunworks; another cheer when an Arab shell brought a spout of water well clear on the starboard side.

Years afterwards, Villiers summed up the action in these words:

The episode of the *Condor* was one of the pleasantest I have ever taken part in. There was no blood or hurt about it—at least with us. The late Archibald Forbes in one of his charming lectures referred to the early days of the Russo-Turkish campaign as a perpetual picnic with a battle thrown in here and there for variety. This affair of ours was a water-party, with just sufficient black powder burned to create an appetizing thirst, with a long drink, not necessarily a soft one, thrown in now and again to quench it.

Waterborne warfare was a subject to which artists returned occasionally during the two decades of conflict in Egypt and the Sudan. It was epitomised in the record of the wheezing, wallowing steamboats that puffed up and down the Nile, carrying the Khedive's flag and letting fly with cannon, machine-gun and rifle fire at river banks held by the Arabs and Dervishes, risen in revolt. It became a favourite subject for Villiers.

His account of the happenings of 11 July ends with a touching tribute to the professional qualities of a colleague, John Cameron, the reporter of the *London Standard*. Cameron sent a series of vivid despatches back to his paper, which rushed out special editions hour after hour. According to Villiers, Cameron—who faced many an ordeal and eighteen months later met his death in the desert—laboured afloat under the most trying circumstances to achieve 'this brilliant coup of journalism'. The trouble was that the old tub, the *Condor*, on its way out to rendezvous with a homeward-bound vessel, 'behaved herself as badly as a Channel packet-boat in choppy weather, for she pitched and rolled disgracefully'. Cameron would scribble a few lines, then make a wild dash from the captain's cabin to the upper deck and the side of the vessel. Seasickness, it seems, almost robbed him of the scoop of a lifetime.

So far, Villiers and Cameron had had the scene practically to themselves, although Prior was on hand to send to his paper sketches of the bombardment. As the first British troops began to disembark for Wolseley's land campaign, however, a flood of correspondents arrived. 'Birds of a feather,' wrote Villiers, 'generally flock together, not out of affection for each other's society, but to keep a watch on one another and to jump the news if possible. I had scored thus far with the fleet, but now I was stranded for want of a horse, something then most difficult to get as they had all been snapped up by members of the fourth estate. I went to rest one night

An engraving of a sketch by Frederic Villiers shows British sailors in action with a machine-gun aboard a Nile gunboat. Villiers, whose strongest subject was not figure drawing, benefited from the draughtsmanship of home-based engraver's artists, one of whom signed this illustration in the *Illustrated London News*. (*National Army Museum*)

very disconsolate for this reason. At dawn there came a thundering knock at my door.'

It was Drew Gaylor, correspondent of a London daily. 'Put on your boots and come along.' He spoke in almost a stage whisper. 'In another hour the opening fight of the campaign will begin.'

'You are sure it isn't a fool's errand?' False alarms from 'informants' had flourished in the fertile garden of newsmen's *baksheesh* for the past week.

'No, it's all right. I got the tip last night. The first regiment has been on the march for the last two hours already, and this time they mean business.'

Gaylor had even provided Villiers with a mount, an ancient iron-grey mare with a crooked ear and a vicious glint in her eye. She had seen happier days, but Villiers could not complain; she was better than no horse at all.

While the rest of the press corps slept, the pair set off, skirting the shore for a few hundred yards, past two giant stone obelisks lying half-buried in the sand and wash of the water's edge. A few years later one stood on the Thames embankment in London, the other in Central Park, New York. The newspapermen's destination was some fifteen miles inland at Kaffir-el-Douar where Arabi Pasha's men held their front line. On the way they passed the 60th Rifles digging trenches. The soldiers had unearthed a skeleton and propped it up, like a scarecrow, above the trench for the enemy to see. They had also found metal buttons, belt clasps and shreds of cloth. Villiers examined them. Some of the buttons were of English regimental pattern, a belt clasp was French. Then the explanation dawned on him. This was the battle-ground fought over by Sir Ralph Abercromby's invading army and General Menou's troops eighty-one years earlier. Here, English and French had found a common grave. As soon as the sentimental Tommies realised that their scarecrow might have been a fellow British soldier he was lifted down and decently re-interred.

Villiers and Gaylor got their action. Certainly it was not very spirited, little more than a skirmish—'hardly worth the trouble of turning out of our beds so early', said Villiers. But he was near enough to hear the Egyptian bullets 'like the buzzing of mosquitoes around me', and on their return both telegraphed an account of the first infantry brush of the war to their respective papers (Villiers increasingly played the role of correspondent as well as artist).

At dinner that evening in the Hotel Abbot the pair indulged themselves in the satisfaction of their minor coup, which, to be realistic, made more impact on their colleagues than on the public back home. 'Our colleagues had not seen us all day, and they looked up at us with inquiring glances,' said Villiers. 'A gloom began to settle on their faces as they noticed our exultant mood, for there had been thunder in the air and they suspected that we had been where the storm had burst.'

Such diversions were merely the prelude to the big fight. It came at Tel-el-Kebir on 13 September when Wolseley smashed Arabi's army which was trying to bar the British advance towards Cairo. The British troops stormed the Egyptian trenches after a night march across the desert, piloted by a young naval lieutenant named Rawson, who navigated by the stars. He was the first to fall, a bullet through his lungs, and his dying words were meat and drink to the newspaper contingent: 'I led them straight, sir.'

On the eve of the battle, of which the press had no advance warning, Villiers had ridden from the base camp of Kassassin to Ismaelia on the Suez Canal, twenty miles to the east, to post a bundle of sketches on a homeward-bound mail steamer. That evening he had an invitation to dine with the Guards in camp—'Seven sharp. Bring your own cup, plate, knife and fork.'

By six he was back in the Guards camp where he found a mystifying scene. It was utterly deserted, a ghost camp. The tents were still there, even the cooking fires were still burning (he later learned that this was to fool the enemy). But the Guards had gone. As night fell, Villiers, scenting action, decided to ride into the desert to try to find them. 'It was not the first time I had gone dinnerless, so I gave my pony a drink of water, lit my pipe, took in my belt an inch or two, and set my face desertwards in search of my hosts.'

It was an eerie, chilling ride, with a clinging mist intermittently veiling the light of the stars. Villiers realised that an entire army—friend or foe—might be marching alongside or towards him, but the sound of its progress would be entirely swallowed up by the soft sand of the desert and the mists. Once, a curious, unpleasant smell

arose and a ghostly phosphorescent light flickered along the sand. His pony pricked up his ears and snorted in terror. In front of Villiers appeared what he described as a luminous mass, which gradually took the form of a dead man lying on his back, with his skull grinning up through the bluish vapour. It was an Arab killed by cavalry scouts a short time earlier. ·

Villiers literally stumbled on the 60th Rifles, who gave him vague directions where he might find the Grenadier Guards. Then he fell in with the Highland Brigade, dozing over their rifles. Still determined to find his hosts, he set off again alone. His next encounter was with a single soldier of the telegraph corps, as lost as Villiers was himself. The soldier had been sent out on a mission that only the military could devise—to find the end of a lost cable in the desert. He had missed his way and the wire too. Villiers decided that by now he was too near the enemy outposts to risk blundering into them in his search for the Guards. He returned with the lost telegraph man and threw in his lot with the 42nd Highlanders, the Black Watch. Already waiting with the Highland Brigade, probably much to Villiers's annoyance, was his arch rival, Melton Prior of the *Illustrated London News*.

It was now bitterly cold and the men were dripping wet from the heavy desert dew. But new life and spirit was being poured into them from a line of carts bearing huge barrels. After the Black Watch had gulped their fiery rum ration, their old leader, Cluny McPherson, mounted his horse and addressed them in a quiet growl: 'Men, not a shot is to be fired. All work must be done wi' cauld steel. The Forty-twa will advance!'

The six-mile march across the desert had the ghost-like quality of Villiers's earlier wanderings that night. Here was a regiment of men, moving forward, heavily armed, but the tramp of their feet was muffled in the velvety surface of the sand, and the only sounds were an occasional cough, a quiet command and the jingle of equipment. Dawn was breaking when the Egyptian trenches blazed with a ribbon of twinkling orange flame. The order to charge was given, and the swiftly appearing morning sun lit the surging lines of red-coated Highlanders.

Prior, holding on to his sun helmet, reached the enemy trenches in a blizzard of fire. He flung himself in a heap in the bottom of a trench as, all around him, the Highlanders slashed and thrust with their bayonets. By his side was Cameron of the *Standard*. For some time they were pinned down in their trench, until successive waves of Highlanders and Royal Irish swept the ground ahead. Soon, however, the squeal of bagpipes announced that Arabi Pasha's army was defeated. Prior squatted among the dead and dying and filled his pad with sketch notes.

Villiers came across a young lieutenant of the Black Watch dying beside the body of his colour sergeant. He knelt to see what he could do to relieve his suffering when a young drummer boy, with tears down his begrimed face, ran up. The boy thought Villiers was going to sketch the scene. He snatched a handkerchief from the breast pocket of the dying officer and laid it gently over his face.

As the sun climbed and the day's heat enveloped the battlefield, there were anguished cries for water from the Egyptian wounded who lay around in profusion. An old man raised himself and beckoned to Villiers. The man's bowels were trailing in the sand from a bayonet thrust. '*Pani, pani,*' he muttered, pointing to his parched lips. Villiers could do nothing. When the Egyptian guns had opened up, his pony, carrying his water bottle and sketch-book, had bolted. He was without water himself.

Hours after the battle, Villiers sat contemplating the loss of his pony and equip-

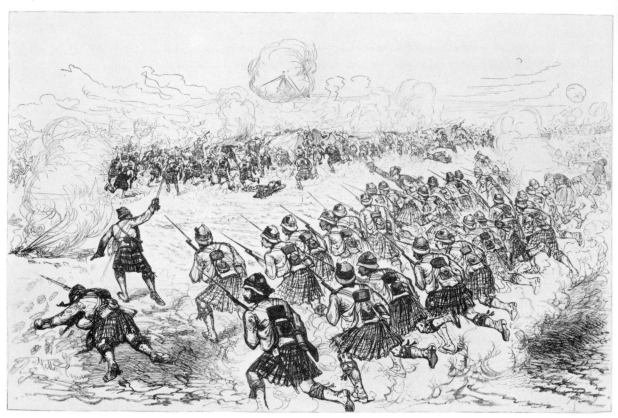

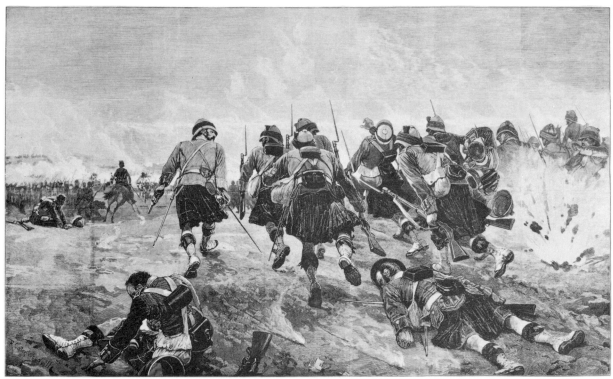

Melton Prior's dramatic original sketch (*above*) of the battle of Tel-el-Kebir in Egypt is compared with the worked-up version by Richard Caton Woodville, each of which appeared in the *Illustrated London News* within a week of each other in October 1882, about a month after the battle. Prior reached the enemy's entrenchments in a wave of attacking Highlanders

ment when a colleague rode up. 'Look, Villiers, here's a find,' said the new arrival triumphantly. 'A rattling nice little beast, saddle and all. Found him sitting in the desert about two miles away.'

'That pony,' said Villiers acidly, 'belongs to me.'

On 14 October, a month after the battle, Prior's signed sketch of the Highlanders' attack was published in the *Illustrated London News*. By this time printing techniques had improved to such an extent that it was possible to reproduce original line work by photographic means, and the illustration appeared above the caption, 'STORMING THE TRENCHES OF TEL-EL-KEBIR', followed by the subsidiary line, 'Facsimile of a Sketch by our Special Artist'. These new methods of reproduction, in use from the late seventies, not only meant that the public could see illustrations of events much more quickly than before; they also afforded readers the opportunity to see the scenes exactly as the specials drew them under fire.

But old habits died hard. Exactly a week earlier, on 7 October the *Illustrated London News* had published a 'worked-up' drawing of Prior's original by Richard Caton Woodville. It was engraved as a wood block and entitled 'BATTLE OF TEL-EL-KEBIR: THE CHARGE AT THE BAYONET'S POINT'. The sub-caption was: 'From a Sketch by our Special Artist'. Woodville, who signed his work, had changed the scene considerably from Prior's original sketch, adopting a different viewpoint, dramatising the stance of key figures, and changing the position of several. In the foreground he introduced a wounded Highlander who had not been in Prior's picture at all. The finished illustration reflected Woodville's superb draughtsmanship, but it lacked the verve and immediacy of Prior's original. It also failed to give a clear impression of the Highlanders' objective, the Egyptian earthworks, which came out clearly in the special's sketch. In fact, the armchair artist appeared to have 'lost' the enemy, the presence of whom was only too real for Prior, who, moments after the incident depicted, was in the thick of hand-to-hand fighting in the trenches.

It is interesting to note that in March of the following year when Prior lectured on the campaign to the Prince of Wales and the Savage Club, 'with battle scenes thrown by the lime-light on to the screen', an illustration of the evening's event in his newspaper showed him, understandably, using a blow-up of his own sketch of the trench assault.

Tel-el-Kebir closed one chapter of the Nile story. Villiers signed off by sketching Arabi Pasha in his prison cell in Cairo for the basis of a watercolour to appear in *Vanity Fair*. But a new chapter was opening in the Sudan to the south, where Mohammed Ahmed, called the Mahdi, the Prophet sent by Allah to rid his people of the Ottoman yoke, was raising the tribes in holy war against the Khedive of Egypt. Gladstone washed his hands of the affair, apart from giving the Khedive tacit support. This included the appointment of Colonel William Hicks, Hicks Pasha, to command the ill-fated expedition of 1883 in which Edmond O'Donovan and special artist Frank Vizetelly met their fate. Politically it was a period of blow hot, blow cold for Britain. In a gesture that was nothing more than lukewarm, the government in February 1884 sent a former governor-general of the Sudan, General Charles Gordon, to Khartoum to report on the situation and to organise the evacuation of Egyptian garrisons hard pressed by the Mahdi's revolt. It was the beginning of a new series of messy, unsatisfactory military entanglements.

Gordon arrived in Khartoum shortly after an Egyptian force under General Valentine Baker had been destroyed in the eastern Sudan in circumstances which

Seven months after Tel-el-Kebir, Melton Prior lectured to the Prince of Wales and the Savage Club in London, and for the *Illustrated London News* drew himself describing his action sketch, projected onto the screen 'by the limelight'. It was one of the few occasions when the artist drew himself hatless: normally a sun helmet or bush hat covered his gleaming bald head.

matched the Hicks Pasha massacre of the previous year. The defeat was at the wells of El Teb, just south of Suakin on the Red Sea coast. Baker survived and telegraphed: 'ON THE SQUARE BEING ONLY THREATENED BY A SMALL FORCE OF THE ENEMY . . . THE EGYPTIAN TROOPS THREW DOWN THEIR ARMS AND RAN, CARRYING AWAY THE BLACK TROOPS WITH THEM, AND ALLOWING THEMSELVES TO BE KILLED WITHOUT THE SLIGHTEST RESISTANCE'. Thousands of garrison troops were slaughtered. The victorious Hadendowah tribe under their Mahdist leader Osman Digna, a former slave dealer, captured a mass of material, Krupp guns, machine guns and rifles.

Now it was the turn of Britain to blow hot again—in the words of Winston Churchill, 'the garrisons they had refused to rescue they now determined to avenge.' Two British brigades of infantry and one of cavalry were sent to Suakin; the 10th Hussars were stopped on their way home from India and mounted on the horses of the local gendarmerie. On 4 March, a month after Baker's defeat at El Teb, the British under General Sir Gerald Graham met Osman Digna in battle on almost exactly the same ground. Three thousand Hadendowah were slain and the rest driven in disorder from the field of battle. In the midst of the fight were the redoubtable rivals Frederic Villiers and Melton Prior.

Villiers complained that when news of Baker's defeat reached London, his paper was as vacillating in its policy as the British government was over Egypt. It delayed sending him to the Sudan until the British troops were actually moving on the enemy: 'The result was that I nearly missed the first fight of the campaign.'

At Brindisi on the way he met Bennet Burleigh of the *Daily Telegraph* and the pair cabled ahead to hire a steam launch to meet their P & O liner, the *Tanjore*, at Port Said, the entrance to the Suez Canal. Burleigh, too, had set off late and in such a hurry that he carried only a bar of carbolic soap and a toothbrush. When they

landed near Suakin there were neither horses nor servants to be hired, so that they had to trudge on foot with the main force of troops towards El Teb. Heavy rain was falling and the force struggled through a belt of liquid mud and sand. In bivouacs that night the downpour was so heavy it doused the camp fires. Soaked through and miserable, the British nevertheless had time to dry out in the morning sun before the order to advance in square was given at 8 am.

As Villiers was not mounted, he thought he would stand a better chance of seeing and sketching the fighting if he were outside the formation. He knew that as soon as fighting began the British square would be wreathed in smoke which would obscure his view. He therefore trudged in the wake of the 10th and 19th Hussars who moved slowly forward on the left flank of the main force. Once the enemy was engaged, the cavalry drew away from him and he was left isolated. It was a dangerous position, but he had a grandstand view of the battle. It was almost as though he was an observer in an expensive seat at a Crystal Palace fireworks show.

In keeping pace with the infantry from a distance he sometimes lost sight of them when he passed through depressions in the ground. Coming to the lip of a gully, he was alerted by a sickening odour. 'Suddenly,' he reported, 'I stood on the verge of a slight depression in the desert and in the hollow in my immediate front lay literally hundreds of glistening bodies, all stripped of their clothing, their glassy skins shimmering under the rays of the fierce sun.' He had stumbled across a killing ground of Baker's defeat in the previous month. Among the dead he found an old friend, Dr Armand Leslie, who had been a companion in Bulgaria and whom he recognised by his beard and clean-cut features. Every man had been given the coup de grace—a slit across the throat by Hadendowah knives.

Villiers watched the British square glide into collision with the Dervish army like a Roman 'tortoise' under its canopy of shields. Then, as the enemy was breaking up and fleeing in all directions, he deemed it safer to be among the British soldiery rather than remaining isolated with only his six-shooter and his press accreditation to protect him.

The Dervish core of Osman Digna's force stood its ground even though the Hussars charged time and again. Some warriors rolled under the horses' bellies and slashed with their two-handed swords, hamstringing several animals and bringing down their riders. Lancers, Villiers opined, would have been more effective because the sabres of the Hussars were not long enough to reach the Arabs when they threw themselves under the horses.

In the mêlée, he had two remarkable encounters, the second of which was nearly fatal. He found himself standing by an officer in Egyptian uniform. At first he did not recognise him because the man's head was swathed in a bloody towel and his eyes glittered with shock and delirium. When the officer addressed him by name, he realised it was none other than Baker Pasha, whose army had been destroyed a month earlier; the two had met in Constantinople. Baker clenched Villiers's hand, and clung on to it. Then he waved towards the 10th Hussars, bearing down with flashing sabres on the retreating Arabs. 'Look! Look at my old regiment charging!' he cried. 'That's it! Let them have it! See how the boys go through the . . .' He rambled off into incoherence, and an aide led him away.

In the second incident Villiers prepared to sketch a pile of Arab bodies around an old iron steam boiler behind which they had made a last stand. Suddenly, one of the 'dead', no more than a boy, leaped into violent life. He bounded at Villiers, brandishing a long corkscrew knife. Villiers took to his heels, frantically trying to wrench

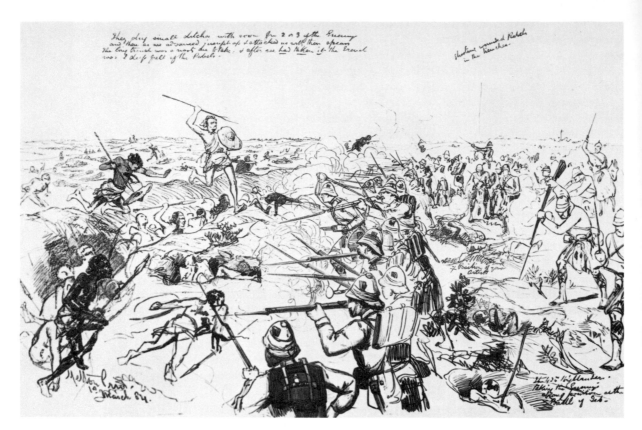

This facsimile of a sketch by Melton Prior of the battle of El Teb was published in the *Illustrated London News* of 22 March 1884, and fuelled protests in Parliament about alleged atrocities by British troops. Prior wrote on his sketch, 'Shooting wounded Rebels in the trenches', and 'They dug small ditches with room for 2 or 3 of the Enemy and then as we advanced jumped up and attacked us with their spears. The long trench was a nasty one to take, and after we had taken it the trench was 2 deep full of the enemy.' He argued that in the face of such fanatical resistance, the troops had no option but to bayonet and shoot the wounded. (*National Army Museum*)

his revolver from his holster. Behind him he could hear the swish-swish of air as the Arab slashed at him. A soldier dropped the boy with a single shot and Villiers turned to find him dead at his feet. 'After this little incident I was for safety's sake obliged to cover with my revolver every apparently dead body I came across,' he wrote.

The fanaticism of the enemy was something new to the old campaigners who had fought against Arabi Pasha's motley troops in Egypt. Fired by religious fervour, the supporters of the Mahdi became a foe to be respected by the British soldiers—'a first class fightin' man,' as Kipling put it in the words of the Tommy. In the fight for the enemy entrenchments at El Teb, the men of the 42nd and 23rd regiments found themselves in a rabbit warren of pits from which black fuzzy heads would pop up, then a rifle would be fired and the Dervish would vanish. Villiers explained that 'the occupant of each pit had to be dealt with individually and many who had feigned death became troublesome customers to those of us who were too eager to reach our objective, for these "dead men" bounded out of their pits and charged our men with their spears and knives.' Consequently the Black Watch and the Royal Welch Fusiliers were not as fastidious as they might have been about respecting the wounded, and many adopted the maxim, 'If it moves, and even if it's dead, bayonet it!'

Without hiding this fact for the squeamish, Melton Prior drew the bitter hand-to-hand fighting as he saw it. His pictures in the *Illustrated London News* fuelled a blaze of protest from liberal opinion which was appalled by the apparent brutality of British soldiers towards the wounded. One of Prior's captions actually drew atten-

126

tion to the killing of enemy wounded. Copies of the paper were waved in Parliament as alleged evidence of atrocities. Afterwards Prior argued, like Villiers, that it would have been suicidal for the British troops *not* to have fired into every hole, *not* to have bayoneted every Arab. 'The only choice lay between killing and being killed. Under these circumstances I maintain that our men could not have done otherwise,' he said. Gladstone defended the army's behaviour in the House. And when the campaign was over he met Prior and assured him that his sketches had been as valuable to him in the soldiers' defence as the protestors hoped they would be in support of their case.

Special artists, unless they were as resourceful as Prior, existed in war conditions on the generosity of the army or friends in the officers' mess. On the evening after the battle of El Teb, Villiers had his first meal for twenty-four hours—a mug of thick army rum and a tin of French asparagus which a young officer shared with him. Next morning he was down with a raging fever and was carried back to the coast on the tailboard of an ambulance cart. Within four weeks, however, he was fit enough to take part in a second battle which gave the British a further taste of the fanaticism and fighting powers of the Mahdi's men, the Hadendowah.

At Tamai, not far from El Teb, the British lay all night in fortified square under the pitter-patter of bullets from an enemy hidden in the rocks and darkness beyond. Villiers's own description as the sun went down was lyrical:

> We had advanced into the jaws of the enemy and we were now bivouacked on a sandy patch between the outlying foothills on one hand and the base of a chain of ragged volcanic mountains which run parallel to the whole length of the Red Sea littoral on the other. The scouts of the enemy were already in sight on the low black rocks of granite and syenite in our front. Splashes of light were flickering like flecks of fire in a distant hamlet when the sinking sun lights up its window panes. But no such suggestion of peace was in those reflections from the hills. The broad barbs of the spears of Osman Digna's warriors gave out the light, blood-red with the rays of the dying sun, as if already reeking with gore.'

As the night went on, Arab bullets found targets among men of the 42nd, holding the front wall of the *zeriba*, or thorn fence. In the centre of the square, a wounded horse writhed in agony before it was despatched with a revolver shot. A friendly corporal of the Black Watch, called Dunbar, advised Villiers to take cover and seek sleep behind the mound of sand he had built. When dawn came with an indescribably beautiful lilac flush it brought bitter cold and sober thoughts of the coming battle. The Scots corporal revived Villiers's flagging spirits and well-being with a flask of rum: 'Dinna be feart, sir. Tak' a sup.' Villiers thanked him and promised to repay his kindness some day. 'Look me up in London if we ever get out of this,' he said. The place where he last saw Dunbar took the brunt of the subsequent Dervish onslaught and was the scene of savage hand-to-hand fighting.

The morning found the British advancing in two squares, the forward of which was soon under heavy attack from spearmen who had hidden in a gully until the British were almost on top of them. The naval brigade's Gardner machine-guns jammed. They were theoretically capable of 120 rounds a minute from each of their five barrels, but they were not as reliable as the older Gatlings and were eventually to be replaced by Nordenfeldt guns. Unbelievably, a corner of the square was breaking and the front lines of the 65th regiment were being hurled back on the Marines.

The Hadendowah advanced in a wild rush, hacking and stabbing and firing their captured Martini-Henry rifles. 'Unless a bullet smashed a skull or pierced a heart they came on furiously, and even when the paralysis of death stole over them, in their last convulsions they would try to cut, stab or even bite. Among the mob of fanatics came even little boys brandishing sticks, led on by their parents to the very muzzles of our rifles,' wrote Villiers.

Melton Prior was one moment behind a wall of advancing troops. The next he was alone, with only dead and wounded British around him, the others having retired to load and fire in turn from behind the second line which covered their retreat. He saw the Hadendowah warriors surging forward towards him. He flung his tubby frame into a headlong rush for the comparative safety of the shattered British square.

There, he found confusion. Officers were trying to rally the men, attempting to form some semblance of order from the intermingled units. Villiers claimed that when things looked blackest the stentorian voice of the *Telegraph*'s Bennet Burleigh saved the day. 'Give it the beggars!' he roared. 'Let 'em have it, boys! Hurrah! Three cheers—hurrah!' Prior looked for his servant, whom he had left holding his horse. The servant had put discretion before duty and fled on Prior's nag, not stopping until he reached the safety of Suakin, fourteen miles away.

How Villiers got out of the fight he never knew. He remembered only whipping his horse into life and urging from it an unwonted burst of speed for an animal that had been condemned by the military authorities as unsound before he bought it on the coast. Somehow he struggled out of the human debris of the broken square and galloped through the smoke. Here and there, a white-robed or loin-clothed figure loomed up and stabbed at him, but he came through unscathed—'I fired my revolver at any dusky form I saw emerging from the smoke; but still the figures flitted. The regulation revolver is not much use against the Fuzzy-Wuzzy; he seems to swallow bullets and comes up smiling.'

The rest of the battle is history. The second force under Redvers Buller turned the tide and allowed the broken square to reform. Sheer rifle power crushed the Arab strength and soon the cavalry were pursuing the fleeing survivors across the sands.

On his return to London after the campaign, Villiers was painting in his studio when there was a ring at the bell. On the threshold was a 'smart Bond Street type of gentleman in frock coat and enamelled boots, with an orchid in his button-hole'. It was Corporal Dunbar of the battle of Tamai, but a new Dunbar. Now commissioned as lieutenant for exceptional bravery in the field, he spoke with little trace of his Scots vernacular.

'I have come simply to ask you for the service you promised me,' he said.

'Right, fire away, Mr Dunbar,' said Villiers.

'The fact is, Villiers,' he slightly hesitated, 'I am, er, I am going to be married tomorrow, and I want you for best man.'

11 Six Graves to Khartoum

We've broken the necks of the Turks,
The Egyptians are our slaves . . .
Ya, ya, Tommy,
Blood, wounds and battles
Rage and rejoice in.
Ya! Great heart red men,
The mighty Ingleesy

Translation of Hadendowah Dervish war song

The opening chapter of this book dealt with the death of the correspondent Edmond O'Donovan and the disappearance of special artist Frank Vizetelly in the massacre of Hicks Pasha's army in the Sudan in November 1883. By February the next year General Gordon was installed in Khartoum where, far from organising the evacuation of Egyptian garrisons as he had been instructed to do, he embarked on a campaign of virtual blackmail of the British government to rescue him. For now, apart from a tenuous lifeline down the Nile, he was isolated by the virulent spread of the Mahdi's revolt. Gordon hoped and schemed that his relief would mean the subjection of the revolt by a British army.

Public opinion in Britain demanded that Gladstone should act, at least to save Gordon, a popular national hero of the wars in China, and to this end a relief expedition was mounted under General Wolseley. The newspapers geared themselves for another bout of campaigning in Fuzzy-Wuzzy land. Before the inevitable clashes with the Mahdi became front-page news in the illustrated papers, however, history wrote a footnote to the saga of O'Donovan and Vizetelly.

The reporter and artist were accompanied as far as Khartoum by a twenty-five-year-old Irishman who had held a commission in the Austro-Hungarian army, Frank Le Poer Power. He was acting as a special artist for the *Pictorial World* of London, one of several illustrated newspapers launched in the wake of the runaway success of the *Illustrated London News*. When his two colleagues rode off into the desert with Hicks Pasha's ill-fated column, Power remained in Khartoum to arrange the forwarding of O'Donovan's despatches. He also became the correspondent of *The Times*, and was appointed British vice-consul in the city.

He was there to record, on 17 February 1884, the tumultuous reception given to General Gordon on his arrival in Khartoum. Only a fortnight earlier he had transmitted to London a full report of the death of O'Donovan and the disappearance of Vizetelly in the Hicks disaster of the previous November. To J. R. Robinson, manager of the *Daily News*, he forwarded a letter from the paper's reporter O'Donovan, written on the march and sent back to Khartoum with an Arab runner who somehow managed to get through the wild country dominated by the Mahdi's roving horsemen. It was a letter in which O'Donovan took no pains to conceal the

deep forebodings of disaster as he and Vizetelly marched with the motley host deeper and deeper into enemy territory:

> By the courier who carries this through the enemy behind us I send a long telegram about the general state of things which for the moment is exceedingly disagreeable, as the prevailing opinion is that we are running a terrible risk in abandoning communications with our base on the Nile and marching 230 miles into an almost unknown country. General Hicks has just sent for me to say that this is the last opportunity we shall have for some weeks of communicating with the external world.
>
> > I remain dear Mr Robinson—I hope in spite of
> > our ugly prospects here
> > Sans adieux
> > Sincerely yours
> > E. O'Donovan

It was, in fact, his last communication with the outside world. A few days later he was killed with Hicks Pasha's army in the wastes of Kordofan.

At the same time Power wrote from the Palace, Khartoum, to say that he would send home the baggage O'Donovan had left there 'as soon as a route for baggage camels is open'. The route, as history knows, opened too late for General Gordon—and for Power himself. Within a few months his body was floating down the Nile. He was the second special artist and third journalist to become a fatal victim of the Sudan wars. There were to be others.

On 10 September 1884 Power set off from Khartoum with Colonel J. D. Stewart, Gordon's aide, aboard the steam launch *Abbas* in attempt to reach Dongola and safety, six hundred or more miles down river. They took with them messages and despatches from Gordon and hoped to contact the British authorities. Gordon was gloomy about their prospects. He wrote in his journal on 17 September: 'I have the strongest suspicion that these tales of troops at Dongola and Merowe are all gasworks, and that if you wanted to find Her Majesty's forces you would have to go to Shepheard's Hotel at Cairo.'

Nevertheless, the *Abbas*, recent veteran of Nile fighting with a thousand bullet scars to her credit, was fitted out like a floating arsenal. She was bolstered with armoured plating, her sides were protected against collision by buffers which went down a foot into the water, she carried a mountain gun and fifty riflemen. The French consul, Herbin, was on board and ten Greeks went along, in Gordon's words, as a bodyguard and to keep the Egyptian soldiers in order.

Stories of the fate of the *Abbas* vary. According to the *Illustrated London News* of· 13 December she hit a rock at the fifth cataract of the Nile. The party struggled ashore and decided to travel across the desert to Merowe, further down river. They made a bargain with local sheikhs for safe conduct and help. But the party carried gold—only £60's worth according to Gordon's journal—'and this excited the murderous cupidity of the Arabs'. A few hours after landing, the survivors were attacked and massacred with the exception of a handful who fled to an unknown fate in the desert. Stewart and Power were said to have fought desperately, killing several Arabs. After the loot had been shared out, the bodies were flung into the Nile.

Most stories seemed to agree that the boat managed to travel a good distance down the Nile through enemy country—one report put the scene of its mishap at Dar Djumma, more than 350 miles from Khartoum. The Mudir of Dongola, a local

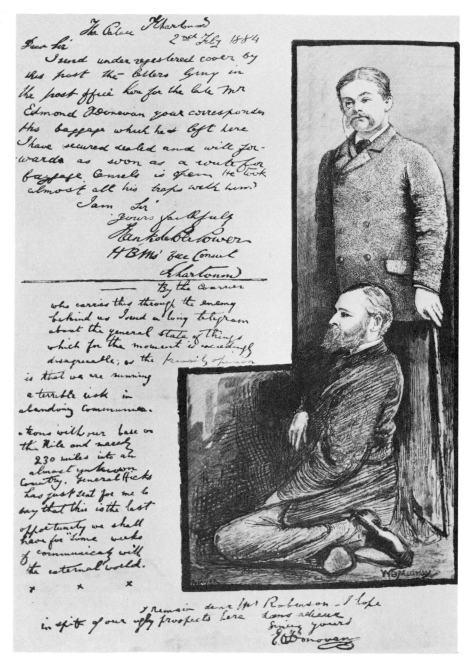

On 13 December 1884, the *Illustrated London News* published this picture of and letters from artist Frank Le Poer Power and reporter Edmond O'Donovan, both of whom died in the Sudan. Power's letter from Khartoum to the manager of the London *Daily News* reads:

'I send under registered cover by this post the letters lying in the post office here for the late Mr Edmond O'Donovan your correspondent. His baggage which he left here I have secured sealed and will forward as soon as a route for baggage camels is open. He took almost all his maps with him.' O'Donovan's letter spoke ominously of 'a terrible risk in abandoning communications with our base on the Nile'.

potentate, reported that Power and Stewart had, indeed, been the victims of treachery. Having run aground, they went ashore and bargained to buy camels. They established the deal with tribesmen but made the mistake of presenting the sheikhs with a gold and a silver sword, whereupon the Arabs massacred them in the hope of finding more loot.

Another, and what surely must be the ultimate, account of the deaths of Power and company came from none other than the Mahdi himself in a letter delivered to the besieged Gordon in Khartoum late in October. The Mahdi wrote:

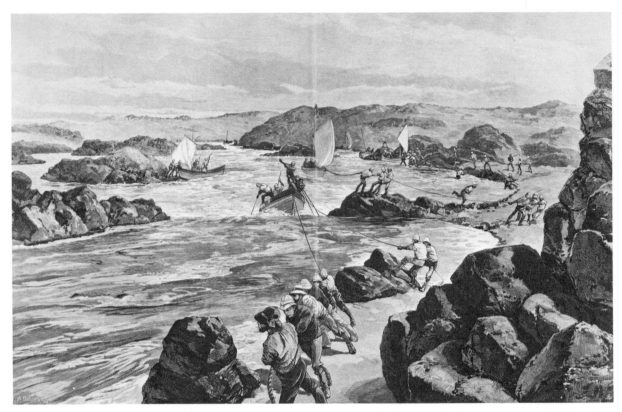

The Gordon relief expedition inched its way up the Nile by the muscle power of the troops and native labour. Progress was tragically slow. Melton Prior drew the sketch that provided this two-page engraving in the *Illustrated London News*.

Know that your small steamer, named Abbas—which you sent with the intention of forwarding your news to Cairo, by the way of Dongola, the persons sent being your representative Stewart Pasha and the two Consuls, French and English, with other persons, has been captured by the will of God.

Those who believed in us as the Mahdi, and surrendered, have been delivered; and those who did not were destroyed—as your representative afore-named, with the Consuls and the rest—whose souls God has condemned to the fire and to eternal misery.

Gordon at first refused to believe this news when the letter was translated for him. But he read on, and his scepticism was demolished as the Mahdi gloatingly listed, detail by detail, the contents of Gordon's own messages and despatches to Cairo which his men had captured. For good measure, the Mahdi added:

We never miss any of your news, nor what is in your innermost thoughts, and about the strength and support—not of God—in which you rely. We have now understood it all. Tricks in making cyphers, and using so many languages, are of no avail.

Meanwhile Wolseley's relief expedition was gathering its strength. Contrary to Gordon's innuendos about languishing in the fleshpots of Cairo, it was engaged in the herculean task of organising and launching a fleet of boats to carry an army, with baggage trains and supplies, up the Nile through a series of cataracts, or rock-strewn rapids. Hundreds of specially equipped boats were assembled, many of them brought by steamer from England. Each was self-sufficient, loaded with medical

supplies, bacon, biscuits, cheese, preserved vegetables, tea, sugar, lime juice and tobacco; as well as ammunition and other military stores, animals and men. The task included the provision of masses of blocks and tackles, and the recruitment of thousands upon thousands of tribesmen to haul the boats over the cataracts at a pace that was often no more than five miles a day. The raging torrent, the lines of heaving labourers, the squads of engineers and the floating expedition all made up an ideal subject to be splashed across double-page spreads of the picture papers.

On 13 September 1884, the *Illustrated London News* informed its readers with a fanfare that its star special artist, Melton Prior, was on the way. He was in Shepheard's Hotel, Cairo, organising his transport arrangements when he received a telegram telling him that he was about to be joined by Walter Ingram, the twenty-eight-year-old youngest son of the late Herbert Ingram, and brother of William, then the newspaper's proprietor.

Prior, not one to stint himself on expenses, was marvelling at the costs being paid by the London morning papers, with telegrams at fifteen shillings a word. He wrote afterwards: 'Sir William Ingram used to call me the "Illustrated Luxury", even without the telegrams, simply because I travelled in comfort.' He has left no clue as to how he reacted to the news of Walter Ingram's impending arrival; proprietorial presence in a campaign could be an encumbrance, even if it only meant a stricter control on expenditure; on the other hand, Walter brought with him his own steam launch, which seemed to meet Prior's immediate transport needs.

The launch was an open nineteen-footer with an unwieldy smokestack. Once the passengers and servants were installed there was no room for baggage, and this problem loomed large as Ingram's penchant for creature comforts was as strongly rooted as Prior's. So they hired a bargelike craft that could be towed, and their Nile odyssey began with the launch chugging along amid clouds of smoke, pulling the barge piled high with baggage, on top of which was perilously perched a servant. They had hardly gone any distance at all when the servant screamed in alarm that the towed boat was sinking. They found that it was leaking and completely unserviceable.

Another boat was hired and the party reached Wady Halfa, more than six hundred miles up river from Cairo, without mishap. There, Ingram's launch faced the problem of climbing the rapids, 'like a salmon at a weir', in Prior's words. In the fierce currents, the bow swerved and hit a rock. The party leaped out onto the rock, but Prior missed his footing and fell into the swift torrent. He was saved by some Canadian boatmen, the 'Manitoba boys', a skilled and experienced corps of rivermen who made a vital contribution to the Nile progress of the expedition; they had been brought to the Sudan by General Wolseley who had been impressed with their achievements in the 1870 Red River rebellion in Canada.

Reuter's man in the Sudan flashed the news to England that Prior had been drowned. Prior's wife read it in the *Globe* and also a further announcement that the *Illustrated London News* was going to send out another special artist to replace him. Disbelieving, she cabled Prior: 'WIRE FULL DETAILS'. Prior replied: 'NO DETAILS STOP AM ALL RIGHT'. A few weeks later his drawing of 'Our artist come to grief at the second cataract' was given front-page prominence in the *Illustrated London News*. It showed Prior being helped from the flood. Thereafter Prior on the Nile relied on the travel arrangements of Messrs Thomas Cook.

Inevitably, the *Graphic*'s Frederic Villiers was pacing his rival, Prior, but without the questionable backing of a launch-owning proprietor, he relied on military

Melton Prior captioned his
original sketch (*above*)
'Mr Walter H. Ingram's
steam launch come to grief at
the 2nd Cataract. Your artist
also came to grief.' He is seen
in the water, receiving a
helping hand from a
Canadian boatman while his
proprietor chats, seemingly
unconcerned, to a straw-
hatted companion. The
second illustration is the
engraving which appeared in
the *Illustrated London News*.
(*Original sketch: National
Army Museum*

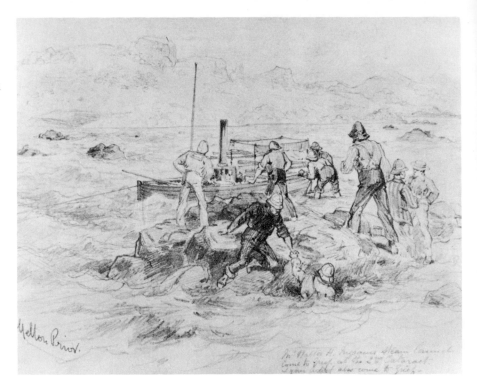

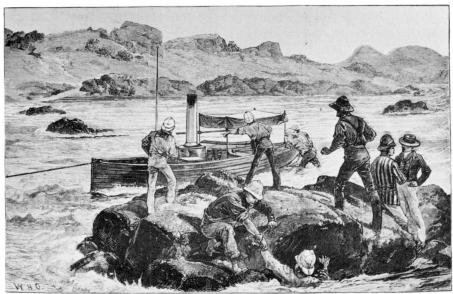

patronage. Capitalising on earlier acquaintance, he sought and received permission
to join Wolseley's official party. (The general had had shipped in sections from
England a magnificent launch called the *Pelican*. It was a paddle wheeler with a
Nordenfelt machine-gun mounted on the elevated saloon deck and another gun on
the roof.) Thus, for many river miles Villiers sailed in comparative comfort, taking
pot shots at crocodiles to ease the tedium.

At Dongola, upstream from Wady Halfa, Villiers hastened ashore to make a

personal pilgrimage. He had once read in a London newspaper an account of the Arabian Nights splendour of the palace of the Mudir of Dongola, a scene of oriental opulence lit by Damascene lamps burning fragrant oil. Such a picture must be sent home for his readers. He found the Mudir in a bare, whitewashed hall, sitting on a cane and bentwood chair. Behind him stood a servant waving to and fro a bamboo to keep the numerous tame sparrows from alighting on his master. From the mud ceiling hung, not Damascene lights, but cheap lamps smoky and smelly with kerosene. The Fleet Street hack who had excited Villiers's dreams had obviously never set foot in Dongola.

Back on the Nile once more, now in a whaleboat much more suited to the prevailing currents and race of the river, it was the turn of Villiers to meet a mishap. The boat ran onto a sandbank and in the course of being towed off by a little steamer it overturned throwing Villiers and a journalist colleague, Charles Williams, into the water. Villiers was trapped under the boat for some anxious moments. He was rescued by the skipper of a pinnace, who threw him a rope and hauled him, half drowned, aboard. Villiers lost everything—'my bed furniture, tea, sugar, canned beef, tobacco, a bottle of pickles, a pepper mill, an extra pair of boots, a dispatch case, and a bag of sixty sovereigns . . . I had nothing but the clothes I stood up in, and they were exceedingly wet'.

He had experienced a similar loss in an earlier Egyptian campaign when his kit fell into the Sweetwater Canal, and on that occasion would have faced the prospect of tramping through the desert in evening dress of swallow-tail coat, white waistcoat and top boots had a colleague not come to his help with a brown holland jacket. Now he relied on the generosity of officers who gave him an assortment of garments. General Wolseley commiserated with Villiers and regretted he could not help out as he had only two flannel shirts for himself.

So far the correspondents had suffered little worse than dousings in the Nile and an occasional fall from a recalcitrant camel. Like all desert tyros they filled pages of their diaries with the vicissitudes of camel travel, and the artists found these strange beasts a wonderful source of graphic material. As a change from river travel, Prior joined the Guards camel corps on a journey across the desert from Wady Halfa to Dongola. On the way he was overtaken by General Wolseley and his staff aboard their 'ships of the desert'. Wolseley by this time was an experienced camel rider, but his mount shied and threw the discomfited general to the ground. He remounted and looked hard at Prior, who had his sketch-book out. 'I did not see you fall, sir,' said Prior. 'Thank you, Prior,' said Wolseley and rode on. Prior's subsequent sketch of the meeting showed the general firmly mounted and in control of his camel. On occasions discretion was the better part of truthful journalism.

The expedition had, until now, been experiencing a 'phoney war' in which logistics and seamanship amid the Nile's torrents had played a more important part than battle tactics. The newspapers had been notably thin on hard copy and, while the British public impatiently waited for news of Gordon's heroic rescue, it was regaled with such snippets as this: 'Pussy is very much at a premium among our troops in Egypt, and happy is the man who has contrived to secure a feline pet. The tents are infested with rats and mice and creeping things innumerable, but they all seem equally welcome to a cat with a taste for game.' The *Illustrated London News* noted that command of boats was given to Colonel Sir William Butler, the husband of Elizabeth Thompson, the artist of *Roll Call* and *Quatre Bras* renown; its columnist trilled: 'The new Kharkee uniform will doubtless figure in some of her future

The Guards Camel Corps on the Way to Dongola — Meeting Lord Wolseley in the Desert.

A minor case of news management. At a meeting with General Wolseley in the desert, Melton Prior saw the commander of the British force fall ignominiously from his camel. Wolseley looked hard at Prior who said, 'I did not see you fall, sir.' The facsimile of Prior's sketch shows the General firmly in control of his beast as he talks to Guards officers. (*National Army Museum*)

compositions.'

In fact, the 'new Kharkee' was about to receive its Sudanese baptism in battle. Progress along the Nile was so slow that Wolseley decided on a daring plan to relieve Khartoum, where time was running out for the besieged Gordon. He mounted a fast-moving desert column which was to strike overland from Korti to Metemma, some seventeen days' march away. The march would shorten the distance between the two points on the river by cutting out the need for a long, difficult water slog around a huge meandering bend of the Nile, and bring the British troops to striking distance of Khartoum at a spot where Gordon's river steamers could pick them up and transport them to the embattled city.

There were only 2,000 troops in the column, but they were the cream of the British army, led by the crack camel corps. In command was a Wolseley favourite, Colonel Sir Herbert Stewart, a talented and brave officer who had served with distinction in the mobile warfare in Zululand. The press went along in force. As the new year of 1885 opened, the tiny column was but a dot in the vast wastes of the Bayuda desert, sparsely populated and traditionally avoided by travellers owing to its notorious shortage of water holes.

Melton Prior, from whom we normally hear concern about his whisky supplies, was obsessed with the idea of preserving his drinking water. By day he rode behind his baggage camel so that he could keep his water skins under his eye. At night he slept with them under his mattress and with a revolver at his waist. The bogey of Hicks Pasha's thirst-crazed army loomed large in this thinking, a not irrelevant thought as the column deliberately severed its communications to speed progress through the desert.

Twenty miles from its destination on the Nile, Stewart's column came to the rocky gorge of Abu Klea, and the Mahdi's army. The tight square of 2,000 British soldiers faced an immediate opponent who numbered about 10,000 on horse and foot; behind these were possibly 20,000 more gathering with delight for the chance to snuff out the pitiful band of unbelievers. The Mahdi reckoned he could have taken Khartoum at any time he wished. He stayed his hand solely to tempt just such a relief force into the desert where his warriors, their appetites whetted with the 'soft' kills of the Egyptians, could dip their spears in the blood of the mighty Ingleesy. Now was the opportunity.

On the morning of 17 January the British moved in square out from behind their thorn fence and advanced on the Mahdi's men. There followed what Churchill has described as 'the most savage and bloody action ever fought in the Sudan by British troops'. As at Tamai, the previous year, the Gardner guns jammed. As at Tamai, the enemy broke into the square. Both Prior and Villiers saw history repeating itself, but this time there was no supporting square to repair the damage. There were, however, the 19th Hussars. They were only a squadron strong and their horses were so weakened by exhaustion and thirst that, according to Villiers, 'if you patted one on the neck he would take advantage of you by falling asleep on your shoulder'. Under Major John French, later Lord French of Mons and Ypres in the First World War, the Hussars whipped their broken-down mounts into a spirited charge which threw the Dervishes into rout. In the meantime, the murderous, slashing, hacking, stabbing, hand-to-hand combat in the square had left the British with seventy-four dead and ninety-four wounded, ten per cent of the actual combat troops.

There were aspects of tragi-comedy in the fight and its aftermath. Lord Charles Beresford, a gallant officer from a distinguished military and naval family, was humiliatingly pinned to the ground by his donkey, which fell shot. But it saved his life from Dervish spears when a torrent of barefoot tribesmen thundered over the prostrate pair.

As the column buried its dead and tended its wounded, the correspondents were recruited to help build a fort of biscuit- and ammunition-boxes. Prior, who seldom lost sight of his role, worked through the night despite exhaustion and produced a bundle of sketches by candlelight. But how to get his 'budget' (as the specials called a consignment of sketches) back to civilisation was the problem. He found a camel-man willing to risk the ride across the desert for £50—£15 down and £35 to be paid by an agent on the production of the sketches and letter of authorisation in Korti. Villiers, whose sovereigns had sunk in the Nile, presumably had no such incentive to offer. Prior later heard that his courier reached Gakdul Wells, fifty miles away, where he boasted about his earnings. He never arrived at Korti. He was murdered and robbed and Prior's sketches were flung to the desert winds.

When the morning of 19 January dawned the column was suffering badly from thirst. A tough night march with their wounded had brought the British to within sight of Metemma and only four miles from their objective, the Nile. But between the force and the precious source of water were thousands of the enemy. They spread far and wide over the thorn scrub and encircled the column. There now began a running fight that was to be known as the Battle of Abu Kru after the small hamlet near which it took place. It was a fight which tragically depleted the ranks of the newsmen.

Prior recorded that bullets flew so thickly that every member of the press contin-

At Abu Kru in January 1885
John Cameron of the London
Standard was shot and killed
as his servant offered him a
tin of sardines. He was one of
six newsmen killed in the
Sudan campaigns. His friend
Melton Prior drew the scene
as he saw it amid the baggage
camels of the British square;
this is his original sketch.
(*National Army Museum*)

John Cameron's newspaper
colleagues buried him in the
sands of the Sudan. In Prior's
original sketch, the burial
party is composed of (from
the left) Bennet Burleigh of
the *Daily Telegraph*, Frederic
Villiers of the *Graphic*, G.
Macdonald of the *Western
Morning News*, Prior, and
Harry Pearse of the *Daily
News*. (*National Army
Museum*)

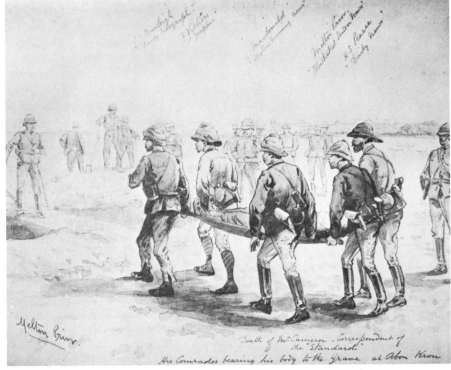

gent was struck, though most of the hits were of a minor nature. 'Pearse [Harry Pearse of the *Daily News*] and myself were chatting with Bennet Burleigh when we heard a tremendous thud, and Burleigh yelled out, "Pick it out, Prior! Pick it out!" at the same time clawing at his neck. I said: "There is nothing to pick out."' Burleigh had been grazed and bruised by a ricochet shot. Shortly afterwards a bullet hit Prior's instep and then struck the heel of Villiers's boot as they ate. Within seconds, another bullet grazed Prior's thumb. Huddled together among the baggage camels, the correspondents were pelted with a rain of mostly spent bullets and largely escaped with bruises and cuts.

John Cameron, reporter of the *Standard*, was killed. He had been in many scrapes with Prior and Villiers. In the Transvaal he came unscathed through the carnage of Majuba Hill and was taken prisoner by the Boers; used as an emissary to seek help for the wounded British captives, he had been allowed to go to the British lines and later returned to captivity under the terms of his parole (being a good newspaperman, he provided Prior with some, albeit amateurish, sketches of the fight and his capture). Now Prior saw him fall with a bullet in his lung at the very moment his servant was offering him a tin of sardines. Prior, of course, drew the bizarre scene for his paper and it duly appeared, together with a sketch of Cameron's burial in the desert by his colleagues.

The next to go was St Leger Herbert, correspondent of the *Morning Post*. Part of the force was to make a fighting march for the water of the Nile and Herbert was preparing to accompany this square. Villiers takes up the story:

My friend had worn out his khaki and was wearing a red tunic he had borrowed from an officer. 'You are drawing the fire with that infernal jacket,' I cried. 'Take it off.' Receiving no reply I looked around; poor Herbert was lying on his back with a bullet through his brain. I knelt by his side. His large blue eyes were staring up at me, but with no speculation in them. He was dead. Then in a frenzy of grief I began to drag his body towards the square, but an officer crawled up to me on his knees and said: 'Hurry up, Villiers, leave the body where it is; they will pick it up from the *zeriba*. We don't want dead men with us.'

About this time, Prior played a hunch that nearly cost him his life. Burleigh and Pearse had been discussing the chances of survival at Abu Kru. Both wanted to ride hard for Gakdul with their written stories which were burning holes in their pockets. The reporters had a tremendous story to tell of the heroic column. They decided to risk it across the desert. 'I did the same,' said Prior, 'but with very different feelings, for I had personally come to the conclusion the game was up, and that it was going to be another case of Hicks Pasha and the total annihilation of the force, and that the only chance left was a ride for life to the rear.' He said goodbye to Walter Ingram and to Villiers, who both thought there was less risk in staying.

Spurring their ponies, the three newspapermen leaped the stunted shrubs surrounding the makeshift British fort and made for the open desert. Burleigh, a superb horseman, was in the lead and Prior lagged behind. Within the first few hundred yards they realised that they had made a dreadful mistake. A line of skirmishers rose to meet them from nowhere: the bush was crawling with Dervishes. Then Prior saw a band of about fifty Baggara horsemen bearing down on him, hooting and brandishing their huge-bladed spears and their rifles. He reined in a flurry of dust, wrenched round his horse's head and returned the way he had come, hell for leather through the Dervish tribesmen in the scrub. He took the British thorn fence in a

prodigious leap, followed only a few lengths behind by his two companions. All three found that their ponies had been hit by bullets.

Now there was no alternative but to join the column that was preparing to fight its way to the water. Supplies would be exhausted in a few hours. Sir Charles Wilson, who had taken command after Colonel Stewart had received a mortal wound in the groin, ordered a guard to be left over the wounded, and about a thousand men set out to march in square the four miles to the Nile bank over ground infested with the Mahdi's men.

Prior and Burleigh carried a wounded private on a stretcher. For four blistering miles in the heat of the day they stumbled and swore, all the time keeping their heads down from the flying bullets. The square would move slowly forward, halt and send volleys into the encircling Dervishes, then move slowly forward again at a pace slow enough to give the orderlies time to pick up the wounded and place them in the ambulance 'chairs' slung on the camels. Villiers helped in this work, but he sadly noted that 'these poor fellows were often shot through and through, for, perched up on the "ship of the desert" they were directly in the line of Arab fire.'

The British smashed through a final concentrated attempt by Baggara cavalry to bar the way and, fighting right to the very banks, reached the water of the Nile. Prior and Burleigh almost tumbled into it with their wounded charge (four years later, in Burma, a soldier came up to Prior, saluted him and thanked him for carrying him that day at Abu Kru). Villiers wrote: 'I could not help admiring the discipline of the British soldier in this more than trying situation. Almost mad with thirst and with the water in plain view, there he stood patiently waiting till he was ordered to be watered by companies.'

Two days later three steamers sent by General Gordon arrived. Sir Charles Wilson knew that his column was too exhausted to make the journey, but he embarked with a company of infantry and headed upstream for Khartoum. Walter Ingram went with them. On 27 January they came within sight of the city and under enemy fire, only to learn that Khartoum was the Mahdi's. Only forty-eight hours earlier his men had stormed into the city and put Gordon to death.

At Metemma the news reached the men of the battle-scarred desert column. Their mission had failed. Further down river, the details of Gordon's death were related to the main Nile force on the very day it cleared the last of the fearsome cataracts and started moving forward at five times the speed of earlier days. The back-breaking ordeal on the Nile, the desert marches, the deaths from bullets and disease, the exhaustion and the agonies of thirst: all these had been to no avail. London signalled its instructions: the army was to withdraw and leave the Sudan to the Mahdi.

Villiers and most of his colleagues, undoubtedly influenced by military thinking in the field, believed this policy to be utterly wrong. The artist was convinced that a continuing strong British military presence would have forced the Mahdi to throw his hordes against the army on ground of Wolseley's choosing, thus leading to the destruction by attrition of the Dervish strength. But this was not to be until a strong Conservative government agreed to the reconquest of the Sudan a decade later. Like the army, the specials and the reporters packed their bags and headed down the Nile.

Villiers was shipwrecked once again, this time in a Nile steamer that ran aground. Washed down the river and almost at drowning point, he was fished out and cared for by some friendly natives. At Wady Halfa, once more with only the clothes he

stood in, he met Walter Ingram who was mentioned in despatches for gallantry in the last stages of the Stewart–Wilson expedition. There, Ingram indulged himself in the current Victorian craze for Egyptology and bought a cased mummy.

When the sarcophagus was opened at Shepheard's Hotel in Cairo, Ingram found a papyrus setting forth a curse of violent death on anyone who disturbed the slumbers of the mummified Egyptian. As Villiers laconically noted in his memoirs, Ingram did indeed meet a violent end within a few years. On a hunting expedition near Berbera on the east coast of Africa, he was killed by a rogue elephant in April 1888.

In the ten years during which Britain appeared to turn a blind eye to the Sudan and its militant Dervish empire, a tenuous frontier was held along a line passing through Wady Halfa, which is roughly half way between Cairo and Khartoum as the crow flies, and stands today on the borders of the Sudan and Egypt. These were the years during which Herbert Kitchener, as Sirdar or commander-in-chief of the Egyptian army, steadily reorganised and built up the Khedival forces. Simultaneously an efficient spy network reported back to Anglo-Egyptian Intelligence the happenings in and the state of the Dervish domain, now under the control of Khalifa Abdullah, following the Mahdi's death from sickness in June 1885 at the height of his triumph. Just as the coming of the railroad had paved the way for the demise of the American Indian, so now did the steady southward advance of the rails herald the coming defeat of Mahdism. According to Frederic Villiers, a large part of the credit for the reconquest of the Sudan was due to 'Thomas Cook & Son . . . and the Egyptian convicts who, under the lash from dawn to sunset, carried the sleepers to build the Nubian Railway which made the campaign possible'.

Vital as these years of regrouping and planning were, they furnished little in the way of newspaper sensations. Consequently, the special artists looked elsewhere for 'little wars' to illustrate, and found them in plenty in the Balkans, southern Africa and Asia. In the last half-decade of the century, however, the Sudan once more provided the newspapers with a happy hunting ground and again became the cockpit in which the irrepressible rivals, Prior and Villiers, schemed and sparred for scoops.

On his way back from the abortive mission to rescue General Gordon, special artist Frederic Villiers was shipwrecked in the Nile, for the second time. Washed downstream, he was rescued and cared for by friendly natives. An anonymous colleague depicted his plight in this primitive watercolour. (*National Army Museum*)

141

Before the army's fighting march to gain the precious waters of the Nile in January 1885, the defences of Abu Kru were built up with sacks, medical equipment and biscuit and ammunition boxes. The *Telegraph*'s Bennet Burleigh was mentioned in despatches for his part in this. A facsimile of Prior's sketch shows the pitifully thin defences being built up. (*National Army Museum*)

Although they did not realise it at the time, the campaign of reconquest was to mark the beginning of the end of the special artists' golden era. For a powerful enemy was gathering strength and attracting a growing number of adherents. Insidious, deadening and more difficult to combat than all the other vicissitudes of campaigning, it radically threatened the free-wheeling, resourceful traditions of pictorial and journalistic war coverage. The enemy was censorship.

The period of reconquest reached its climax in 1898 with the battle of Omdourman at which the Khalifa's might was decisively destroyed by an Anglo-Egyptian army. During the build-up to this battle, the press corps was shocked to hear the order that no correspondents were to be allowed south of Assouan, in the rear base area of upper Egypt. Kitchener 'like most generals in command . . . looked upon war correspondents as a great nuisance', said Villiers. The newspapermen raised a loud outcry, the telegraph lines to London buzzed angrily, and within twenty-four hours the order was rescinded. But artists and reporters continued to be hindered by the censors to whom all material had to be submitted. Despatches and drawings were subjected to long delays. Often correspondents had no way of telling what had been cut from their stories. Mutual distrust flourished. What angered the press more than anything was the knowledge that nothing they wrote or pictured could possibly hamper the British military effort by giving help or information to the desert-based enemy. The army mind was more concerned with public opinion at home than with the Khalifa's Intelligence.

That old campaigner, Bennet Burleigh, of the *Telegraph*, fought tooth and nail against censorship, which was ironical, for he was among the more militarily-minded

142

of the correspondents. His accounts of the campaign are sprinkled with references to 'bagging Dervishes'. He wrote of 'hitting heads' with his rifle from a Nile steamer, of having 'dropped a number of truculent gentry' on a scouting expedition. In the Nile fighting of 1885 he was mentioned in despatches for his part in helping to build under fire the defences of Abu Kru (Prior drew this scene in a sketch which he neatly annotated while the bullets flew). At the battle of Omdourman Burleigh rode his horse through the Dervish thorn fence with the Camerons and pistolled his way through a mob of attacking spearmen. When he returned to London he championed the army in an acrimonious exchange with a writer, E. N. Bennett, who, in the *Contemporary Review*, accused the British of countenancing and taking part in barbarities towards the Dervish wounded and the shelling of unarmed civilians from the river gunboats.

'The fact is,' Burleigh thundered, 'that the Mahdists made it a constant practice to ruthlessly slaughter all prisoners in battle, wounded or unwounded; to enslave, torture or murder their enemies, active or passive; to loot and to burn; to slay children and debauch women. To set up a pretext that such monsters are entitled to the grace and consideration of the most humane laws, is to beggar commonsense and yap intolerable humbug.' He denied that it had been the British practice to kill the wounded in battle from Tel-el-Kebir to Omdourman—'in action there are no soldiers less prone to needless blood-spilling, or men readier to forgive and forget, than "Tommy Atkins" '—but allowed that there might have been individual instances of unwarranted brutality: 'Alas! You cannot eliminate from armies any more than from ordinary communities, the foolish, insane, and criminal.'

While the reconquest of the Sudan provided an early example of a concerted attempt by British commanders to impose organised censorship, it was also historic in the context of this story, in introducing into a British campaign an agent that was eventually to make the special artist as redundant as the cavalryman in modern warfare. Once more Frederic Villiers was going to war with a movie camera. This time he represented the *Illustrated London News* and the *Globe*.

Among his baggage when he reached the army's Nile base in the summer of 1898 was a large box, the contents of which he tried to keep secret from his newspaper colleagues. But the sheer size of his package soon defeated his efforts and the news leaked out: Frederic Villiers had brought a cinematic camera, a cumbersome, hand-cranked machine of the type he had tried without much success in Greece a year earlier. Now, however, in the sunshine of the Sudan, he was determined to demonstrate that the movie camera had its place in war reporting. With the introspective madness that can only breed in a group of correspondents on a common assignment, and which only a newspaperman can understand, his confreres were frantically anxious not to be left out; in the words of Villiers, they 'wanted to take movies as well'.

He relates:

Why they imagined they could get the necessary camera and spools simply by wiring to Cairo, as one would for a packet of tea, I have no idea; but, anyway, the whole thing caused no little excitement in our mess. The two who were going to upset my little plan would occasionally look at me with a kind of pity for the 'beat' they were making. Presently their box arrived, and the look of triumph quickly died out of their faces when they found that instead of a camera it contained a lantern projector and quite an amusing series of films of a racy terpsichorean nature to please an Egyptian audience.

This engraving in the
Illustrated London News in
1898 was after a sketch by
Frederic Villiers. It was from
a gunboat such as this that he
tried to take movie films of
the battle of Omdourman. It
was, he thought, a superb
floating grandstand from
which to see the battle—but
the results were totally unex-
pected, and the camera once
more bowed to the sketch-
book. (*National Army
Museum*)

Villiers, in keeping with his regard for the benefits of technology, had also
brought with him to the front his bicycle. It had after all proved its usefulness in
Greece, and he reasoned that it would be effective for making swift progress over
the desert, large stretches of which, he remembered from previous campaigns,
consisted of a light covering of sand over a hard floor, called the *agaba*—'I could
always get a spin over that and my camel could carry my "iron horse", as the natives
called it, on his hump whenever I came across heavy sand.'

Thus, on his boneshaker and followed by his camel carrying his movie equipment
and a tent rather like 'a glorified umbrella that could be put up in less than five
minutes by tugging a cord', Villiers went to war at Omdourman.

In the event it was his obsession with the movie camera that robbed Villiers of a
chance to record the fighting at Omdourman from close at hand, but it compensat-
ingly provided him with a floating grandstand view of the battle in its entirety. On
the eve of the battle he found that the moonlight was so brilliant, even in the little
hut in which he was taking shelter, that he could not risk the long and difficult
process of loading his film into the body of the camera. He went aboard a gunboat,
anchored on the Nile and set about loading the machine in the darkness of the
vessel's hold.

To his chagrin, the boat was given sailing orders before he could land his equip-
ment and he found himself in midstream when the battle opened on the morning of
2 September 1898. He had often drawn dramatic scenes of warfare from such vessels

144

and he cheered up considerably when the gunboat moved closer inshore to be in a position to give supporting fire to the Anglo-Egyptian army.

From his vantage point he could see the whole panorama of battle, the massed attacks of Dervishes cut down by rifle, machine-gun and artillery fire, the bitter backs-to-the-water fight of the camel corps, the famous charge of the 21st Lancers in which the young Winston Churchill, correspondent of the *Morning Post*, took part ('I saw little of that but the dust and the spear points, for it took place on the extreme left of our formation and I was on the extreme right'). Somewhere in the mêlée of the battle, Bennet Burleigh saw a shell explode and kill Hubert Howard, correspondent of the *New York Herald* and *The Times* of London. He was the sixth journalist to become a fatal victim of the Sudan wars.

As the battle surged and ebbed in front of Villiers, here was the opportunity to prove the mettle of his movie camera: 'The dervishes were now streaming toward us in great force—about ten thousand spearmen—just as I wanted them, in the face of the early sun and in the face of my camera.' Villiers was weak from the effects of a recent scorpion sting in his shoulder, but he forgot all this as he began enthusiastically to crank his camera from his position atop the aft battery which had been put out of action the previous day.

Alas, film history was not destined to be made that morning. As Villiers explained: 'I had just commenced to grind my "coffee pot" when our fore battery opened fire. The effect on my apparatus was instantaneous and astounding. The gunboat had arrived on the Nile in sections and had evidently been fixed up for fighting in a hurry, for with the blast of her guns the deck plates opened up and snapped together, and down went my tripod. The door of the camera flew upon and my films were exposed.'

There was only one thing to do. Villiers cast aside his newfangled apparatus and took up his pencil and sketch-book. The special artist was in business again.

12 Atrocities to Order

The 'fog of war' has again descended on the theatre of hostilities from Mafeking to Maritzburg

The Graphic *in the Boer war*

After the British Tommy sailed away to South Africa in the autumn of 1899 it quickly became apparent to Dolly Gray, on even the most cursory reading of the newspapers, that her man had gone to fight a foe who was not only crude and untutored, but also cunning and treacherous.

The rebellious Boer, it appeared, was capable of and practising atrocities that were counter to all the so-called rules of civilised warfare. On the other hand, faced with its first war against white soldiers since the Crimea (if one discounts earlier, lesser confrontations with the Boers) Britain was doing the honourable thing in employing no native troops among its forces; that surely was a measure of imperial rectitude.

Patriotism, pride in the army and the need to defend Britain's cause dictated that certain images of the Boer should be fostered, particularly as Victorian complacency was being threatened by voices which were questioning the justness of the southern adventure.

In the field the generals had the weapon of censorship, encouraged and tested in the Sudan by Horatio Herbert Kitchener. It was now an integral part of senior military thought and enthusiastically implemented in South Africa by those of lesser commissioned rank who shared the belief of General Wolseley that newspapermen were 'a race of drones'.

At home the generals had strong allies inside the very bastions of free speech and opinion that had most to lose by censorship, the newspapers themselves. Here there were those who believed fervently that wars in the imperial cause were by nature right, and therefore the adversary in any such war was a villain of the blackest order, thus to be deeply etched in the image presented to the public; and there were many more who, while perhaps not having analysed their opinions, were in no frame of mind to question the thesis that, in the case of South Africa, British was good and Boer was bad. This was an assumption by no means confined to the newspaper industry: when the country's principal and rapidly advancing firm of toy soldier makers, William Britain, introduced Boer troops into their merchandising lines it did so with figures that wore black hats, the readily recognisable sign of the 'baddie'.

Documented evidence of Boer 'atrocities' was difficult to establish, although it would have proved most welcome in the face of a rapid series of British defeats just before Christmas 1899. Nevertheless the illustrated press had the imaginative resources of its home-based corps of artists on which to lean, and many a deed of Boer treachery reached the British public through their fertile pens.

Richard Caton Woodville, patriotic in nature and prolific in output, seized the opportunity eagerly. He was not alone, but his unerring journalistic instinct for reflecting popular aspirations and prejudices in vivid illustration has left us with some classic work in the realms of 'atrocity art'. On 9 December 1899—presciently on the eve of 'Black Week' in which three British generals were trounced at Stormberg, Magersfontein and Colenso—the *Illustrated London News* called on Woodville's services for a full-page illustration entitled 'BOER TACTICS'. The reader was informed: 'The abuse of the white flag by the enemy in the present campaign has met with general reprobation.' The picture showed a Boer with Red Cross armband holding aloft a flag of truce in view of approaching British soldiers, while other Boers, concealed in ambush among rocks, crouched with rifles ready and vulpine looks on their faces. Some degree of balance was afforded by a factual, professionally observed sketch by Melton Prior on the facing page, in which the special artist on the spot soberly depicted British wounded being entrained after the battle of Elandslaagte. But there was more to come: the very same issue carried a notable example of a manufactured 'atrocity'. How it came about is interesting in any examination of the roles of special artists and illustrators at home.

A week earlier, the *Illustrated London News* had published in facsimile a superb panoramic sketch by Prior of the battle of Lombard's Kop on 30 October, when General Sir George White's army was shelled during its retirement on to Ladysmith, the scene subsequently of a four-month siege. It consisted of a detailed pictorial analysis of the fighting withdrawal, vintage Prior in fact. Packed with information, it stands today as much of Prior's work does—as a valuable contribution to military history.

While the civilians of Ladysmith watched from the foreground, gun teams from HMS *Powerful* pounded the distant Boer gun positions on the ridges and infantry was dotted over the far plains, covering the main column's retreat. This last, as Prior's captions revealed, was under constant fire from the enemy during its winding progress across the plain to the haven of Ladysmith. Prior dutifully noted Boer shells bursting here and there across the entire panoramic scene. One of his captions referred to 'Field hospital and spare ammunition retiring on the Newcastle road', and with such a mixed composition of column of route it is reasonable to suppose that anything that moved was fair game to the Boer gunners (even supposing that the long range gave them any specific choice of target at all). Almost in the centre of the scene, on a bend in the road which was being navigated by a medical unit, Prior illustrated an incident—one of many in his picture—which he marked with a cross and captioned at the side: '40 Pounder shell bursting and upsetting Ambulance Cart'. And there, in minuscule could be seen the blast of the explosion, and a few yards away the stricken oxen, listing cart and reeling men.

Prior, I am sure, incorporated this incident into his picture just as it occurred—an unfortunate happening of war in the midst of a wider conflict in which long-range artillery was playing a major part. But what an opportunity for the atrocity seekers. On 9 December, in time for the edition's supplement which was used as a stop-press vehicle to accommodate the latest sketches, the *Illustrated London News* gave a whole page to a 'worked up' sketch of Prior's thumbnail illustration. What had begun as an isolated incident in a general mêlée had become a juicy Boer atrocity entitled: 'FIRING ON THE AMBULANCE: A SCENE DURING THE BATTLE OF LOMBARD'S KOP AT LADYSMITH, OCTOBER 30. From a Sketch by our Special Artist, Mr. Melton Prior.' Directly underneath the bursting shell lay the

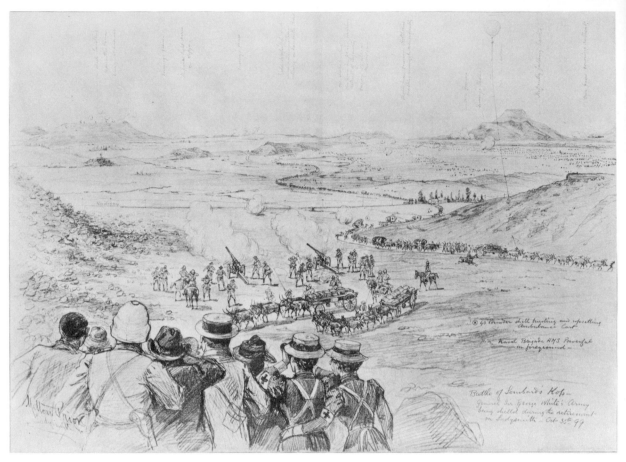

Within the illustration, handwritten notations read:

40 [pounder] shell bursting and upsetting Ambulance Cart

Naval Brigade HMS Powerful in foreground –

Battle of Lombards Kop – [...] Sir George White's Army being shelled during the retirement on Ladysmith – Oct 30th 99

The making of an 'atrocity'. On 2 December 1899 the *Illustrated London News* published this detailed sketch by Melton Prior of the battle of Lombard's Kop, as a British army retired on Ladysmith under Boer fire. Just right of centre he placed a cross and at the side of the picture scribbled the explanation: '40 pounder shell bursting and upsetting Ambulance Cart.' It was just one incident in a large panorama.

shattered cart, the felled oxen and wounded men staggering in agony and bewilderment. The illustration, reproduced by a photogravure process, was signed F. Patterson. It would have needed a sharp and willing eye to relate the horror to a detail in Prior's panoramic sketch of a week earlier.

It has been argued by historians that contemporary attempts to blacken the character of the Boers stemmed from Britain's uneasy conscience about the war (and, later in the war, about the British use of concentration camps for the Boer soldiers' dependents). In 1881 the first Boer war had ended with Britain recognising the independence of the Boer Transvaal under the suzerainty of Queen Victoria. The discovery of gold on the Witwatersrand in 1886 brought an influx, mainly British, of what the Dutch-descended Boers called Uitlanders, and these became the catalyst in southern Africa's volatile mixture. Refused civil rights, including franchise, in the Transvaal, now allied with the Orange Free State, the Uitlanders petitioned to the Queen for help. Pressure was put on Kruger, president of the Transvaal, but he replied with an ultimatum on 9 October 1899 demanding the withdrawal of British troops from the frontier and others on the way. Two days later Boer commandos invaded Natal and Cape Colony, and on the twelfth the first shots were fired in an incident involving an armoured train.

Militarily Britain was woefully unprepared despite advance warnings, and its cumbersome army, polished on the drill ground and practised in nineteenth-century colonial wars, was often badly punished by the mobile Boer farmers fighting for

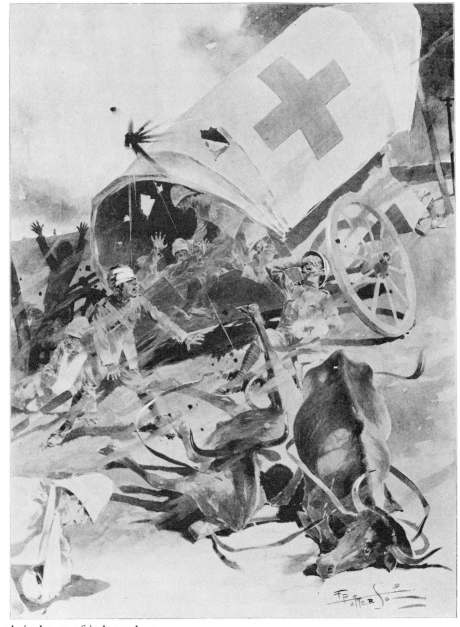

A week later, in the hands of a home-based artist, Prior's thumbnail incident had become a frightful Boer atrocity: 'FIRING ON THE AMBULANCE: A SCENE DURING THE BATTLE OF LOMBARD'S KOP AT LADYSMITH, OCTOBER 30' (*Illustrated London News*)

their dream of independence.

If ridicule alone could conquer the Boer, a study of the popular British press in October 1899 might give the impression that Britain was on the way to a swift and easy victory. The Boer was pictured in cartoons and advertisements as a crude, homespun oaf in bearded dotage. An advertisement for the popular Monkey Brand polish was captioned with a quotation from a daily paper to the effect that 'Mr Kruger's Ultimatum is an unpolished document'; it showed a leering monkey offering the Boer leader a packet and saying, 'Need a little polish, Sir!'

By month's end, however, casualty lists published in the *Illustrated London News* and the *Graphic*, accompanied by rows of oval pictures of the victims, were harbin-

gers of the war's final count of 50,000 British dead and wounded. The *Graphic* complained bitterly about mistakes in official cables listing the casualties, a lapse which was 'giving much annoyance, and causing in some cases much suffering'. It pointed out that the government's grip on the communications was unprecedented and spotlighted another unacceptable face of censorship: 'As the African cables are all controlled by the British military censors, it is astonishing that the news of the reverse which occurred to our forces at Ladysmith last week reached the Continent before it was communicated to the authorities at the War Office.'

As it slowly dawned on England that these crude, troublesome Boers were going to be no pushover and that the country was in for a long and costly campaign against determined opposition, the mood in the press changed discernibly. News of reverses became commonplace. By December, the *Graphic* was referring to one reverse as 'our disaster in South Africa'. It was just one of many to come.

The *Graphic*, its sister the *Daily Graphic* (the world's first picture daily, founded in 1890), the *Illustrated London News* and lesser illustrated newspapers were busy fielding teams of special artists, correspondents and, for the first time effectively, photographers. The *Graphic* sent its special photographer Reinhold Thiele, who obtained a magnificent picture of the Boer general, Cronje, after his surrender with 4,000 men on 27 February 1900. For the *Illustrated London News*, George Lynch doubled as artist and photographer; sometimes his photographs were redrawn. One such picture appeared as a two-page spread with the explanation 'from photographs by Mr G. Lynch' and the laconic detail, 'who we regret to say, has now been taken prisoner by the Boers'.

His capture was entirely due to his zest for news. As the Boer investment of Ladysmith appeared imminent, Lynch decided that his newspaper would best be served from outside the ring of encircling Boers, if only for the reason that his lines of communication for sketches and photographs would then remain open. He tried to move out and was seized. After overtures from London, however, he was released within a few months and he brought back interesting sketches of prisoners in Boer hands. On his way by train to Pretoria, the Transvaal capital, he sketched himself 'playing a rubber of whist with the enemy', and after his release he was quickly in action again with sketch-book and camera.

A Dr Arthur Stark, who died from a shell explosion in Ladysmith, wrote to the *Illustrated London News*: 'I was all the morning with Melton Prior and a troop of cavalry among the stones of a low hill under the Dutch position where the shells passed over our heads, and whence we could see the Dutch artillerymen working their great guns.' He sent with his letter a sketch from which the newspaper reproduced a full-page illustration of its intrepid special artist, already the veteran of twenty-three campaigns, making his own drawings of the bombardment. It was the first of many Boer war portraits of Prior in action, most of them drawn by the artist himself: indeed, Prior became, after the leading generals and heroes, probably the most portrayed character of the war for readers of the *Illustrated London News*.

'Our Veteran Correspondent has been under fire so often and in such a long succession of campaigns, that he seems to regard bullets and shells with the same indifference that he would display in a summer shower,' said his paper. After Ladysmith was relieved, readers were treated to a rare photograph of their hero, sun-helmeted, pince-nez glasses clamped on his nose, and cigarette in hand, in the company of newsmen who shared the hazards of the siege with him. The accompanying text described him as 'the Father Prior of war artists and correspondents'.

One of the reporters pictured with him was Ernest Smith of the *Morning Leader*
who had been Prior's companion on his journey up to Ladysmith, a focal point of
activity, they had both decided, and therefore more likely to be a source of good
copy and pictures than other places on the uncertain South African war front. They
shared Ladysmith's vicissitudes and later in the war joined in purchasing a covered
cart (here was Prior's old penchant for comfort coming to the fore again). It was
emblazoned on the side with their names and those of their newspapers like a
trader's vehicle. It became well known to the army in South Africa as 'the Melton
Prior cart'.

Prior's first Boer war taste of fire was at Elandslaagte, on the way to Ladysmith,
an occasion on which Sir George White's force provided the British public with
some light amid the encircling gloom of defeats. Under heavy fire, Prior realised that

colleagues and soldiers alike were hastily moving away from him. The reason was that his white sun helmet, new from his London tropical outfitters, was drawing the Boers' fire. It was as though he had the plague. 'I realised that if I took it off my bald head would act as a heliograph,' he later wrote. As he started to remove his helmet an officer angrily shouted at him to cover his head. Prior wrapped a waterproof cape around his gleaming dome and sat out the battle turbaned like a Sikh.

As the firing died at nightfall, he tended the wounded until exhaustion overtook him. For a few nightmare hours he tried to sleep in a Boer bedroll, sopping wet, but sleep came only fitfully through the screams of wounded men begging for water, of which there was none other than that which could be collected from falling rain. Ultimately he moved under a waggon and snatched an hour or two of rest. When he woke at dawn he found that two men who had shared his shelter were corpses.

Elandslaagte was hailed as a victory by the British press. Certainly it resulted in Boer prisoners and was a coup for White's column. But a little over five months after the news and pictures of the fight had appeared in Britain, the *Graphic* received a letter from a Boer participant which shed fresh light on the encounter. The letter was written from the Boer in Colesburg, reached London by devious means, and was published in the *Graphic* on 5 May 1900. It read:

> I herewith beg to inform you that I got your illustrated paper of Nov 21. I found it on the Coleskop, the mountain evacuated by the Imperial troops, and see that there are several mistakes made for instance. As the Gordons stormed the Elands Laagte Kop they came by twos and threes, most of them being shot. The last charge of the Lancers is not correct either. There were no waggons on the field, and the fact is this, that the Lancers were charged by the Boers. I write you this because I do not like to see the many wrong versions given of the battle. I was there and killed many a Britisher. I got a few slight wounds, and was a prisoner for some hours, but managed to escape, so thus ought to know how the battle was fought and lost by us. We had 28 killed and 180 prisoners taken, amongst whom 40 wounded. I do not think it right to publish our loss as 2,000 to 3,000. We had only 350 men fighting, with two guns, against your 6,000 with twenty-four guns, so cannot have lost more than stated by me here above. I do not think you will alter your statements given in your issue ... but hope you will take better correspondents who give you truer accounts of the fighting.

White was driven into Ladysmith and the four-month siege began. Inside the beleaguered town was a substantial corps of pressmen, although René Bull, special artist of *Black and White*, and Bennet Burleigh of the *Daily Telegraph* managed to escape before the siege began. Later, Arthur Hutton of Reuters News Agency made his way through the Boer lines to British territory beyond. W. T. Maud, special artist of the *Graphic*, saw the siege through, as did Melton Prior. On 24 February 1900, four days before the town was relieved, the *Graphic* published a letter from Maud:

> Since the beginning of the siege we have made efforts to get letters and telegrams through the Boer lines, but they have all been captured and sent back. One night we despatched one of our Kaffir boys called Jim, who boasted that he knew every pass and track between here and Maritzburg. He speaks, or rather gurgles, a little English, but it is very hard to hear or understand him, because he articulates the words in his stomach instead of his mouth. Before leaving he changed his khaki suit for some old black rags, and a more weird object it would be hard to find as

'I sent him out again and now I hear he was shot on the road'—Melton Prior tells of the death of one of his native runners in this, his last letter from Ladysmith before the siege was lifted. Runners, the artists' only channel for their sketches had to return with a receipt before they were paid. ('*Illustrated London News*')

he stooped before us and pointed with a knobbly hand in the direction he was going to take.

The newspaper opined that the rewards for the successful running of the blockade had, no doubt, been great, but so too were the risks . . . 'The fate of a Kaffir runner who should fall into Boer hands with English despatches found sewn into his clothes is easily imagined. To be sjambokked [flogged] within an inch of his life would probably be the least evil that would befall him.'

Prior, in his memoirs, told how the artists and correspondents vied with each other to get pictures and news out. G. W. (George Warrington) Steevens of the London *Daily Mail* paid £70, an astronomical sum, to his first runner, but later the price fell, as Prior explained: 'I made my sketches carefully, then traced them on the thinnest paper I had, folded them up into as small a compass as I could, and the first

six I sent away cost me no less than fifty pounds.' The black runner would go out at night, hide during the day, and either try to sneak through the Boer lines or join the enemy's native servants and waggon men. He had to reach British-held Colenso about twenty miles away, obtain a receipt from the postmaster and then return to Ladysmith to be paid. In the later stages of the siege, the army took over with a regular weekly 'post' operated by official runners, and the charge was £15 a letter.

One of Prior's letters telling of the death of a runner was published as a facsimile in the *Illustrated London News*, and it is reproduced here. He once sent nine tracings with different runners in the hope that one might get through; large sketches, he explained, he could not trust as only one in twenty was successfully 'run'. In his memoirs he referred dismissively to the death of one of his runners in a way which all too revealingly betrayed his belief in the dispensability of the 'native': 'Unfortunately my man was killed, so my sketches were lost, but I made more tracings and sent out another Kaffir. This fellow was captured and his sketches taken from him; he was thrashed and sent back to us as an example. Once more I made tracings, and sent a third Kaffir out. This time he got through and brought back the receipt from the post-master.'

Press attitudes to native non-combatants in the war veered from callous disregard to mawkish patronage, with the balance coming down in favour of the latter. Typical of the second attitude was the treatment given by the *Illustrated London News* to a drawing by Caton Woodville, published as a whole page on 9 June 1900. It was entitled, 'THE DANGERS OF MERCY: INDIAN AMBULANCE-BEARERS UNDER FIRE', and the accompanying text read: ' "The Dangers of Mercy" shows us the Indian stretcher-bearer busy at his perilous and kindly task. Not since Mr. Kipling's great ballad of "Gunga Din" has the service rendered by loyal natives to the British soldier been so vividly brought home to us. It is almost impossible to estimate the work done for our men in South Africa by these brave non-combatants, dusky without, but "real white inside".'

As the weeks rolled into months at Ladysmith, the 'dusky' runners were increasingly relied upon as the garrison's only link with the outside world. For the besieged it was an existence of intense boredom punctuated by moments of extreme danger. Boer shells were arbitrary in their choice of victims and civilians fell alongside soldiers. In one bombardment a shell splinter took off the leg of a table at which the *Graphic*'s W. T. Maud was sitting. After the war Melton Prior—whose life had hardly left him short of campaign souvenirs, would proudly display his military pass, issued to him by the Ladysmith authorities on 13 November 1899. It was pass number 452 and was inscribed as follows:

Name	Melton Prior
Nationality	English
Age	54 years
Complexion	Fresh
Height	5 ft 6½ in
Hair	Bald and fair
Occupation	War artist

The artists and correspondents messed together and when Ladysmith's cattle supplies ran out they ate horseflesh like everyone else. Towards the close of the siege they mourned the passing of one of their number, G. W. Steevens of the *Daily Mail*, who finally succumbed to enteric fever after a distressing illness. In his last

letter, demoralised and depressed, he wrote: 'Constant bombardment. Feeling of never returning to England ... Beyond is the world ... To your world and to yourself you are every bit as good as dead ...'

Steevens was nursed devotedly by his friend, the artist Maud. When both realised the hopelessness of Steevens's condition, they shared a last bottle of champagne. Maud later caught enteric fever, which left him weakened, and he died in 1903 probably from the effects of his Boer war illness.

In one of his despatches Steevens had talked about Ladysmith 'squirming between iron fingers'. Perhaps in his lowered state of health he had a tendency to look on the darkest side. From Prior, on the other hand, there came strongly the feeling of an old campaigner that things were bound to improve, therefore his letters and despatches sustained a kind of cautious optimism. Nevertheless, the dangers under which he lived and worked were real enough. One of his sketches showed him, a *Daily Chronicle* colleague and a servant caught in a shallow drift with Boer shrapnel bursting overhead. To inform readers of the type of conditions under which the press reported the siege he sent out a sketch of the newspapermen's dugouts on the banks of the Klip river, which the Boers tried to dam. Prior and company were seen seated in an earth and corrugated iron shelter watching a shellburst which flung a man out of a neighbouring 'rabbit hole'.

Serving soldiers contributed to the news illustration of the war to an unprecedented extent, in the form of both sketches and photographs. Scores of

From a sketch by Melton Prior, the *Illustrated London News* showed their special artist (centre) under fire from bursting shrapnel as he crossed a drift at Ladysmith in the company of Nevinson of the *Daily Chronicle* and a sombrero-hatted servant. Prior carries a pistol slung beneath his arm. (*National Army Museum*)

AT LADYSMITH DURING THE SIEGE.—ON THE BANKS OF THE KLIP RIVER: "MORNING LEADER" AND "ILLUSTRATED LONDON NEWS" CAMP; CAMP OF THE 18TH HUSSARS ON OPPOSITE BANK.

Facsimile Sketch by our Special Artist, Mr. Melton Prior.

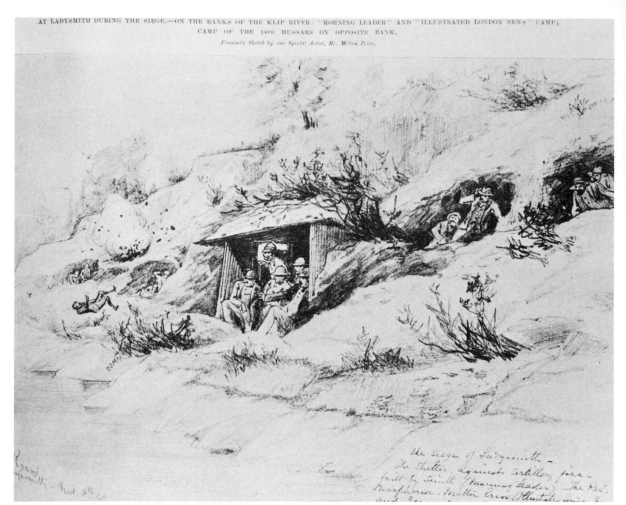

How they sat out the bombardments at Ladysmith. Prior's original sketch is captioned in pencil: 'The Siege of Ladysmith—The Shelter against Artillery fire—built by Smith (Morning Leader), the Rev. Macpherson, Melton Prior (Illustrated London News) and Servants on the banks of the River.' (*National Army Museum*)

Kodaks were taken to the field. A prolific source of illustration was Colonel Robert Baden-Powell, defender of Mafeking and subsequently founder of the scouting movement for boys. Both the *Graphic* and the *Illustrated London News* used his sketches of the siege. A few were action scenes of the daily bombardment, but most were vignettes of siege life, laced with typical officers' mess humour. Another distinguished contributor to Boer war art was Winston Churchill, who represented as correspondent the *Morning Post*. Captured during an attack on an armoured train at Estcourt, he escaped from Pretoria and reached the British lines with a Boer price on his head. Posters (and fakes of the same) offering a reward for his recapture sometimes appear in salerooms today. Three of his sketches, two showing him hiding from searching Boers and a third of Churchill jumping a slow-moving freight train, were published in the *Graphic*, by permission of the *Morning Post*, on 3 February 1900.

In a fluid campaign fought often against guerrilla tactics, capture was a frequent hazard faced by the newsmen. In the case of George Lynch release came within a relatively short time, and on the whole the Boers treated their captured correspondents as honoured guests. John Stuart, a *Morning Post* reporter, was another who fell into Boer hands. Frederic Villiers narrowly escaped capture.

While Prior, his old rival of the Nile, was mining a rich seam of action pictures up to and in Ladysmith, Villiers was having a none too successful war. The outbreak found him in Australia on a lecture tour (it was for use on such tours that he had held out such high hopes of his movie camera in Greece and the Sudan). He immediately sailed by troopship from Sydney to Port Elizabeth, where he set about trying to join General Lord Methuen's army, in an attempt to relieve Cecil Rhodes, besieged in Kimberley, the diamond mining centre.

Armed with what he thought were all the necessary passes, he reached Orange River rail station only to be told that Methuen was 'so fed up with war correspondents that he wanted no more'. He could go no further. 'This was a grave setback,' he wrote. 'I tramped the platform for some time hardly knowing what to do. However, I was allowed to wire Lord Methuen. I spent a restless night rolled up in my blanket at the station. Early the next morning a reply came: "Glad to see you, come at once." ' Once more it was a case of artists being tolerated where reporters were unwelcome, as William Simpson first discovered in the Crimea.

Villiers was entrusted with military despatches for Methuen, with the instruction, 'If the train is attacked, don't destroy the papers till the situation is hopeless.' After a night in the brake van, sleeping on the carcase of a sheep with a sack of potatoes and onions for his pillow, he arrived at the scene of Methuen's final push to find a disaster in the making. A desperate attempt was being made to cover the retreat of the Highland Brigade 'which had been bunched up and almost decimated in a corner of a purple hill called Magersfontein'.

Villiers filled his book with sketches of the fighting retreat and the care of the wounded, then remembered the official despatches in his pocket. He delivered them to Methuen who was lying in a cart with his leg cocked up on the rail, having been wounded in an earlier fray. 'What do you think of this business?' asked Methuen. Villiers shrugged, 'It is only a setback. Surely you must expect a check sometimes.' It was, in fact, Britain's 'Black Week' and Magersfontein was but one of a series of 'setbacks'.

Villiers realised that the British offensive would not be resumed for some weeks, so he sought fresh news pastures for his paper, the *Illustrated London News*. New Year's Day 1900 found him in another sector with the Canadians and the Australasians. After a sharp, successful fight, they were retiring under Boer pressure. Attacked by violent lumbago, Villiers collapsed. He was too weak to travel and rested in a Boer farmhouse, 'the occupants of which were so scared by the success of the British that they treated me with kindness'. The rearguard passed on. 'I watched the last cloud of dust kicked up by their heels in the face of the setting sun; and I was left alone in the gloaming with my friends the enemy.' Resigned to capture, he buried his revolver and ammunition, so that the Boers would not take him for a belligerent, swallowed a sedative and went to sleep.

At dawn, he related, 'I was aroused not by a posse of rough and truculent Boers but by the buxom landlady with a steaming mug of coffee.' The rest had done him so much good that he was able to get up and drive the five miles to the British rearguard camp. He was soon back in action, drawing New Zealand troops storming the Boers on a hilltop at Slingersfontein.

Bedevilled by pass problems, Villiers trailed around the western sector of the war zone, increasingly despondent about military obstruction. He grumbled: 'These stringent restrictions may be all right in the case of men who write and cable, but for the artist they seem unnecessary and they are certainly a tremendous handicap.'

This facsimile of a sketch by Frederic Villiers of New Zealanders in action reveals his weakness in figure drawing. Top right, he sketched a detail of the troops' legwear, with the inscription 'Costume of New Zealanders same as other colonials with exception of gaiters . . .' The detail was meant for the office artist in case the sketch was redrawn. ('*Illustrated London News*')

He was returning from a front-line foray (in which he had had yet another brush with authority over passes—this time with a Major Haig, who was to become the famous Earl Haig of the Great War) when he heard a remarkable story of how a British officer and his horse had been shot and killed at three thousand yards from a kopje, or hill. Boer marksmanship was legendary; many a British defence line had been enfiladed and its occupants decimated by accurate rifle fire at long range. But three thousand yards was something extraordinary, even for the Boers.

Villiers decided to visit the scene, a gloomy pass in the hills, to reconstruct a sketch of the event if indeed it was true. This he found to be so and, after making sketch notes, he began to return down the track in a light, two-horse carriage known as a Cape cart. It was midday and the heat was intense.

'I was lying back dozing,' Villiers wrote, 'when suddenly a bullet pierced the side curtain of my cart and the report of a rifle awoke my boy, who immediately lashed out at the horses. I threw my arms around him and pulled up. "Wang!" came another shot. As we came to a standstill I threw up the back curtain and put up my arms. Then I saw three men approaching in shirt sleeves.'

One of the men wore the sombrero of the Boers and the others helmets. When they drew near Villiers saw that all were British soldiers. According to Villiers, he said: 'Can I put my hands down now, or do you wish to murder me? Who are you?'

'The Suffolks,' one replied.

'Well,' said Villiers, 'I shall report you for damned bad shooting anyway. What

did you think you were doing?'

'We took you for a blooming Boer. Their officers always ride in Cape carts, and there is a scare on today. There's lots of our fellows looking out for them, so be careful, or maybe you'll find better shooting next time.'

Villiers, who discovered that two bullets had gone through the curtain of his cart, used the incident to provide his paper with a portrait of the artist under fire. Unlike Prior, he seldom incorporated himself in his pictures. This was a rare opportunity, and the *Illustrated London News* published a 'worked up' version of his sketch as a half-page on 28 April 1900.

After Kimberley was relieved in mid-February, Villiers returned to Britain. He regarded the whole interlude as not the most distinguished of his campaigns. His colleague, Prior, was to soldier on for a few months before returning in triumph for a furlough in the summer. On 21 July the *Illustrated London News* announced that 'the doyen of war artists' was back in England, adding, 'It is a curious irony of fate that Mr. Prior should have escaped shot and shell at Ladysmith to be wounded in the eye by a cricket-ball during the voyage home.' He brought with him pictures of Lord Roberts's victorious army entering the Boer capital of Pretoria and the release of captured British soldiers. At the war front special artist Frank Stewart, who was twenty-four, continued to furnish the *Illustrated London News* with finely drawn sketches of the continuing struggle (after the war, his only campaign, he returned to specialise in painting hunting scenes). *Black and White*, a weekly founded in 1890, received a series of dramatised illustrations from its man, René Bull.

The war was far from over, despite a rosy-hued picture presented by the popular

Taken for a 'blooming Boer' by men of the Suffolk Regiment, Villiers portrayed himself under fire. Unlike Melton Prior, he seldom drew himself in his sketches, but on this occasion the humour of the situation appealed to him. His sketch was redrawn and appeared like this in the *Illustrated London News.*

In the summer of 1900 Charles Fripp sent his paper, the *Graphic*, this finely detailed sketch of the City Imperial Volunteers of London manhandling a machine-gun into action at Diamond Hill—'They brought their Maxim over the roughest ground—almost carrying it—and managed to keep it in action for about quarter of an hour, to the great discomfort of the enemy, notwithstanding a cross fire of "pom poms" and field guns.' (*National Army Museum*)

press. Announcing *The Graphic History of the South African War*, a hard-backed volume at five shillings, that newspaper remarked on 22 September that the struggle was 'now happily drawing to a satisfactory conclusion'.

It was far from the truth. Although the Boers were now cut off from outside help, their main forces dispersed, and Kruger exiled in Holland, guerrilla warfare continued under tenacious and skilled leaders such as Botha, de Wet and Smuts. There was a long and difficult campaign over the veldt, farms were seized and burned, and Boer dependents were housed in special camps—concentration camps as Britain's detractors abroad and liberal opinion at home called them. It was not until May 1902 that the Treaty of Vereeniging was finally signed, which led to the granting of self-government for the Transvaal and the Orange Free State five years later.

Charles Fripp, who had been with Prior in Zululand, covered the mobile warfare for the *Graphic*. He was now forty-seven and a seasoned campaigner with a skilful eye for the human incident rather than the large set battle piece. In a clear, informative and beautifully observed line, he had drawn some excellent scenes of the City Imperial Volunteers, London's regiment, in action near Pretoria, and now he found ideal subjects in the incidents which occurred across the veldt as mounted infantry visited Boer farms on a 'pacification' exercise. The patrols were sent out to bring in the Boers who were then asked to hand in their arms and take an oath of neutrality.

The *Graphic*, noting that the shrewd Boer was in the habit of delivering his arms minus certain vital parts, complained that he 'is constantly found taking the oath

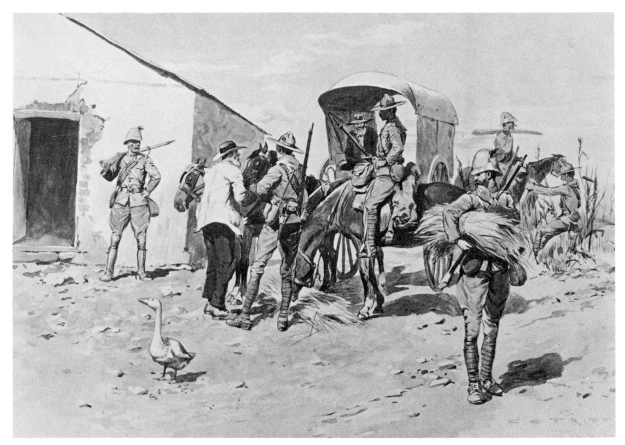

and then returning to his comrades in order to bear arms against his too magnanimous enemy'. When Fripp and his colleagues sent off sketches of blazing Boer homesteads they were often published bearing such captions as, 'Boer treachery punished', intimating that the occupants had been guilty of firing on the British troops while under a flag of truce, had broken their parole, or had committed some similar crime against the recognised rules of warfare.

In *The First Casualty*, a penetrating examination of the fate of truth in war, Phillip Knightley asserts that 'throughout the latter stages of the war the British press carried a stream of reports from its correspondents of Boers murdering wounded men, massacring pro-British civilians, flogging natives, and executing Boers who wanted to surrender. Since, in most cases, the stories contained little evidence to support the charges, an artist would be employed to render a highly realistic version of the atrocity.' The assertion is correct, but requires qualification. Measured against the volume of output, the artists in the field were seldom guilty of this interpretation of events. It was generally when the special's work arrived in London that it became the basis for what we now know as propaganda, either being 'worked up' in dramatic style by a home artist or coloured by selective editing and clever captioning as in the case of Prior's 'FIRING ON THE AMBULANCE'.

Knightley, however, presents an incontrovertible theory when he writes:

Britain was fooled, but it was her own fault. She never had a full and accurate picture of what was happening in South Africa. The correspondents blamed the

Fripp excelled in human detail in the pictures which he drew for the *Graphic*. Note the trooper covetously eyeing the goose. In this scene Canadian soldiers are rounding up Boers to take the oath of neutrality after Kruger's main resistance had collapsed. (*National Army Museum*)

military for this, claiming that censorship kept the public ignorant. The military blamed the correspondents and the public ... There is no doubt that the Boer war offered correspondents a remarkable opportunity. They could have seen that the imposition of imperial rule requires an ever-increasing amount of force, and that when this force is faced with a determined nationalist sentiment the point must eventually be reached at which the expending of it is no longer worth the return.

Rightly he concludes that the policy of meeting the Boer's bitter guerrilla resistance with farm-burning, concentration camps and collective punishment was as ineffective as a similar policy employed in Vietnam many years later.

The *Graphic*, as we have seen, was unhappy about censorship and military restrictions. Throughout the war it continued to campaign against the trammels on reporters and artists. In March 1900 it rejoiced that the then commander-in-chief, Lord Roberts, had relaxed, if not entirely abolished, the censoring of letters from correspondents, and quoted an officer as saying: 'The war correspondent will hold a much freer and more dignified position with the Army from now on. Letters will not be censored. Lord Roberts says that any criticism will be read by him with great interest. He is big enough to feel that his actions may speak for themselves.'

But, the newspaper argued

a certain restriction continues to be still imposed on war correspondence by wire with an eye, mainly, to the mystification of the enemy's Intelligence Department, if they have such a thing. It follows that if the Boers are to be kept in the dark as to our movements and intentions at the front, we ourselves, here in the rear, must to a great extent share their perplexing ignorance, and that is why, for the last fortnight ... the 'fog of war' has again descended on the theatre of hostilities from Mafeking to Maritzburg.

The army had learned that the supply of news from a war could be controlled by taking charge of the correspondent's lines of communication and dictating what he should not write. The Boer war had proved that the special artist could be prevented from witnessing disasters and blunders—which South Africa provided in plenty—simply by barring him from the front. Much more useful to governments and generals was the home-based artist who had never seen a shot fired in anger and who was willing to conjure glory and heroism out of the most abysmal defeat.

In the traditions of the game, the special, as epitomised by Simpson, Waud, Prior, Villiers and company, needed freedom of movement, freedom to decide the risks he would take where the fighting was thickest. To confine him to rear areas was to emasculate his role and reduce him to no more than a man in a studio with drawing technique, some military knowledge and a fund of imagination. In Egypt Villiers had learned that the smoke created by the firepower of a British square obscured the view of the artist if he was trying to observe the battle from the centre of that square. Even more obliterating, however, was the 'fog of war' generated by military restrictions. Unfortunately, the fog thickened as warfare moved into the twentieth century, and this, coupled with the increasing effectiveness of the photographer, sounded the knell for the specials.

13 Redundant Fools

I was not allowed to put dead men into my pictures because apparently they don't exist

Official war artist in the First World War

The nineteenth century ended with the business of war in full boom. In Britain's sphere of influence the last decade saw no fewer than forty-five campaigns, expeditions and incidents in which shots were fired in anger, another roll of exotic names to add to the list of Victoria's 'little wars'. The year 1898 gave the United States an opportunity to send its special artists back into action, an opportunity that had been notably absent since the end of the Civil War, apart from coverage of the Indian wars. American newspapers had shown little interest in the rash of colonial wars in Africa and Asia, but the Spanish-American war, fought mainly in Cuba and the Philippines and fostered by the jingoistic yellow journalism of William Randolph Hearst, put war once more back on the breakfast tables of the nation.

This war produced the legendary story of Hearst's cable exchange with Frederic Remington, who was assigned to Havana to do for Cuba what he had done for the West. Remington is supposed to have cabled Hearst: 'EVERYTHING IS QUIET. THERE IS NO TROUBLE HERE. THERE WILL BE NO WAR. I WISH TO RETURN.' Hearst's reply has gone down into journalistic lore: 'PLEASE REMAIN. YOU FURNISH PICTURES. I WILL FURNISH WAR.' The rest is history. Thanks to rabble-rousing journalism and clever lobbying, Hearst got his war, and Remington produced the pictures, adding a brilliant collection of action scenes 'for boys from ten to seventy' to his already enormous portfolio of art.

From London, Paris, Berlin and Vienna, editors were still despatching a steady stream of artists to faraway battlefronts, but photographers were increasingly being fielded with improved equipment available both for taking pictures and for reproducing them in mass circulation publications. When anti-foreign feeling boiled over in China in 1900 in the Boxer rebellion, the world saw a rare and interesting example of Western co-operation in an international force which was assembled to relieve foreign legations besieged in Peking. John Schönberg, of Balkans experience, went out for the *Illustrated London News* and produced his usual quota of professionally observed pictures; studio-based stalwarts, such as Woodville, churned out the expected tide of illustrations depicting occidental heroism and chivalry quelling oriental savagery and ignorance. The enemy's viewpoint was seen when, for instance, the *Graphic* published a contemporary newspaper sketch by a Chinese 'Woodville', showing Billy Bunter-like characters being chased out of the woods by the Boxer rebels.

The craft of the special artist was, however, unquestionably fading. Several of the first-generation specials had already died. William Simpson—'Crimean Simpson' and the prince of specials in the Franco-Prussian war, the veteran of colonial

Contrast in viewpoints. When the Chinese Boxer sect rose against foreigners in Peking in 1900, Western illustrated newspapers carried dramatic scenes of the international contingent's brave fight against the besieging Chinese hordes. This illustration, taken from a soldier's sketch, shows British and Americans dealing with their adversaries and was published in the *Graphic* on 13 October.

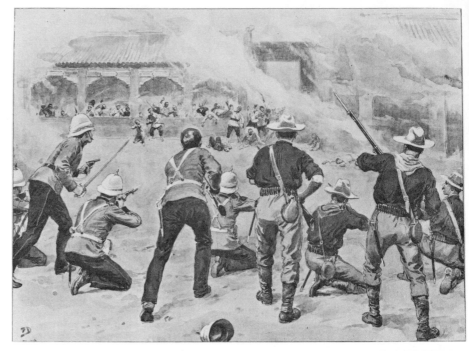

How the Chinese saw their struggle. In August 1900 the *Graphic* published this contemporary Chinese illustration with the caption: 'This print was issued by a Chinese newspaper as a supplement. It is from a drawing of a native artist, and represents the "retreat" of the Europeans from the Chinese during the present troubles. It is interesting, not only as being a sample of native art, but also as being the first illustration of the fighting in Peking and Tientsin to reach this country.'

campaigns from Afghanistan to Abyssinia—died on 17 August 1899 aged seventy-five. A cold contracted when he was covering the opening of Scotland's Forth Bridge in 1890 (described in Chapter Two) developed into bronchitis from which he never recovered. Six years before his death he completed his *Notes and Recollections* and wrote on the last page, 'Finished'. Sickness and age, he knew, would prevent him ever again going to war with his sketch-book. On 20 January 1900 the *Illustrated*

London News announced that a number of his sketches and watercolours were being sold at a Pall Mall gallery for the benefit of his widow; among them were some of his incomparable drawings which scooped the world in the 1870 war and the following year's Commune troubles in Paris.

Eight months after the death of Simpson, the veteran war correspondent Archibald Forbes died at the age of sixty-eight. His friend Frederic Villiers, to whom he gave the 'infernal fools' advice, wrote of him:

> He was a man of great physique and grand courage. Moreover, he was by nature an ideal war correspondent, for he could do more work, both mentally and physically, on a small amount of food than any man I have ever met. Amid the noise of battle and in close proximity to bursting shells, whose dust would sometimes fall upon the paper, I have seen him calmly writing his description of the fight—not taking notes to be worked up afterward, but actually writing the vivid account that was to be transmitted by wire. His one great aim was to get off the first and best news of the fighting; and he never spared himself till that was done.

Simpson's old artist colleague of Crimean days, Edward Goodall, died in 1908. He had spent his later years quietly painting and travelling abroad in peaceful lands and survived to the ripe age of eighty-nine. All these missed the First World War as did Melton Prior, who died in November 1910, nearly four years before the conflict that was to confront special artists and war correspondents with insuperable problems of censorship and obstruction.

Prior lived to be sixty-five years of age. According to a view expressed by an *Illustrated London News* colleague, S. L. Bensusan, who edited the memoirs and notes left by Prior, the fact that the buccaneering old special missed the First World War was in itself merciful. His experiences on his last overseas assignment, the Russo-Japanese war of 1904–5, had deeply depressed him. Chained by officialdom in Tokyo and refused access to the fighting, he returned immersed in gloom about the future of his calling. In fact, Bensusan and other friends were convinced that the experience broke his heart. Prior believed—and as it transpired, rightly—that the day of the special artist was over. To the generals who commanded the huge armies of the twentieth century, news was too dangerous a commodity to be trusted to the hands of free-ranging war correspondents and special artists. They robbed the special of his most important stock in trade, mobility.

When Frederic Villiers arrived in Tokyo in the spring of 1904 he found his old colleague, Prior, down with asthma. Sickness dogged Prior throughout all the frustrating months he spent in Japan, and his lowered physical state undoubtedly added to his depression over his enforced inaction.

Prior's initial reaction to Villiers's arrival was one of surprise. 'Why on earth have you turned up?' Prior asked him. 'You will surely get your throat cut for what you said of the Jap army ten years ago.' Villiers remembered on that occasion, when China and Japan were engaged in a war, he had exposed the cruelties of a Japanese commander, General Yamagi, a repulsive, one-eyed little man responsible for massacres at Port Arthur.

Villiers shrugged. 'My dear boy, Japan is a progressive country . . . There's a new generation today and they won't bear any resentment.' He was right. Later Villiers met a senior Japanese official who assured him: 'The general you condemned for his ferocious conduct was cashiered and died two years afterwards. It was a shocking

165

business, which the government deplored. I am glad you are with us, for you spoke the truth on that occasion and no doubt you will speak the truth now.'

Unfortunately 'the truth', as correspondents and artists quickly discovered, was going to be strictly limited to that which could be perceived from their hotels in Tokyo and at army briefing sessions.

During six frustrating months Prior sent home a diary of his experiences in the east. The entries reveal how his spirit was relentlessly sapped by Japanese insistence on controlling the output of news and pictures of the war.

23 February The Japanese, he wrote, were 'frightened to death at our giving away movement of troops.'

8 March 'At last there is prospect of going to the front.'

15 March 'Since writing to you last I have had a great trouble here about going to the front.'

20 March 'Really it is disgraceful the way we are being treated. They will not tell us anything truthfully, but keep on humbugging us.'

15 April Still confined to the hotel and now sick, he wrote: 'I am afraid the office must be very upset at not receiving sketches, but that cannot be helped, and we are all in the same fix.'

30 May He protested to the British Minister, but in vain.

19 July 'Rejoice with me! I am absolutely off to the front with Bennet Burleigh and the other Pressmen of the second column, and I really believe we are going to see the fight for Port Arthur.' But there were more disappointments to come.

20 August 'I fear that I must own that at last I am sick and sick of this campaign, just as all the other correspondents are ... It is true that we are at the front, with the enemy within four miles of us, but—and this is a very big "but"—we are simply prisoners within these city walls, and if we very particularly wish to go outside we have to make special application, and an officer is sent to accompany us.'

Prior, disillusioned and weak from sickness, returned to London, his twenty-fifth and last war behind him, his sixtieth birthday just before him.

Villiers, seven years Prior's junior, had a little more success and managed both to reach the front line and send home dramatic sketches of the fighting before Port Arthur. After the Japanese wrested the port from the Russians he returned to his wife, son and daughter at their Hampshire millhouse and wrote the first book on the campaign.

In the west the clouds of war were massing. When the storm broke in August 1914, the military leaders had stoked up a fog of censorship that covered Europe from one end to the other. Newspaper reporting, both textually and visually, was about to enter its dark ages. Editors of illustrated publications resorted to home-based artists, such as the long-surviving Woodville, to provide a torrent of 'death or glory' pictures that painted war in scenes of individual heroism and endurance.

Kitchener loathed journalists and decided to ban them from the British front in France. The Germans were faring no better, with war correspondents barred from the front line and official communiqués providing the press's sole source of war news. A British officer, appointed to write news of the Western Front, churned out a series of meaningless, gutless despatches that said more about the weather ('fine with

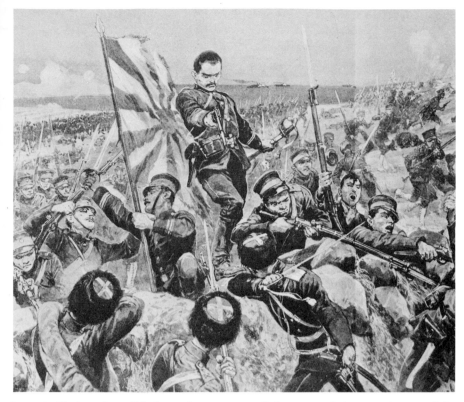

From a sketch by Frederic Villiers, this *Illustrated London News* engraving of 1904 depicts General Oku's Japanese troops storming the Russian entrenchments at Kin-chau. The section shown is a detail from a much larger picture, and Villier's work benefited from the intervention of a home-based artist. (*National Army Museum*)

less wind') than they did about the progress of the war and the experiences of the British Expeditionary Force.

Winston Churchill, a former war correspondent himself and now elevated to the post of First Lord of the Admiralty, was asked by editors to use his influence to persuade the War Office to allow accredited war correspondents and artists in the war zone. Wearing his new hat of authority, he dismissively remarked: 'The war is going to be fought in a fog. The best place for correspondence about this war will be in London.'

He could not have been more right about the fog. Those correspondents who were sent regardless by their exasperated editors faced threats from Kitchener of arrest, confiscation of passports and expulsion. This was the fate of several. In choleric mood, Kitchener once fumed that there would be a firing squad for Philip Gibbs of the *Daily Chronicle* should he return to France after a modestly successful bout of front-line 'snooping'. Gibbs was arrested five times. The *Times* man in Paris organised a team of reporters with instructions to be 'as inconspicuous as possible', to travel by bicycle and on foot and to avoid the British 'who take a fiendish delight in arresting war correspondents'. Indeed, some British officers threw journalists into prison on sight during the first year of the war. In January 1915, however, the War Office gave way to renewed editorial pressure and a small number of accredited war correspondents, dressed in officers' uniform, were allowed at the front, but they operated under such harsh restrictions of movement and censorship that they might as well have stayed in Fleet Street.

Moreover, as Philip Gibbs (who saw the war through and was afterwards knighted) wrote in 1923, 'We identified ourselves absolutely with the Armies in the

field . . . There was no need of censorship. We were our own censors.'

But what of the artists? If anything, the situation for them was even worse. Two official photographers, working for the War Office, were initially appointed to cover the Western Front, but their pictures told little of the mounting carnage, the early Allied reverses and the sufferings of the troops. Death was the penalty for unauthorised photography at the front. Artists were completely barred until 1916. Under the Official War Artists Scheme, men like C. R. W. Nevinson, Wyndham Lewis and Paul and John Nash produced some excellent and lasting work for publication and exhibition, but none worked on free-roving, independent commissions. Those who did had to resort to what they called 'tramping', wandering inconspicuously around the rear areas, dodging military police and officious brasshats, and snatching what material they could in the face of severe censorship and restriction.

By 1918 more than ninety official war artists had contributed to the approved record. The first was Muirhead Bone. His colleagues included Eric Kennington, Francis Dodd, James McBey, the Nashes, William Orpen, Lewis, Nevinson, Adrian Hill, William Roberts, William Rothenstein, John Sargent and Stanley Spencer. One protested, 'I was not allowed to put dead men into my pictures because apparently they don't exist.' This was Paul Nash, who declared: 'I am no longer an artist. I am a messenger who will bring back word from the men who are fighting to those who want the war to go on for ever. Feeble, inarticulate will be my message, but it will have a bitter truth and may it burn their lousy souls.'

Often the truth was better served on the German side and sometimes in France where intellectual and literary magazines employed talented artists to draw what they had seen as serving soldiers; there were some bitter indictments of the war and satire of the motives of those responsible for it.

To this background there was little scope for British specials of the calibre of Frederic Villiers, who, nevertheless tried to soldier on as an artist on the Western Front for two years before his spirit was broken by the restrictions. His experiences of tramping are worth recording.

In 1914 he arrived in Paris and, aware of the paranoid attitude of the British, set about trying to arrange permits to join the French army. In this he had almost achieved success when he was summoned to the British Embassy and peremptorily informed that the War Office in London would not allow it. For months he was kept waiting, hoping for accreditation to the British front. Villiers relates:

> In the meantime I had to do something for my paper; so I became a tramp—a refugee—and saw probably more of the picturesque end of the war in this guise than if I had been properly accredited to the forces. At first it was an irksome business dodging those gentlemen in khaki with red tabs and patches on their caps and collars; but at last it became a joy to circumvent the 'red tabbies' as one of our party christened them.
>
> Eventually I was allowed by the French to join their army and I filled my paper with the doings of the French. But at the same time I resented being so scurvily treated by my own folk, when through forty years of British warfare I had been persona grata with generals like Wolseley, Roberts, Methuen, Browne and Buller.
>
> Time and again during the early days of the war I called at the War Office in London to ask for an explanation of this extraordinary fiat against the artists, but with a shrug the officials told me there was no explanation. The only reason that I could find to account for the silly restriction was that the War Office itself was trying to make a corner in pictures, for it eventually produced some wonderful

films. They could hardly have entertained the idea that our work might be a 'give-away' to the enemy, for the press censors were lively enough to see to that, and everybody at the front knew that the Germans were always well acquainted with our movements without the assistance of the English war artists. So well were the Germans posted regarding all our actions that it was a common thing when we put some fresh regiment into a section of the front line to hear a voice shout from the opposing trench: 'What oh! Bedfords (or Manchesters), how do you like your new quarters?'

At times Villiers tramped with Philip Gibbs and other distinguished reporters. For a period he joined Gordon Smith of the *Herald*, Smith carrying a bag full of canned goods and Villiers taking a spirit stove and water bottle 'so we could always get a warm meal'. Both spoke French, and to inquisitive British officers they posed as Belgians looking for friends and relatives among the refugee communities behind the lines.

To escape arrest Villiers once had to stuff his sketches into a pair of boots; they were drawings of the battle of the Aisne and Villiers was desperate to get them home to the *Illustrated London News*. He could not trust a courier, so he made the journey with them to London, where they were published with a flourish as the only pictures of the battle. So unaccustomed had newspapers become to the independent exercise of journalistic enterprise, that other picture papers complained to the War Office that the *Illustrated London News* had been unfairly favoured. The War Office brass-hats could only reply, lamely, that the affair had nothing to do with them.

Villiers campaigned vigorously against the ridiculous British restrictions. After the war he wrote:

The powers at the War Office were so sour with their own countrymen of the 'fourth estate' that even after the ban was raised and we were allowed to go to the front, I have seen Englishmen sent back by the escorting officer while foreign representatives of the press were given extended time in the war zone . . . everything that could be done to annoy, irritate and delay English correspondents in the execution of their duty in the early days of the campaign was done by the War Office officials.

Their illogical attitude was beyond comprehension to him and other artists. After ten full pages of his sketches were passed for publication by the censor in London, the War Office decreed that any further sketches would also have to be sent to British headquarters at St Omer in France for examination. Surely not, argued Villiers. Here was a sketch he had drawn of a British soldier watering a patch of daffodils with a perforated jam tin. Would that have to go to St Omer? He was told it would. Villiers's response was that, 'if the jam pot was a give-away to the enemy, I could easily camouflage it as a beer mug'.

After two years of this, Villiers, by now in his sixty-fifth year, had had enough. He departed on a world lecture tour—and even then could not resist the lure of a campaign against dissident tribesmen on the north west frontier of India. During the tour he went down with an illness that had its roots in the chill and discomfort of two years' tramping on the Western Front. In 1922, four years after the war ended, he died, the last of the great ones among the ranks of the special artists.

In the war he had left behind him, hate was being peddled in art as in no other war. It reached new dimensions when America entered the fray in 1917 on a barrage of anti-German propaganda. Each side sought out atrocity stories and portrayed the

Hate in America, First World War. A contemporary lithograph shows a German soldier smoking a cigarette while a woman, her left breast amputated, is nailed by a bayonet through her hand to the door of a ransacked farmhouse. War artist George Bellows called his utterly imaginary scene 'The Cigarette'. (*National Archives, US War Dept. General Staff*)

other as fiendish and moronic, brutal and sadistic. The artist had become a major weapon in the battle for minds.

The battle had its lighter side. Bruce Bairnsfather, a young British officer in whom the magazine *Bystander* had discovered a talent for comic drawing, was taken from his machine-gun section by the War Office and given the official job of making the nation laugh. Bairnsfather's principal character was the resourceful Old Bill, an old sweat who soldiered through the war with dogged good humour laced with the right amount of cynicism. Bairnsfather, promoted to captain, was despatched by the authorities as a sort of 'comic special' to report on the funnier side of life among the French, Italian and American armies as well as the British. His most famous cartoon became for the British probably the most memorable war artist's impression of all time. It showed Old Bill informing a disgruntled comrade with whom he was sharing a muddy shell crater: 'Well, if you knows of a better 'ole, go to it.' Similar advice might have been given to the disappearing race of special artists, except that most had no 'ole to go to.

Wars, the men who ran them, and the way they were fought had changed. These facts and the supremacy of the camera edged the special artist into redundancy. The photographer and the film crews dominated the Second World War, and yet, paradoxically, this, the most sophisticated and 'impersonal' war to date, provided the special artist with a brief, new lease of life after the deadening experience of 1914–18.

Artists in uniform, assigned by Hitler to record the victorious history of the 'Thousand Year Reich' alongside squads of still and movie cameramen, contributed to the pages of the German army's *Signal* magazine vivid battle scenes reminiscent of some of the 'worked up' illustrations of Victoria's heyday. The magazine, produced fortnightly by the Wehrmacht under the Propaganda Ministry, was aimed

mainly at the subjected peoples and the neutrals of Europe. It was a highly profes-
sional production, modelled on the American *Life*, and its editors had 1,000 photo-
graphers available, equipped with the latest cameras and geared to dramatic use of
colour. *Signal* began in 1940 and the last issue was in March 1945.

Behind the Russian lines talented artists who shared the dangers of the Red Army
illustrated sieges, advances and isolated heroic actions in a flowering of stark,
representational Stalinist art. Some of their work, heavily slanted with propaganda,
was meant for the patriotic magazines, some found its way into posters and pamph-
lets, some remained as a permanent record in watercolours and paintings for exhibi-
tion.

In Britain official war artists were again recruited to picture the war effort, from

171

Heroics for Germany,
Second World War, 'Front
correspondent' Hans Liska
drew this scene of three
German generals and a
colonel resisting to the last in
the closing stages of
Stalingrad. It was published
in the magazine *Signal*,
which had versions in several
languages for occupied coun-
tries of Europe.

Sentimentality in Russia,
Second World War. Stalinist
war art depended on clear,
representational treatment. A
painting by Nyeprintsev por-
trays Red Army men 'After
the Battle' as clean-cut,
wholesome fighting men
enjoying themselves in vic-
tory.

the grim post-Dunkirk days through to victory on the Rhine. Malta, the desert and Europe, as well as the home front, became their stamping grounds. Felix Topolski produced memorable portfolios of London in the blitz and embattled Russia.

But it was from America, and the *Life* stable, that the greatest contribution was made by artists who came nearest to the old traditions of the nineteenth-century specials. The magazine, seeking creative ways to widen the visual reporting of the war—in colour—employed twenty-eight artists in the last three years of the conflict. Aaron Bohrod covered jungle fighting against the Japanese, then moved to Europe just after D-Day to portray the invasion. He narrowly escaped death when a land mine blew up a jeep in front of his own vehicle. Another *Life* man, Bernard Perlin, joined British and Greek commandos attacking German-held islands in the Aegean, and for several days was holed up in the mountains when his raiding party was ambushed and scattered. David Fredenthal followed Allied troops into Germany after he had recorded bitter warfare in the South Pacific and Tito's guerrilla campaign against the German in Yugoslavia.

Life's artists produced 'shorthand' sketches in the front line, then later translated them into colourful paintings to be reproduced in special issues of the magazine, thus augmenting its graphic photo-coverage of the war. Other American magazines were supplied with illustrations by agency artists and fighting men who sketched on the spot as the battle went on around them.

Despite these brave efforts, however, war art was merely a drop in the ocean of photography. In the historic pages of the *Illustrated London News*, artist Ronald Searle's eye-witness drawings told of the sufferings in Japanese prisoner-of-war camps, but even in that magazine, the birthplace of the special artist, the cameraman was winning. The names of photographers were emerging with worldwide acclaim undreamed of by the specials like Melton Prior. Newsreels served up war in the cinemas. And soon television would bring it, just as it was happening, right into the home in a world which no longer had a place for the infernal fools.

American artists made the most significant contribution to eye-witness war art in the Second World War. In this drawing navy medical men are seen working in a smoke-wreathed shell hole during a Pacific island invasion. It was drawn by navy man Samuel Bookatz. (*National Archives, US Navy Department*)

14 The Legacy

In some unconsidered debris of a long-forgotten battle is there, even, a Vizetelly, sketched in haste before he was dragged off to an unknown fate in the Mahdi's camp?

In the early 1970s a rare saleroom find occurred in London when a collection of seventeen 'forgotten' watercolours by William Simpson came on the market. They consisted of views of India and several were on the theme of the Indian mutiny, painted after Simpson's visit to India in 1859 to produce a pictorial record of Britain's struggle to quell the mutineers.

A splendid impression of a British elephant battery in action is among some of Simpson's finest work. It is no field sketch meant simply as a guide for the engravers, but a painstakingly finished picture that was intended to be lithographed and published in an album of similar illustrations. Some time after Simpson finished the picture in 1864 the elephant battery and the other sixteen works were bought by an officer of the Iniskilling Dragoons, in whose family the small but distinctive collection rested until it came up for auction.

The appearance of the watercolours raised optimistic speculation among those who collect the works of artists at war. If 'unknown' Simpsons can materialise, could there be hopes of finding Prior's missing Sudan sketches or the mysteriously vanished Ulundi sketch-books of the Zulu war? Might the pictorial documentation of America's Civil War be strengthened by similar finds? In some unconsidered debris of a long-forgotten battle is there, even, a Vizetelly, sketched in haste before he was dragged off to an unknown fate in the Mahdi's camp?

Such hopes are likely to remain sadly unfulfilled. The heritage of original drawings left by nineteenth-century special artists represents a thin field, which has been minutely gleaned for pickings, and those pickings have been slim compared with the massive volume of sketches once produced. The very nature of the specials' craft has ensured that.

In the case of Simpson's watercolours, there were special factors. He was sent to India by the lithographic firm of Day and Son in order to produce material for an album of 250 plates, similar in size to the highly successful—and today valuable—work by David Roberts on the Holy Land and Egypt. In his memoirs Simpson explained how the portfolio was produced:

> I had finished and sent home very few of my pictures while in India. The great mass of them had still to be done. I had only made sketches or procured the material from which to work, and most of the subjects were full of elaborate detail, and could not be knocked off in a hurry. They occupied my time for three or four years of constant work before I managed to get all finished. There were in all two hundred and fifty drawings. Some were very elaborate, owing to minute details of architecture or figures, and a number were exhibited before all were complete.

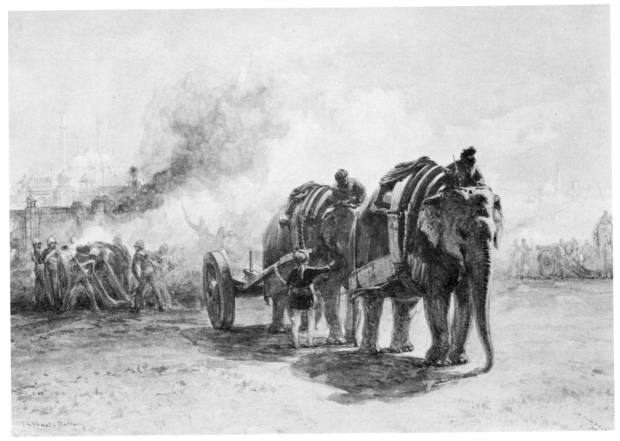

As Simpson laboured to finish his work, he was unaware that Day was slipping into severe financial difficulties. The firm finally went bankrupt and Simpson, whose hopes had been based in Day's shares, was left without a penny. Only fifty of his drawings were published in an album called *India Ancient and Modern*. His originals were 'thrown on the market to be sold cheap as a sort of bankrupt stock'.

Simpson was ruined. The money he was expecting to make out of the enterprise would have enabled him to fulfil an ambition. As he explained: 'One of my plans was to have taken more regularly to painting for the exhibitions, but this was out of the question. I must earn money to live.' Simpson regarded the crash as 'the big disaster of my life', but, as history knows, fine art's loss became journalism's gain. Within a very short time he turned to the *Illustrated London News* to earn a living as a special artist.

Until that time, 1866, Simpson's artistic endeavours had been motivated by the desire to produce a permanent record. He was, in effect, working for posterity, both in the Crimea and in India. The medium he used, the detailed and substantial nature of the lithographic prints that were the end of the process, sometimes even the topographical and architectural nature of the subjects he chose—all these had an enduring quality that was lacking in much of the day-to-day output of the special war artist. Once he became a special, he was concerned primarily with immediate publication and consequently worked to a set of rules that had more validity in journalism than in fine art.

A British elephant battery in action during the Indian mutiny, watercolour by William Simpson, completed in 1864 after his visit to India. A rare find, this was one of the seventeen 'forgotten' Simpson watercolours which came on the market, in what is otherwise a slim field for collectors of special artists' work. (*Phillips Fine Art Auctioneers*)

175

Those rules meant that sketches in the field would often be drawn on materials that were easy and economical to pass through the available communications system. Small, lightweight tracings made much more sense than large canvases when the sketches had to be concealed in the clothing of a bush runner who was attempting to sneak through the enemy's lines, as in South Africa. Even when specials enjoyed the luxury of the military despatch pouch or the diplomatic bag, there was no room for large sketches. And once the essential information contained in a field artist's sketch had been assimilated and translated onto wood by the office artists and engravers, the original was highly dispensable. Indeed, it is thought for instance that the dearth of original material drawn at war by Constantin Guys of the *Illustrated London News*—who produced hundreds of sketches—is due to the fact that much was destroyed in the wood-block process. Like several other artists, he drew on flimsy paper which was pasted onto the wood, so that his line should act as a guide for the engraver's tool. Arthur Boyd Houghton, on the other hand, often drew directly onto wood blocks, few of which have been preserved owing to storage problems.

Returning to Simpson, however, we find that his earlier work, in the Crimea and India, has, paradoxically, more public currency than that done by him at the height of his later career as a special artist. Complete sets of eighty plates of his portfolio, *The Seat of the War in the East*, are not all that uncommon at auction sales. A set in good condition, with original wrappers, can fetch several hundred pounds. His Indian mutiny pictures are rarer, and the 'rediscovered' Indian watercolours which appeared in 1972 each brought as much as a full set of his Crimean lithographs.

For the enthusiast, the focal point of a collection must consist of those examples which demonstrate the 'before' and 'after' stages of battlefront art—seen in the contrast of the special's original sketch and the published engraving in the pages of the illustrated newspaper. Shortly after the Simpson find, the National Army Museum in London was fortunate to acquire six original drawings by Melton Prior during the 1884–5 Sudan campaign. They enabled fascinating comparisons to be made between his eye-witness impressions and the versions seen by the readers of the *Illustrated London News*.

Simultaneously, the museum received on loan from the Earl of Amherst seventy-eight papyrotype reproductions of what are probably most of the sketches Prior made during the campaign. The papyrotype is an unusual photolithographic process developed by an officer at the School of Military Engineering at Chatham, England. Paper coated with gelatine was exposed under a negative and developed to give an image in hardened gelatine. This was spread with greasy ink to form a positive ink image which could be transferred to a stone or metal plate for lithographic printing.

An example of this process can be seen in Prior's dramatic sketch of the British desert column finding much-needed relief at a water hole. The composition of the scene and the stance of key figures are remarkably faithfully reflected in one of a small collection of primitive, anonymous watercolours in the museum's possession. The watercolours appear to be of contemporary date. Were they first 'roughs' by Prior? Their crudeness hardly makes this likely, yet the handwriting on the reverse of the pictures bears some resemblance to Prior's own. A possible explanation, in the absence of any conclusive information from their source, is that the watercolours are the work of a soldier who had access to Prior's originals, or of someone who was inspired by the artist's contributions in the pages of the *Illustrated London News*. Incidentally, the newspaper itself, now a glossy monthly magazine illustrated almost entirely by photographs, has retained few originals of its famous corps of war artists.

This is a papyrotype, a photolithographic process, of a Melton Prior sketch in the Sudan, some seventy-eight examples of which are on loan to the National Army Museum in London. It depicts British troops at a desert waterhole. Prior wrote: 'Discipline alone prevented a wild confusion setting in.' (*National Army Museum*)

A poser for students of front-line art: this anonymous watercolour, in the same museum, is remarkably similar in principal features to Prior's original. Was it a first 'rough', or a crude copy? (*National Army Museum*)

176

The Desert March
Scene at the Wells of Aboo Halfa
Animals no water for three scorching days.
Many of the men had only a Pint in the morning & the
Discipline alone prevented a wild confusion setting in ––

Those that remain are to be found in private collections and museums.

Paintings and prints by the prolific Richard Caton Woodville abound. His oils of heroic military occasions fetch prices in four figures when they appear in the London salerooms. He has not, however, reached the dizzy saleroom prices that can be guaranteed for Remington's Western scenes.

What must be the world's most important collection of specials' art is to be found in the Library of Congress which boasts 1,150 original drawings made during the Civil War by Alfred Waud and his brother William. Other significant collections of Civil War originals are housed in the US National Archives and the Museum of Fine Arts in Boston, Massachusetts. Examples of the original sketches of Theodore Davis are notably rare. Little exists, for instance, of the sketches he made for *Harper's* on his famous stagecoach ride to Denver in 1865; it is presumed that his originals were lost in the newspaper's publication process. In a small pocket note-book carried by Davis on this trip there is, however, a faded outline sketch of the 'Interior of the Adobe Fortification at Smoky Hill Station'. For such morsels the collector of specials' art must be grateful.

The story of artists at war lies in the bound files of the newspapers that sent them out to risk their lives for news. *What* they did was seen by a vast public every Saturday morning over a period of not much more than fifty years—for the fraternity known as 'specials' had a comparatively short existence. *How* they did it is much more important in telling their story.

After the American Civil War, the *New York Evening Mail* in 1868 asked Theodore Davis to describe something of the life and requirements of a special artist. In his clipped style, this is how he wrote it:

Total disregard for personal safety and comfort; an owl-like propensity to sit up all night and a hawky style of vigilance during the day; capacity for going on short food; willingness to ride any number of miles on horseback for just one sketch, which might have to be finished at night by no better light than that of a fire— this may give an inkling of some of it, and will, I trust, be sufficient to convince my *Mail* readers that the frequently supposed mythical special was occasionally 'on the spot'.

That is what it was about.

Bibliography

Ambrose, Stephen E. *Crazy Horse and Custer.* 1975
Bairnsfather, Bruce. *Bullets and Billets.* London, 1916
Barnes, Major R. M. *Military Uniforms of Britain and the Empire.* London, 1960
Barnes, Major R. M. and C. K. Allen. *The Uniforms and History of the Scottish Regiments.* London, 1956
Beckett, I. F. W. *Victoria's Wars.* Aylesbury, 1974
Blake, R. L. V. ffrench. *The Crimean War.* London, 1971
Burleigh, Bennet. *Khartoum Campaign, 1898.* London, 1899
Burleigh, Bennet. *The Natal Campaign.* London, 1901
Burleigh, Bennet. *Sirdar and Khalifa.* London, 1898
The Camera Goes to War: Photographs from the Crimean War. Catalogue, Scottish Arts Council Exhibition
Charlesworth, Mary. *Revolution in Perspective.* London, 1972
Churchill, Winston S. *The American Civil War.* London, 1961
Churchill, Winston S. *The River War.* London, 1899
The Civil War, American Heritage Picture History. New York, 1960
Civil War Art, The American Heritage Century Collection. New York, 1974
The Civil War 1861–65: list of Drawings, Water Colors, Sculpture, Museum of Fine Arts, Boston, Massachusetts
La Commune Telle Qu'Elle Fut. Catalogue of Bourges Exhibition, 1971
Davidson, Basil. *Africa: History of a Continent.* London, 1966
Eye-Witness Narrative of the War: Official Despatches. London, 1915
Forbes, Archibald. *Barracks, Bivouacs and Battles.* London, 1892
Forbes, Archibald. *Battles of the Nineteenth Century.* London, 1896–7
Forbes, Archibald. *Memories and Studies of War and Peace.* London, 1895
Forbes, Christopher and Margaret Kelly. *War à la Mode: Military Pictures from the Forbes Collection*
Gibbs, Sir Philip. *The War Dispatches.* London, 1964
General Gordon's Journal, Khartoum. London, 1885
Graphic, The, (from 1869)
Hassrick, Peter. *Frederic Remington.* New York, 1974
Herold, J. Christopher. *Bonaparte in Egypt.* London, 1963
Hodgson, Pat. *The War Illustrators.* London, New York, 1977
Hogarth, Paul. *The Artist as Reporter.* London, 1967

Holme, C. Geoffrey (Ed.) *Constantin Guys.* London, 1930
Arthur Boyd Houghton. Catalogue, Victoria and Albert Museum, introduced by Paul Hogarth.
Illustrated London News, (from 1842)
Illustrated London News, a History of (pamphlet). London, 1967
Illustrated London News: A Record Number of a Glorious Reign, 1902
Jackson, Mason. *The Pictorial Press, its Origins and Progress.* London, 1885
Johnson, Peter. 'Front-line Artists' (article), *Art and Antiques Weekly* 28 February 1976
Knightley, Phillip. *The First Casualty.* London, 1975
Mayer, S. L. (Ed.). *Hitler's Wartime Picture Magazine 'Signal'.* London, 1976
Morris, Donald R. *The Washing of the Spears.* London, 1966
National Army Museum Annual Report, 1973–74
Norris-Newman, Charles. *In Zululand with the British Throughout the War of 1879.* London, 1880
Ohrwalder, Father Joseph. *Ten Years' Captivity in the Mahdi's Camp, 1882–1892,* edited by Major F. R. Wingate. London, 1892
Oko, Andrew J. 'The Frontier Art of R. B. Nevitt' (article). *Canadian Collector,* January–February, 1976
O'Shea, John Augustus. *An Iron-bound City* [Paris]. London, 1886
Pearse, H. S. *Four Months Besieged* [Ladysmith]. London, 1900
Pope, Dudley. *Guns.* London, 1965
Prior, Melton. *Campaigns of a War Correspondent,* edited by S. L. Bensusan. London, 1912
Ralph, Julian. *Toward Pretoria.* London, 1901
Raphael, Ralph B. *The Book of American Indians.* New York, 1953
Ray, Frederic E. *Alfred R. Waud, Civil War Artist.* New York, 1974
Russell, William Howard. *The British Expedition to the Crimea.* London, 1877
Russell, William Howard. *My Civil War Diary, North and South.* nd.
Simpson, William. *Autobiography,* edited by George Eyre-Todd. London, 1903
Steevens, George Warrington. *From Cape Town to Ladysmith.* London, 1900
Steevens, George Warrington. *With Kitchener to Khartoum.* Edinburgh, 1899

Taft, Robert. *Artists and Illustrators of the Old West 1850–1900*. New York, 1953

Thomas, Donald. *Charge! Hurrah! Hurrah! A Life of Cardigan of Balaclava*. London, 1975

The Times, (from 1853)

Villiers, Frederic. *Villiers, His Five Decades of Adventure*. London, 1921

Vizetelly, Ernest Alfred. *My Days of Adventure: The Fall of France 1870–71*. London, 1914

Vizetelly, Henry. *Glances Back over Seventy Years*. London, 1893

Vries, Leonard de. 'Panorama 1842–65' and 'History as Hot News 1865–97': from the pages of the *Illustrated London News* and the *Graphic*, London, 1973

White, Anne Terry. *Indians and the Old West*. New York, 1961

Wood, Christopher. *Dictionary of Victorian Painters*. England, 1971

Woodham-Smith, Cecil. *The Great Hunger*. London, 1962

Woodham-Smith, Cecil. *The Reason Why*. London, 1953

Index

*Note: figures printed in **bold** type refer to the illustrations; italic c after a figure refers to a caption on that page*